Advanced Style

OLDER & WISER

ARI SETH COHEN

FOREWORD by Simon Doonan

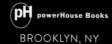

powerHouse Books
BROOKLYN, NY

FOREWORD
by **Simon Doonan**

I just typed the words "leopard-print blouse" into my search engine and—bingo!—one million nine hundred thousand results popped up. Does that mean that there are one million nine hundred thousand leopard-print blouses in the world? I would not be at all surprised. After all, we are now living in a fash-tastic universe where style is everything—Who are you wearing?—and fashion has become nothing short of a global spectator sport. From Barneys to Zara, from H+M to Target, from cheapo eBay vintage to schmancy red-carpet couture, fashionable schmattas have never been more ubiquitous than they are today. You can buy any item, leopard-print or otherwise, at any price, in any size, at any time of the day or night.

Despite this 24-hour, anything-goes, sartorial freak-fest, we, the citizens of planet Earth, still retain some very outmoded, conventional ideas regarding style, especially when it comes to… drumroll…senior style. Strong opinions regarding the alleged perils of *age-inappropriate dressing* are still widely held and frequently voiced:

"Look at her! Mutton dressed as lamb."

"She's too old for her outfit."

"He looks like he's been shopping in Austin Powers' trash can." (I can hear you.)

Underpinning this outdated notion is the crazy idea that the older you get, the more conservatively you should dress. Color and experimentation are for young people. Restraint, propriety, and formality are for seniors. Once you hit 50, you must dismount from the carousel de la mode and start dressing in beiges and greiges, sort of like an East German librarian/prison wardress circa 1950.

Needless to say I do not support any of these ageist restrictions and neither does Ari Seth Cohen, the pied piper of glamorous oldsters. Ari's growing/greying army of style warriors wake up every morning and fling themselves onto the ramparts in order to fight for their rightful place on today's fash-tastic landscape. Instead of drones and bombs they use flamboyance and panache. Rather than bullets and grenades they deploy cloche hats and minaudièrs. (And that's just the men!)

Are the *Advance Style* gals and guys at a disadvantage because of their age? Au contraire! Age has emboldened them to adorn themselves with individuality and creativity. They have reached their don't-give-a-shit years and can happily compete with any of today's young street-style icons. Exhibit A: Ilona Royce Smithkin (page 20) makes fake lashes from her own ferociously hennaed locks. Case closed. Such proprietorial flourishes of self-expression are, as you will plainly see as you linger languidly over the pages of this gorgeous tome—hopefully while eating lotuses and wearing dove-grey spats—the bedrock of *Advanced Style*, and, for that matter, style at any age.

Now let's address the elephant in the room, yes, that *Advanced Style* elephant over there, the one wearing the canary-yellow patent-leather thigh boots and the Philip Treacy lobster hat. Let's address the question of *motivation*. Why? Why bother? Why make the effort? Why dress to express? Wouldn't it be easier to just throw in the towel and go the East German librarian route?

First and foremost, it's about consideration for others. Creative dressing is simply good manners. While dressing *down* is a crime against humanity—everyone knows that— dressing *up* is a veritable mitzvah, a gift to those around you. When an *Advanced Style* visionary walks into your field of vision you will always feel as if you just spotted a rare butterfly or found a 20-dollar bill in the street. Optimism fills the air. Life is suddenly exciting again. Advanced Stylistas are life-enhancing avatars who fill the world not just with glamour, but also with a sense of *possibility*.

On a less altruistic note, advancing your style is beneficial not just to the psyches and wellbeing of the audience, but to the wearer too. Dressing with vitality and creativity acts like a nifty antidepressant on your mood. Concocting ever-more fabulous ensembles is, especially now that there is such a stupendous breadth of choice, a profoundly satisfying artistic endeavor.

As rewarding as it may be to play stylist *chez toi*, the real fun begins once you leave your closet and hit the streets. Skeptical? Throw on that Schiaparelli cape—so what if it has a few moth holes?—over that Stella McCartney jumpsuit, accessorize it with silver Wellies and a Zabar's bag, and vamp your way down the avenue. Flaunt yourself. Feel the joie de vivre. Enjoy the surge of endorphins. Such is the mysterious power of *Advanced Style*. Dame Vivienne Westwood, thinker, visionary, and no spring chicken, articulated it best:

People who wear impressive clothes have better lives.

Needlepoint *that!*

———————————

This book is dedicated to the memory of
my friends and muses Lynn Dell Cohen,
Rose Sachs, and Zelda Kaplan

and to

Grandma Bluma and Nana Helen whose
guidance, wisdom, generosity, warmth,
style, and spirit planted the seeds for the
Advanced Style movement early on.

———————————

INTRODUCTION
by **Ari Seth Cohen**

When I originally started *Advanced Style* over eight years ago, I had just moved to New York City after the passing of my grandmother and best friend Bluma. I began to document the style and stories of some of the city's most inspiring older people as a tribute to her and way to deal with the profound loss of living without her inimitable guidance. I knew that the people I was photographing had the power to inspire, but I never could have imagined the extent to which this personal project has since blossomed into a global movement re-imagining the picture of aging—the idea that one can look forward to their later years as one of the most productive, liberating, and rich chapters in life.

Since the publication of my first book and the release of the *Advanced Style* documentary, it's been quite an adventure. From Sydney to Tokyo, Rome to Buenos Aires, I have had the privilege to meet some incredibly dressed and inspirational ladies and gentleman who continually astound me with their wisdom, creativity, and vitality. No matter where I find myself in the world, when I hit the streets to photo-hunt, it's not one particular style that attracts me—nor am I attempting to judge what is in good or bad taste. Who truly catches my eye are those whose artful and creative dressing is a reflection of their indomitable spirits and the refusal to become invisible.

Over the years, I've picked up my fair share of advice from the *Advanced Style* set. Never do when you can overdo. You must dance your way through life. Don't ever stop playing. The true key to aging with advanced style is maintaining an attitude of optimism, a healthy and active lifestyle, and a sense of continued purpose.

The following pages contain photographs accompanied by selected essays from some of the exceptional people that have allowed me to take their photographs. You'll first meet 97-year-old Tao Porchon-Lynch, a yoga master who travels the world teaching and sharing her wisdom with thousands of people. Her energy is boundless, and she lives by the mantra "there is no age." She is proof that the secret to growing old with exuberance is simply a matter of mindset. Men and women, young and old alike, email me every day saying that people like Tao have helped not only rid them of their anxieties about getting older, but have also made them look forward to the freedom and sagacity that comes with aging.

I hope that if we begin to see aging differently that we will start to treat older people with the respect and reverence they deserve. By refusing to accept the notion that growing older is something to be feared, we can begin to fully embrace our elderhood with as much joy, creative growth, and imagination as our childhood.

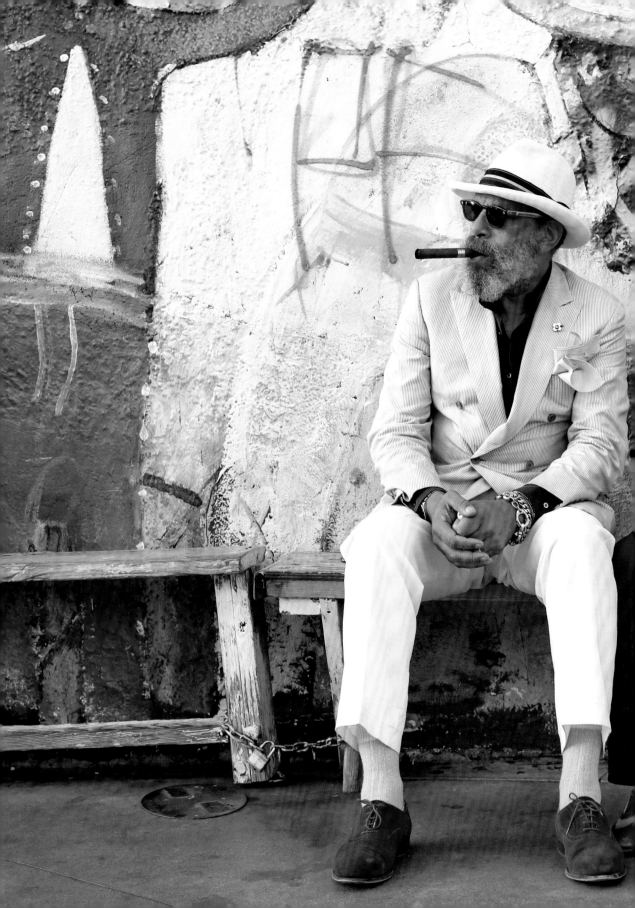

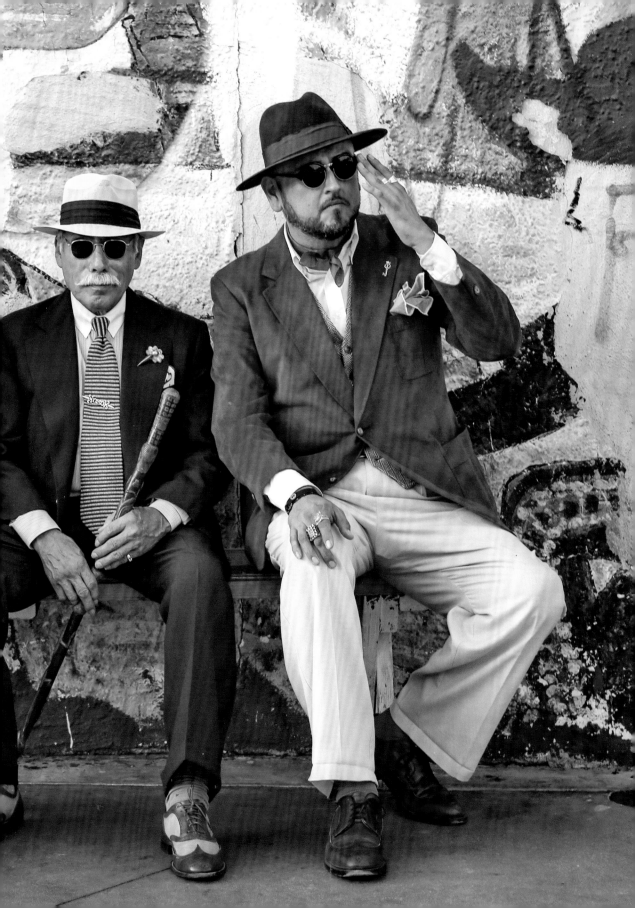

Tao Porchon-Lynch, 97

In my head I'm still in my 20s, and I have no intention of ever growing up. When people ask me about age, I tell them to look at all the trees around them. They're hundreds of years old. They may look as if they're dying at the moment, but they're not; they're recycling themselves. In a couple of months, they're going to be reborn again. I believe we can recycle ourselves with each breath we take.

It's important to have no fear. My uncle in India taught me that. He was a friend of Mahatma Gandhi. I marched with Gandhi in 1930. Through both of these great men I was inspired to always do what I believe. I performed nightly through the World War II bombing Blitz in London and people were amazed. I worked with General Charles de Gaulle and the French Resistance helping Jews escape the Nazis. I didn't think it was anything special. I later married the love of my life and modeled for top designers such as Coco Chanel, Jeanne Lanvin, and Jean Dessès. Then, I was an actress under contract with MGM in Hollywood. When disappointments came, my dear friend Marlene Dietrich said, "Close the book." Instead of dwelling on things, I learned to move on.

I live every day with style. I like color and I always wear high heels. Although I am considered a yoga master and have certified over 1,600 yoga teachers, I love wine and chocolate. When I was 87, I started competitive ballroom dancing and I have since won over 721 first place awards. It's never too late to follow your heart. When I get up in the morning, I say to myself, "This is going to be the best day of my life," and then it is. Just know that there is nothing you cannot do, for you're not the doer, you're the instrument. You have the power inside to do everything you set your mind to!

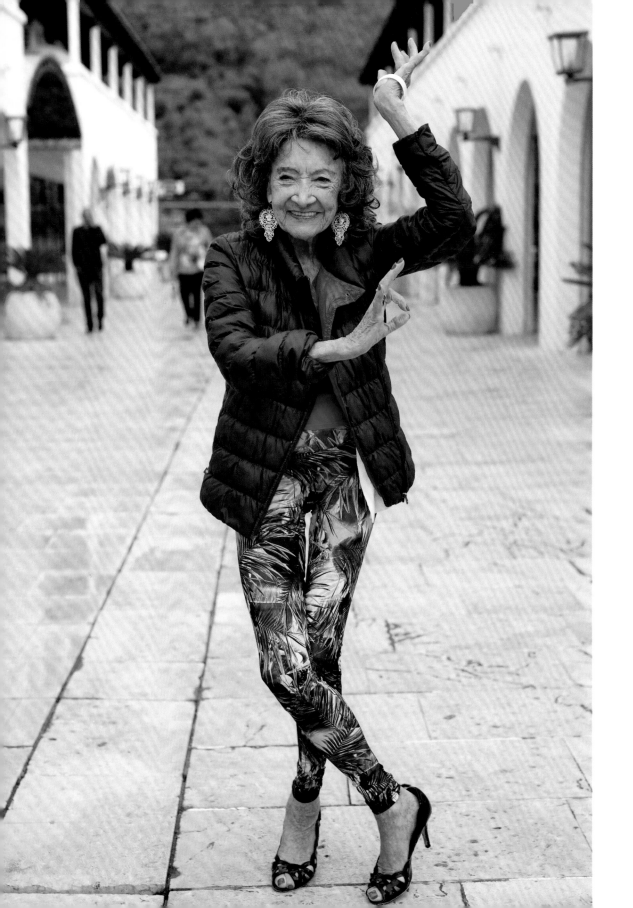

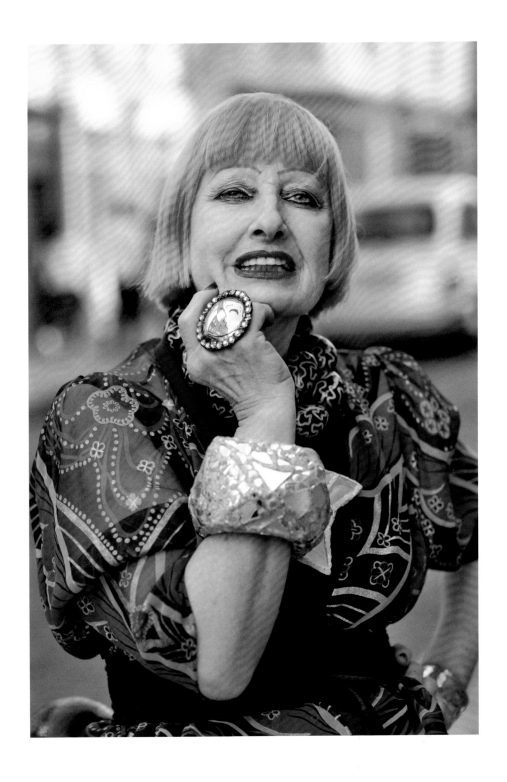

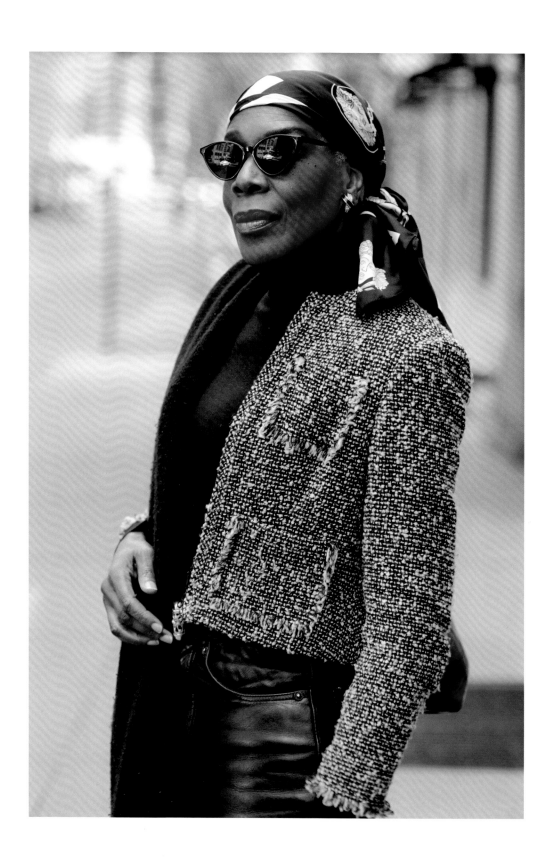

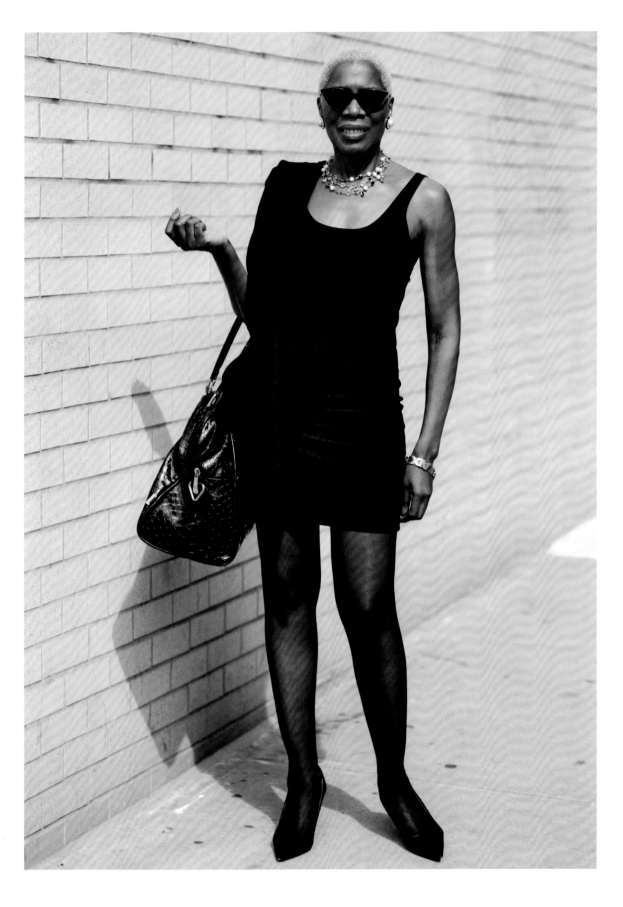

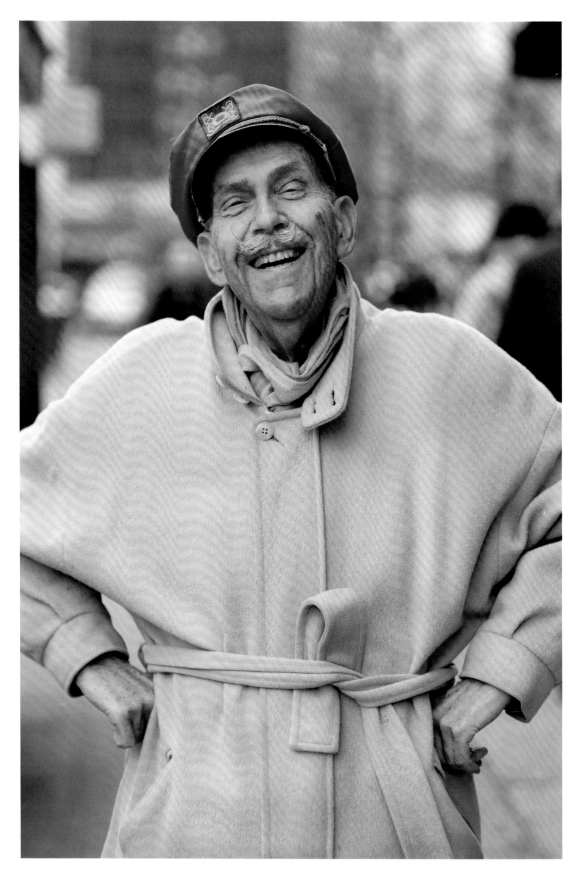

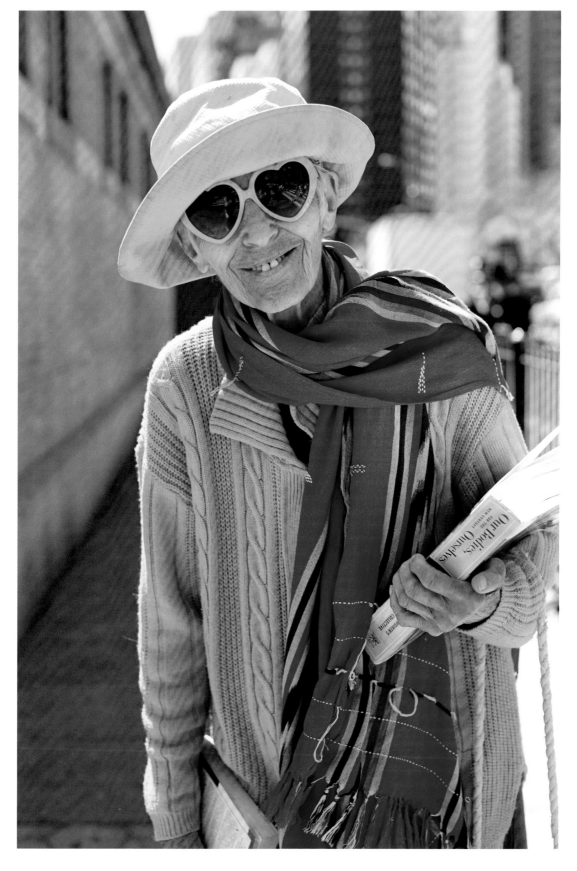

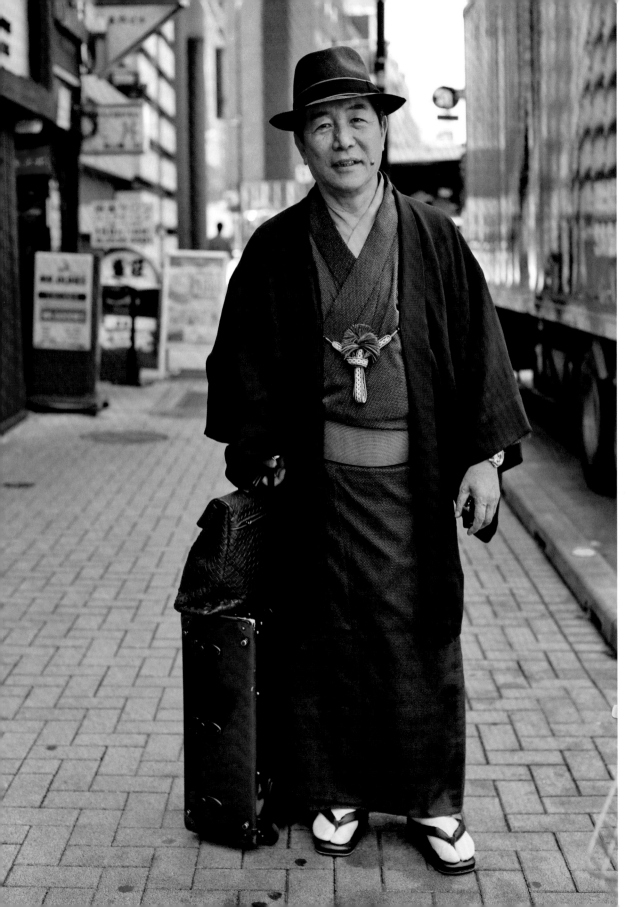

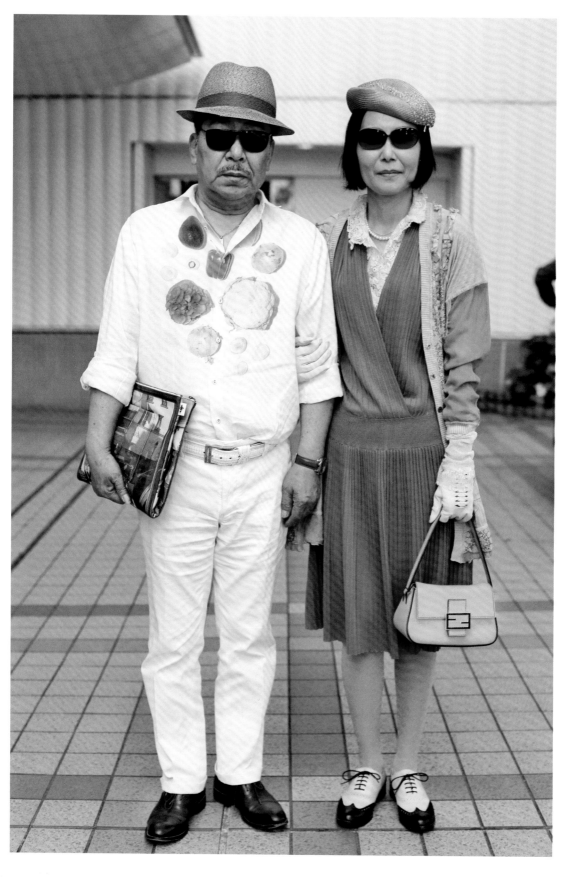

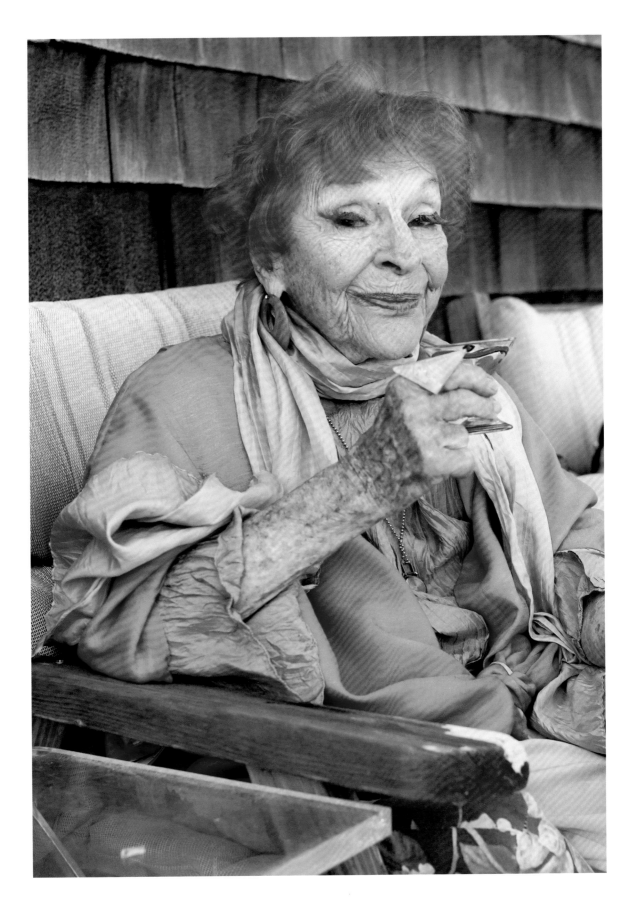

Ilona Royce Smithkin, 95

When you don't have to worry about yourself anymore, you are free for any experience. It's like opening the door and letting the fresh air come in.

All of my life I have been an artist, and without being aware of it, I was also an entertainer. Entertaining isn't really something new for me, only now it's on stage. When I was teaching all over the country, which I did for 40 years, I always entertained my students. I cheered them, teased them, and flirted with them. I sang to them and I told them funny stories. In retrospect I have always entertained. It seems to be in my blood.

When I met Ari a few years ago and became a part of *Advanced Style* my life changed. It took on a completely different color. I have always enjoyed my life, but that involvement brought a new dimension to my existence. It made my life far more interesting.

I remember when I first moved into my own apartment and had my own telephone, each time it rang, I would think, "Somebody saw me in the street and discovered me for a film!" I was never disappointed when that didn't happen, I thought, "Next time…" and I had a great deal of fun with that idea.

Now when the telephone rings people want interviews right and left, people want to talk with me, they want to tape things, they want to make appointments for a photo shoot. It's constant, it doesn't stop, and it's an amazing thing for me. It's a lot of fun!

Lately when I walk down the streets of my neighborhood, people recognize and approach me. They say, "I've seen the film. I liked you so much. Can I take a photo with you?" They feel inspired by me. So many tell me that my philosophy has helped them deal with their problems.

It makes me feel good if I can help someone. That is a joy for me. When you meet someone who is depressed or sad and you can cheer them up, it's a positive thing. It's an incredible feeling. It's a contribution to *happiness*. It might be a small one, but if one can help someone else feel happier, even if it's not for long, that's an accomplishment and we should give ourselves credit for that and strive for it.

For me, cheering someone comes naturally, because it's right inside of me. When I see somebody sad I want to brighten their lives.

When I was younger, I was very self-involved. I was worried about so many things, and I was very self-conscious. But I always had empathy for other people. When I first came to this country I was about 18 years old and lived with my parents. I've always loved flowers, but in those days money was scarce. Since I could not afford them, I figured out a way to get them. I made an arrangement with the corner flower shop and once a week I would pay them a small amount of money and they would save me damaged daisies, which were the cheapest of the flowers. One day while taking the subway to work, with my flowers in hand, I saw a man who looked very sad. I walked over and said, "You look so unhappy, here's a flower, I hope it cheers you up." Then, I gave a daisy to a couple of other people who looked downtrodden. When I walked out at my stop I had several men follow me, they thought I was a prostitute and that that was my way of soliciting them. So I turned around and said, "What's the matter with you people, can't someone be nice to you, without wanting anything in return?" I learned my lesson. You can't give flowers to strangers even if they look sad!

At 80 years old I finally became free of my worries, my self-consciousness, and my feelings of not being good enough. I realized that I had something to offer, as an artist and as a teacher. Now I am totally free and full of openness, and that openness permits me to let so much of the world enter in—sounds, feelings, emotions. When I'm with people I see not just their outer appearance, but I feel almost what they are like inside, and that is an interesting experience. It is as if somebody has opened a door for me, or pulled back a curtain, and I see things so much more clearly; the delicate things, the vulnerabilities, the strengths, the joys, the pains of life. I see everything magnified.

I now write a lot. I write about my feelings. I write about things that are beautiful, or interesting, or difficult. I don't want to lose the discovery of whatever it is that intrigues me. The other day I was walking on the beach and I saw the waves splash onto the shore. The sound was so different that I stopped to listen to it. As the waves crashed against the sand it sounded like thousands of pearls being thrown upon the land.

I do more now than I have ever done before with a great deal more confidence. I experiment more with my paintings, and I try to do interesting things that I would not have dared to do earlier in my career because I wasn't sure of myself. But now even not being sure is interesting because you have an adventure, you don't take it serious, you don't treat it like somebody stands behind you with a whip saying, "You've got to do that." It's a great experience to be free enough to permit yourself to try, even if it doesn't come out right.

I am happy to have gained so much insight and knowledge in my old age. When one is ready to learn, or when one permits oneself to learn every day, you get an unexpected, wonderful sense of satisfaction.

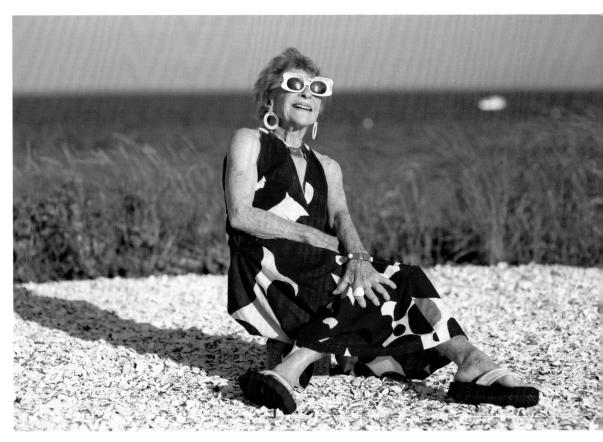

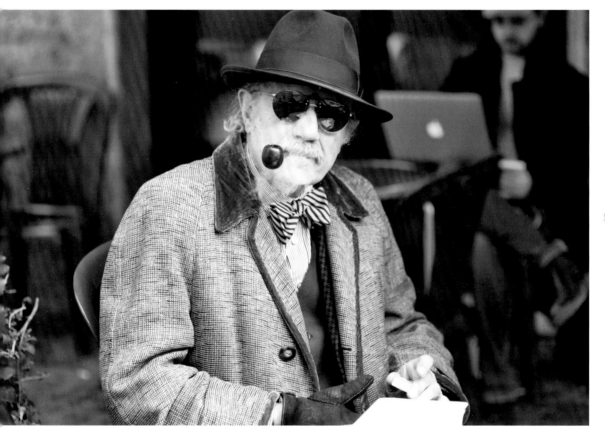

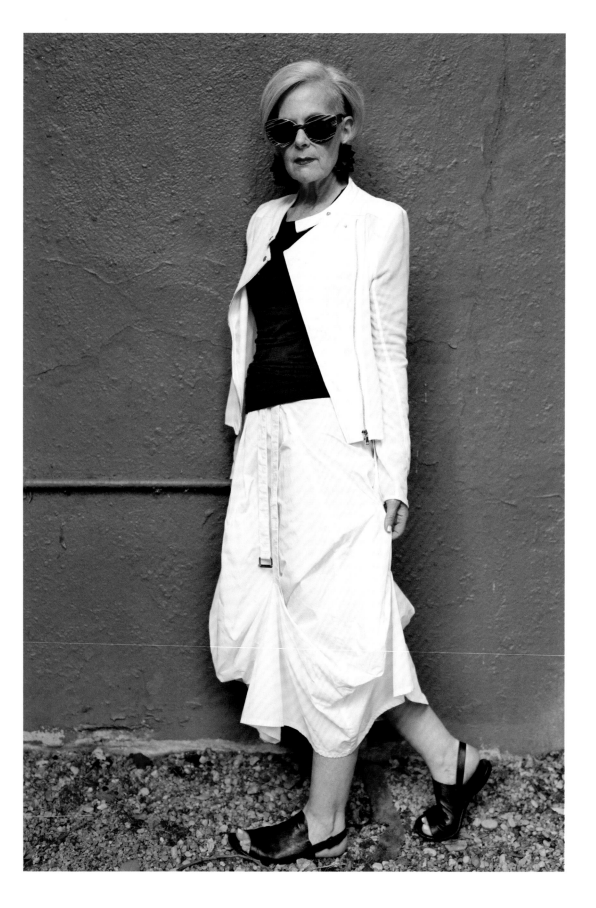

Lyn Slater, 62

I have always believed that life is performed. We can write original stories or we can accept the scripts that others have written for us. I came up in a generation that refused to accept the status quo, the roles, and the life that our mothers and grandmothers had before us. We decided to rewrite the narrative and we burned bras, experienced "free love," participated in demonstrations, and had important careers and families. So why people would think we would accept and enact somebody else's scripts of invisibility, "retirement," "age appropriate dress," and dismissal simply because we got older is rather astounding.

Now that I am in my 60s I have successfully raised a beautiful daughter, I am a grandmother, I have achieved success in my chosen career. This means I have time and resources to devote to my passions. I can reinvent the next 20 years of my life, as I am fortunate to be in good health. Although I always had personal flair and style, I began to experiment and indulge myself even more in the world of fashion. I started to take more risks with my styling. I looked and felt more exciting. My style began to be noticed and people suggested I start a blog. The week after my first post happened to be New York Fashion Week, and it was conveniently located a block away from where I teach. I went to meet a friend on the plaza and before I knew it I was surrounded by a group of photographers and tourists asking to take my picture because everyone mistakenly believed I was some famous fashion person. I appeared on Instagram and in online magazines. Thus began my adventures as "Accidental Icon."

Accidental Icon is the creative and artistic parts of myself that are being allowed full expression. She is the heroine of my reinvention story. I am still a professor, but I am now also Accidental Icon. She is the older and not shy version of myself. Accidental Icon is the amazing and life changing result of taking a risk. She is the woman who was and the woman who is becoming. Importantly, Accidental Icon is the visible representation of accepting the joy, the possibilities, and the wisdom that comes with an acceptance of aging and a disavowal of the aging narratives that society still wants us to perform.

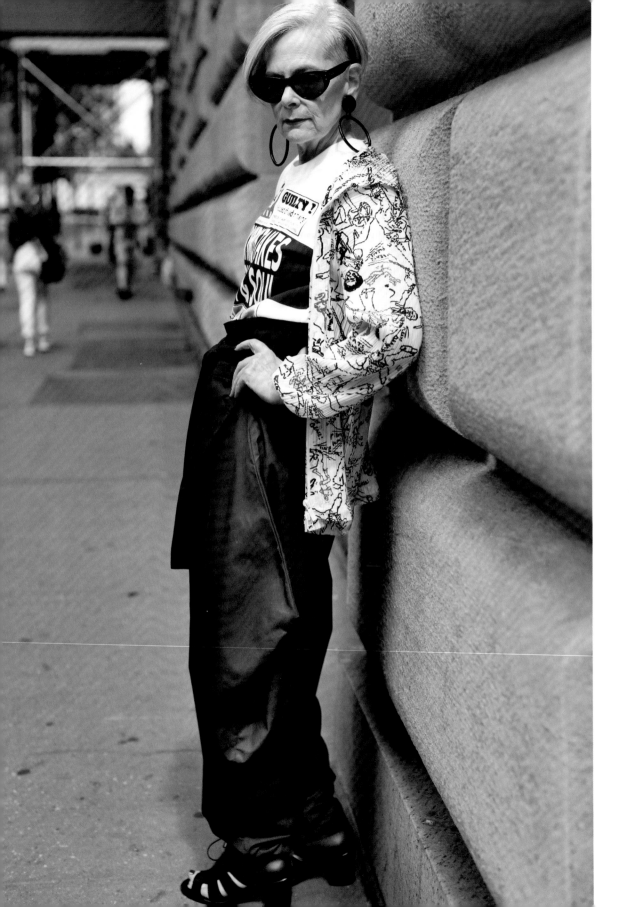

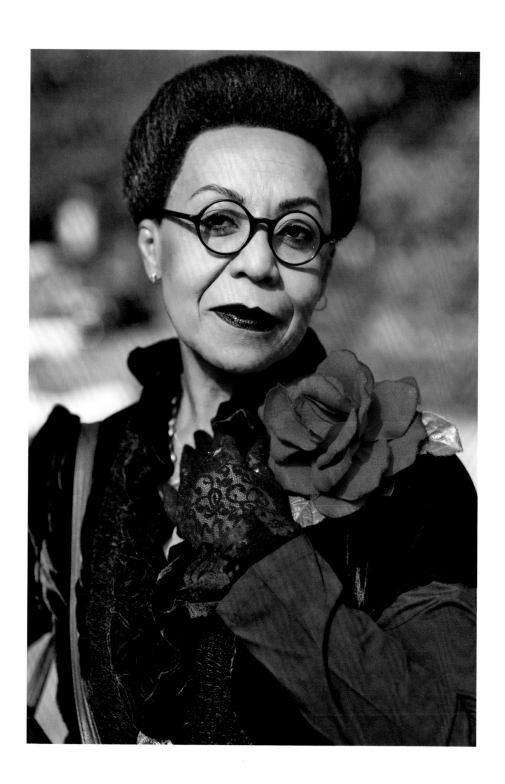

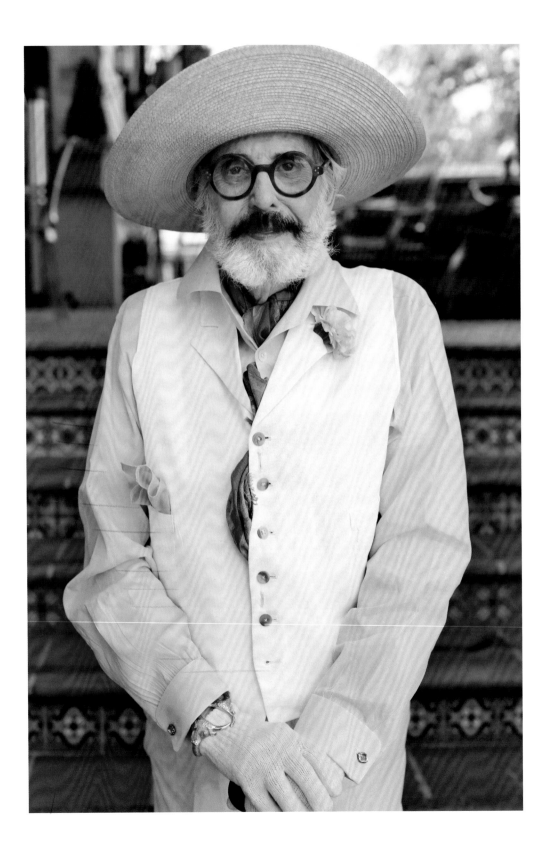

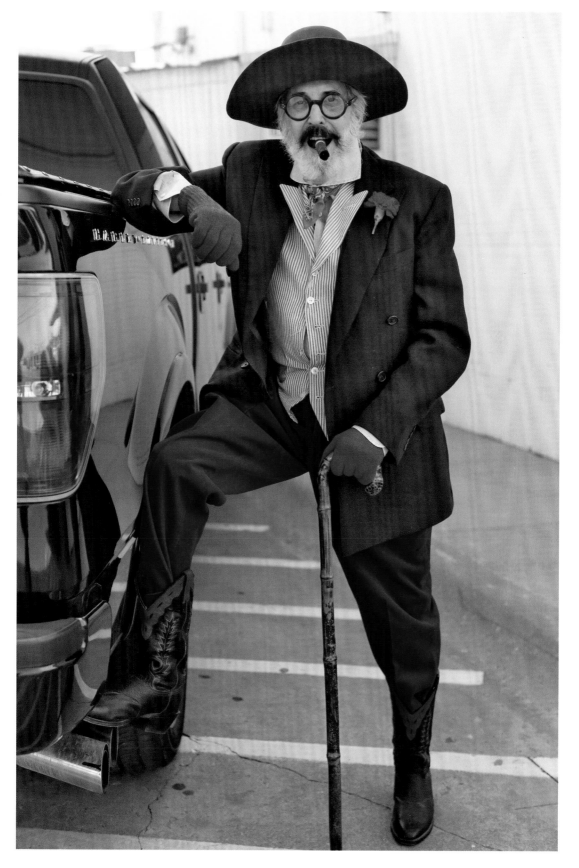

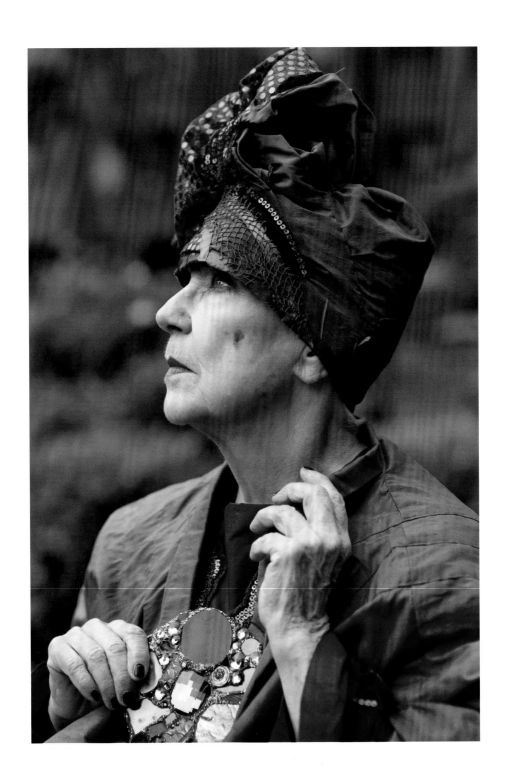

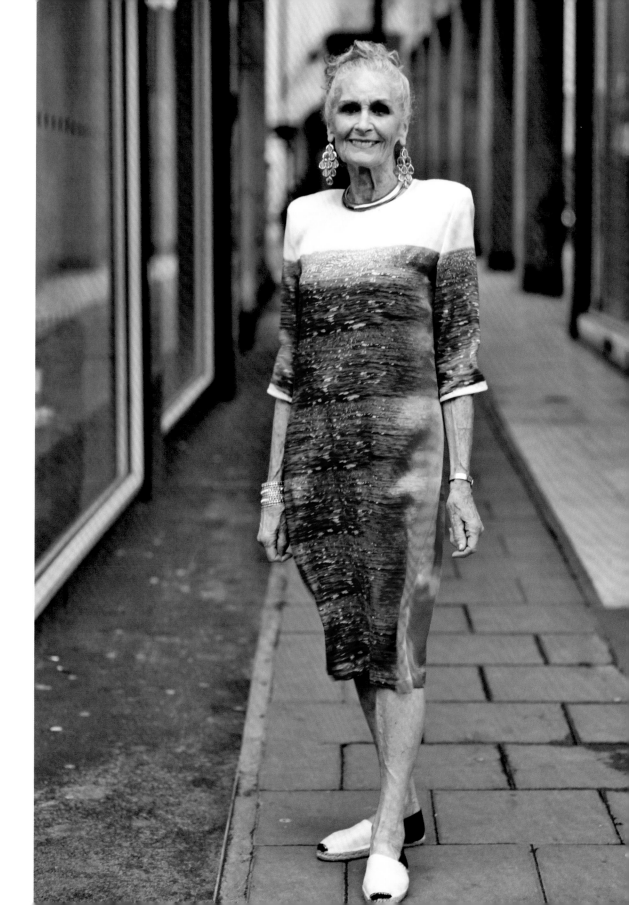

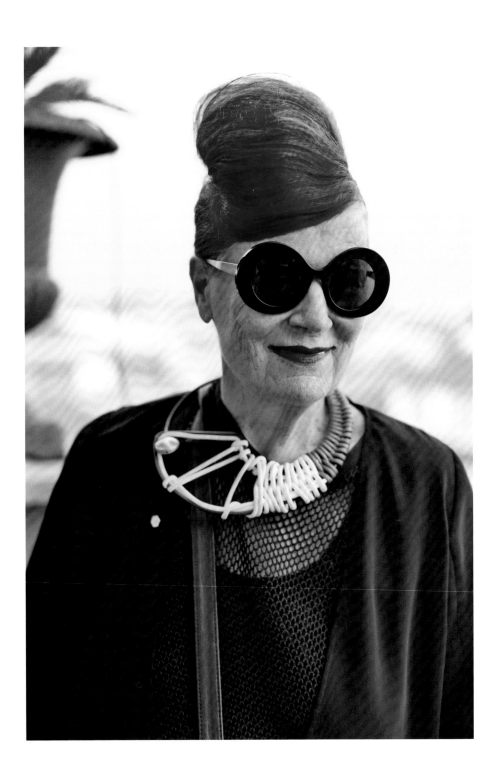

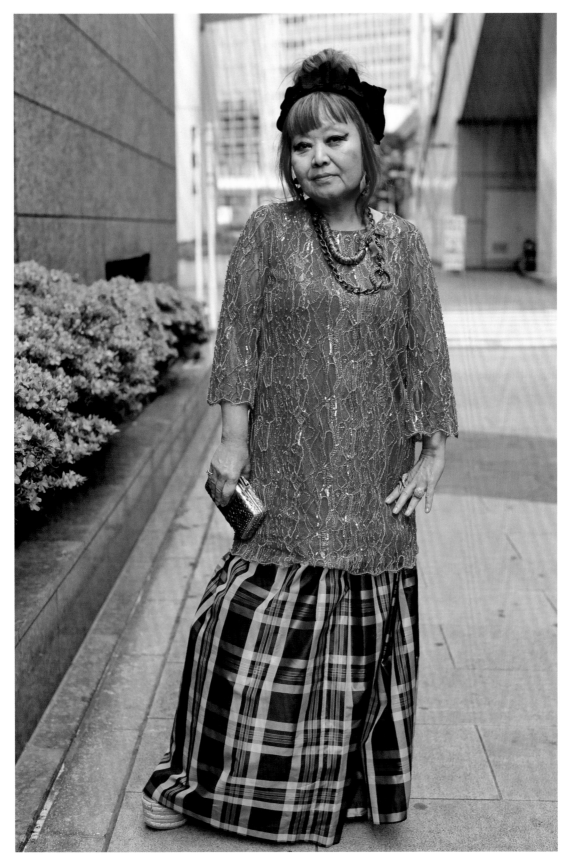

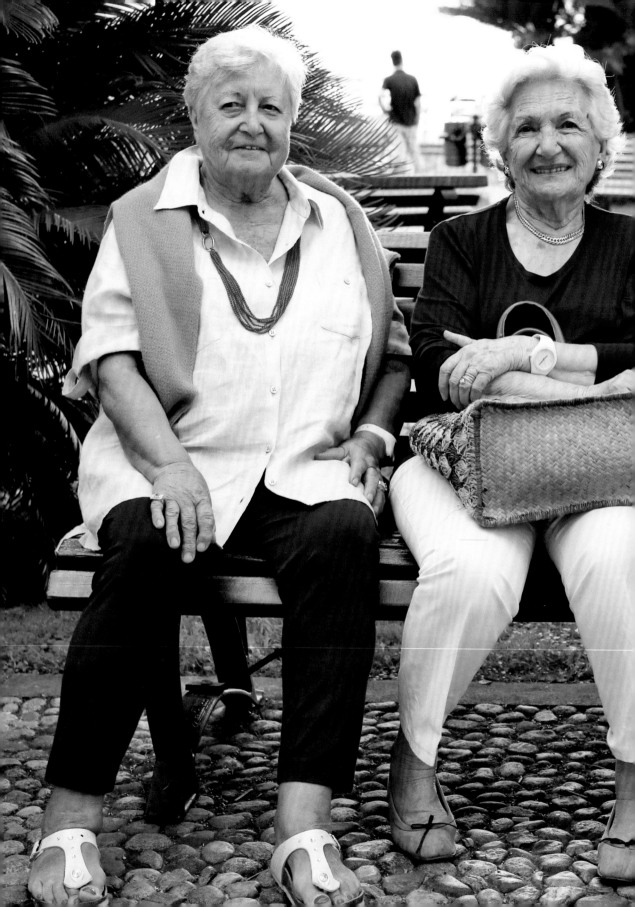

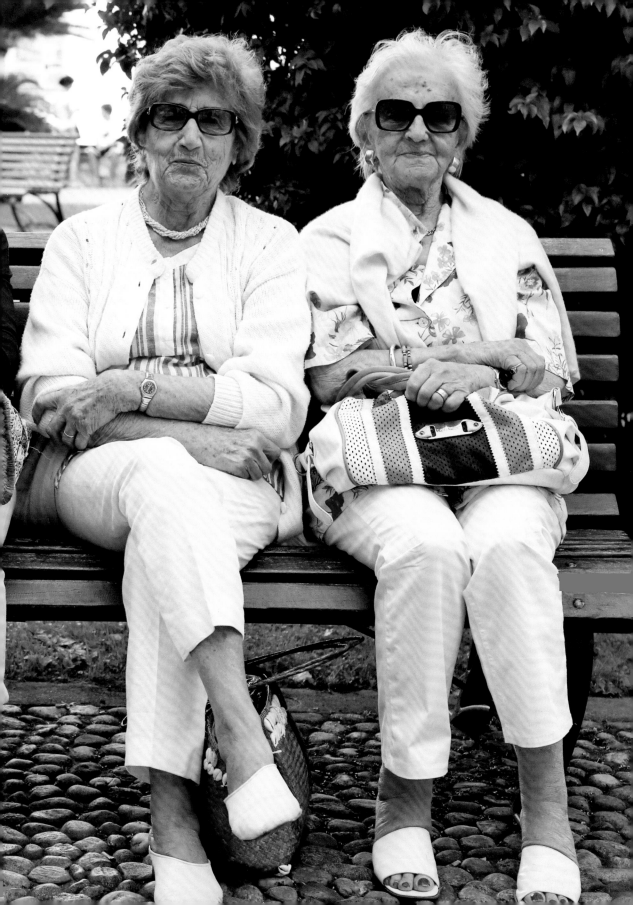

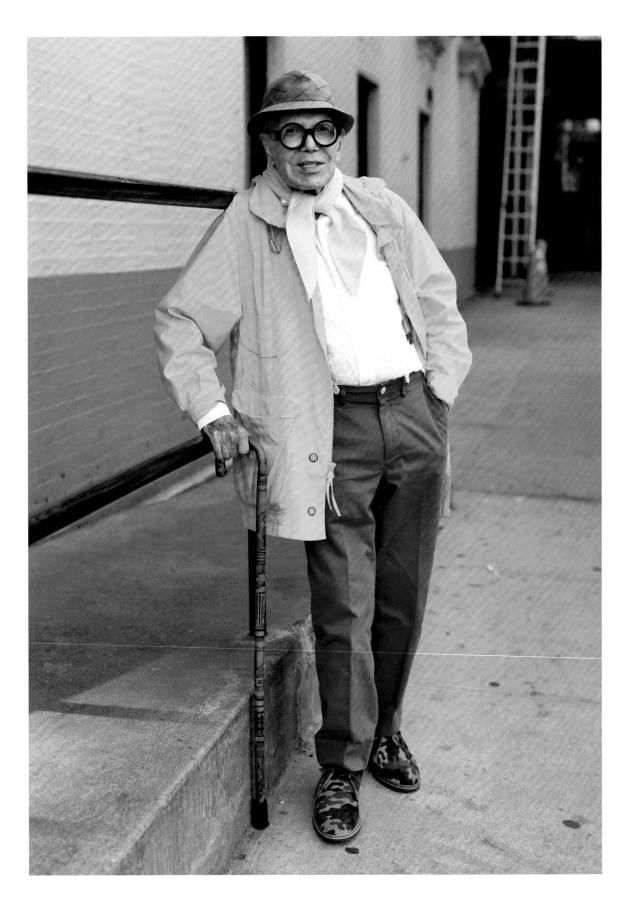

Bob Miller, 89

I've never been 90 years old before, nor had I ever been 89 or 79 years old before, but I have been, am now, and will be. Not all things were a surprise. I had the advantage of observing the age-related changes and modifications of movement, thought, and physical appearance of my parents; a dynamic, involved, loving couple who were together from ages 16 and 19 and who lived to be 92 and 95 years old respectively. In their case, only in death were they separated.

We spent many hours discussing the "aging experience." Suddenly they were their "age" first and then they were these nice "elderly people." All very disconcerting and upsetting. Suddenly they were "different"— maybe not as "sharp" or "with it"—and all because they the had the "good fortune" of "growing older"; of becoming a "senior citizen."

Ageism is the discrimination towards the aged and ageing. I urge you to pay attention to two comments: "Oh you forgot," and, "You don't remember." That's ageism. When you are passed over or ignored, when you are spoken to as if you were a child, when in any manner or means you are belittled or insulted because of your advanced age, that is ageism at work. When your doctor talks to his assistant about you and your concerns instead of talking directly to you, the patient, that is ageism at work.

I want to see political involvement in a program that informs a course of action to correct these ills and advises when to call the better business bureau, or the department of discrimination, and what to do when your complaint is ignored. I feel that ageing can be insulting, belittling, and diminishing. It destroys one's sense of self, ones quality of life and good health. You must make a noise to have things change. Call and write your representatives—your senators, the president, all elected officials—advise them that they will not get your vote unless they help cure this disease.

In the meantime, be sure that you are involved in life and living. Know what is going on in the world around you. Listen to young people, do not lecture them, and you might just learn something you didn't know or consider before. Avoid spending all your time with your age group; you'll not learn anything you don't already know. Make an effort to be well groomed and polished at all times; you'll like yourself more, you'll want to take "you" out. (Your clothes and grooming should and must be age appropriate.)

Life is an adventure. Get out there and live it!

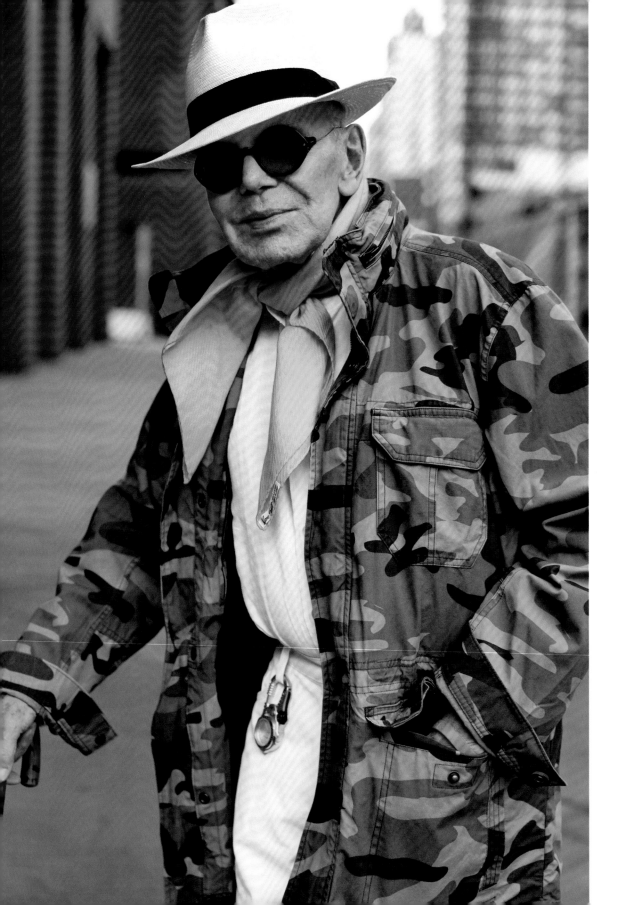

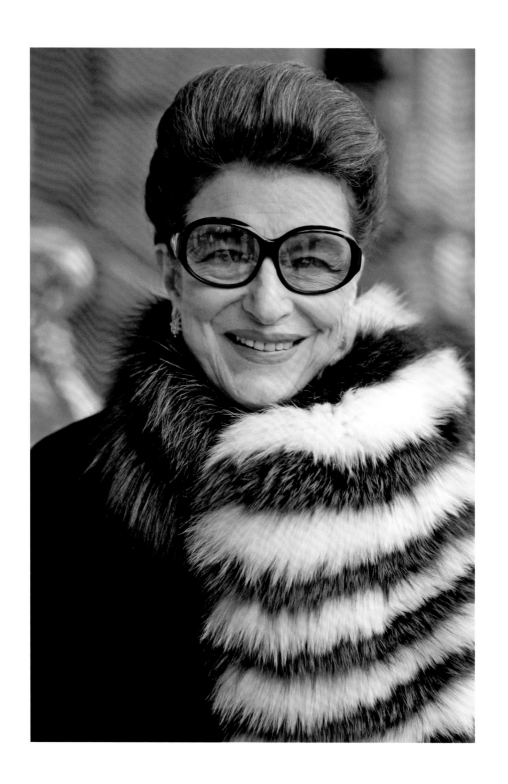
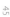

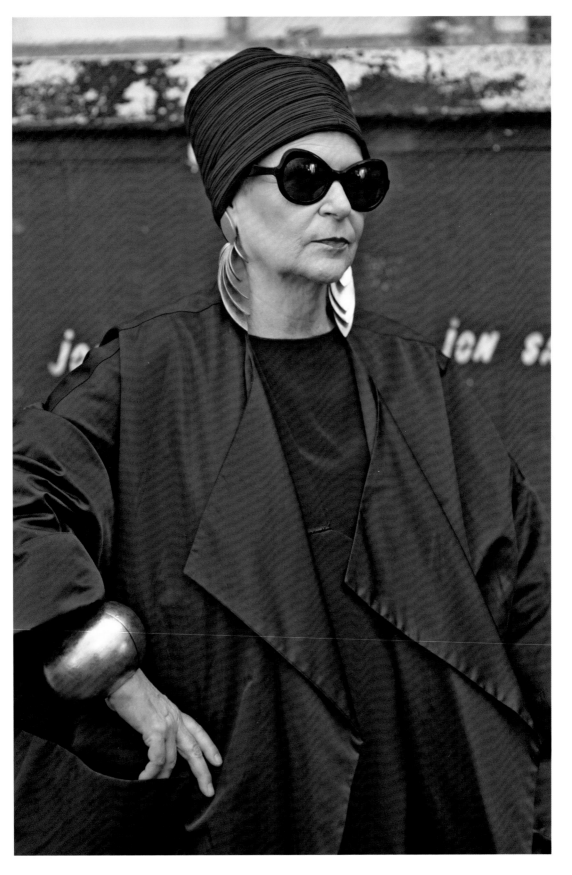

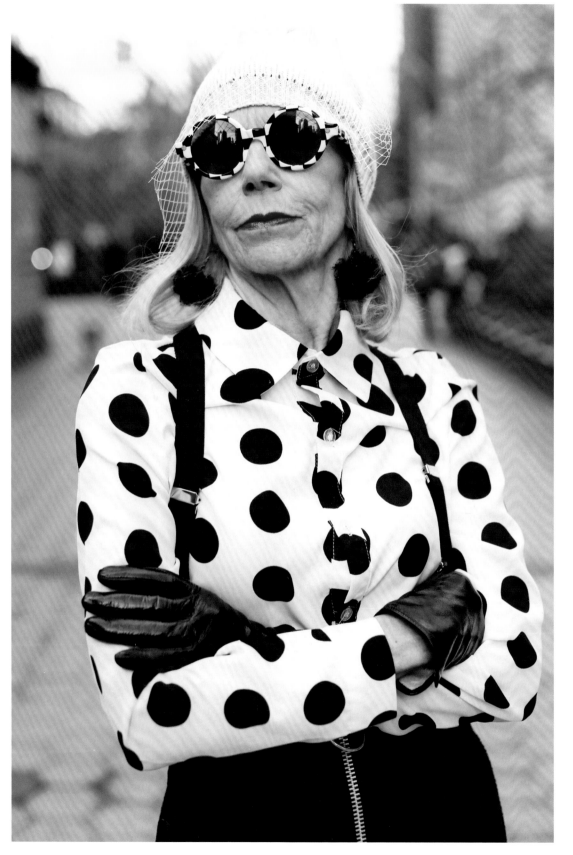

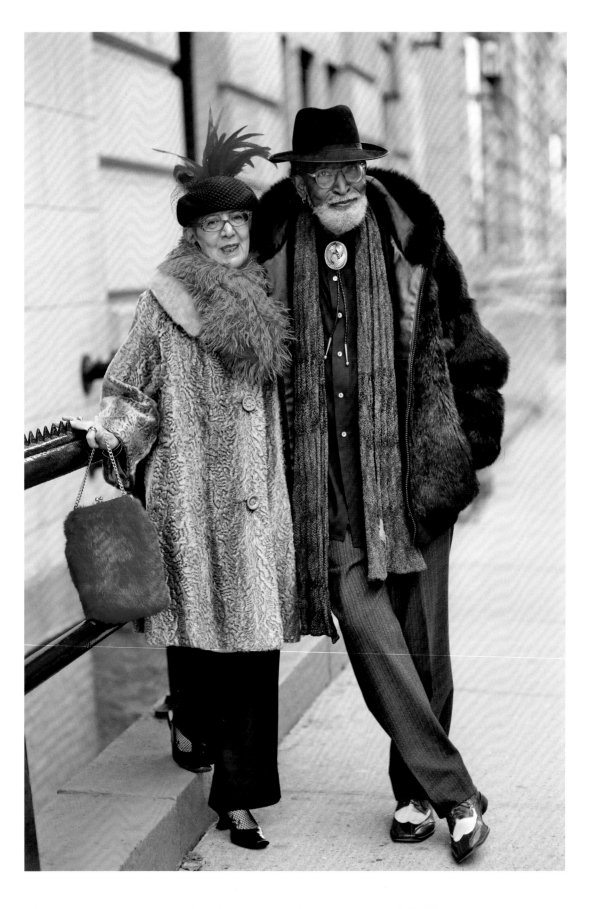

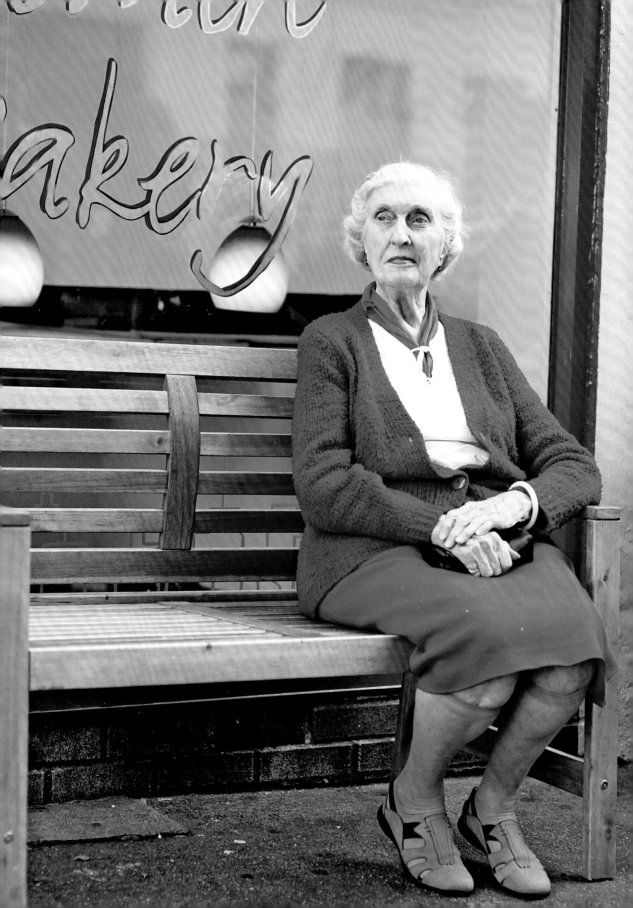

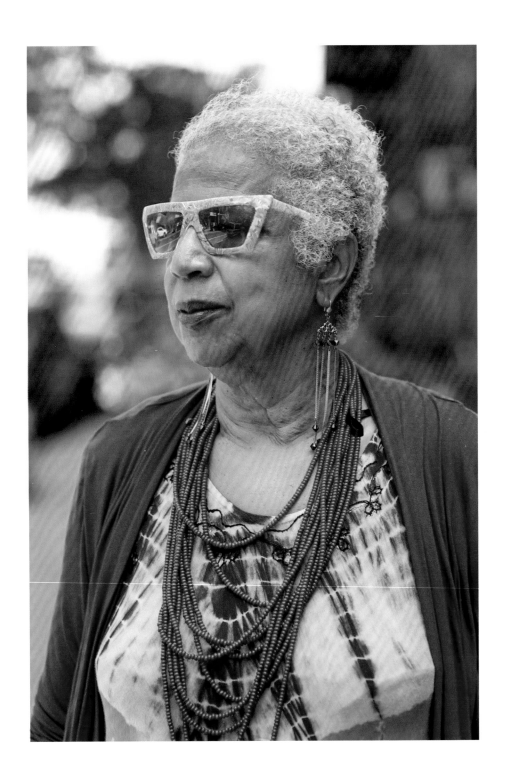

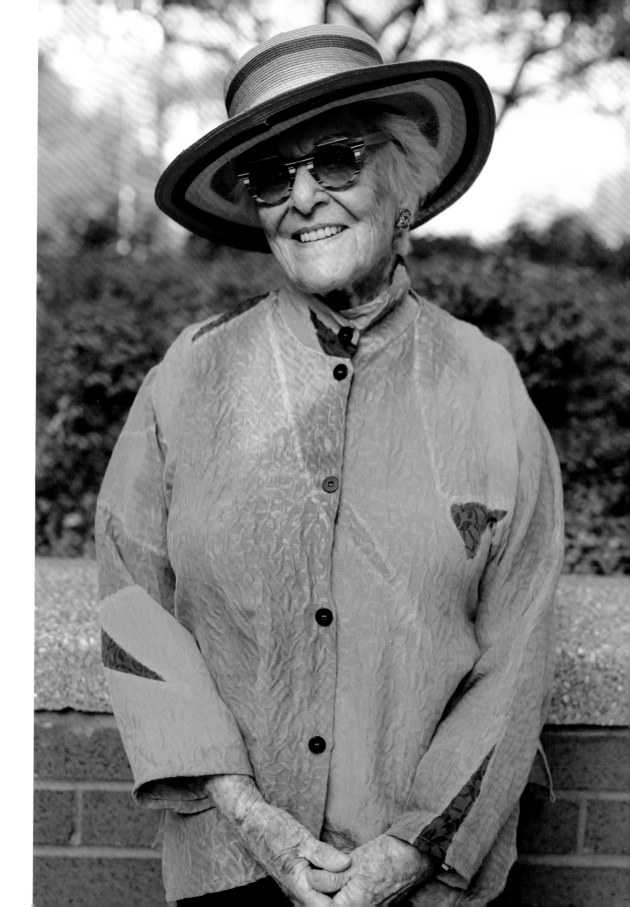

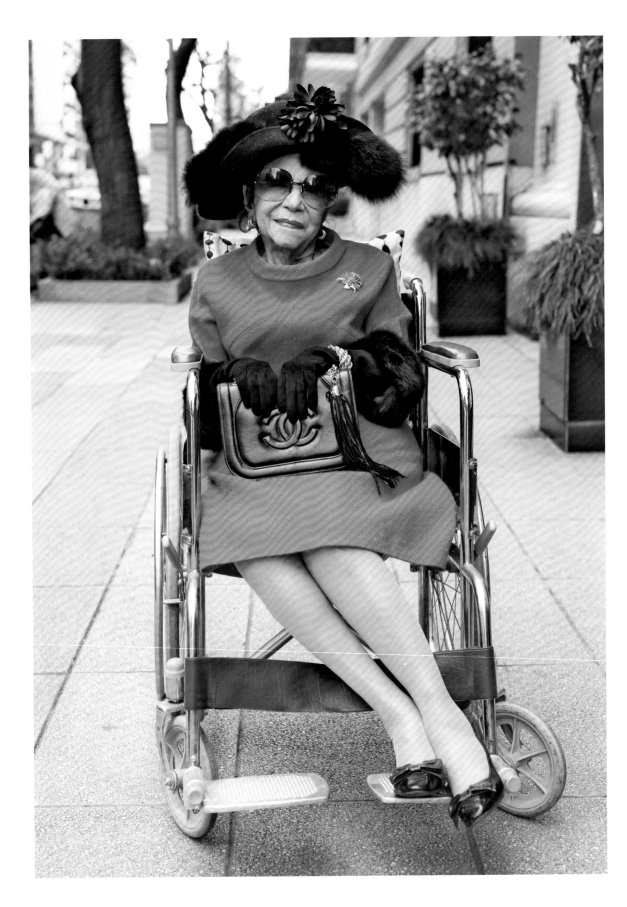

Mme. Manuela Muguerza y Grarcía-Moreno, 93

My passion for fashion started at a very early age, and it was greatly the influence of my paternal grandmother, the Marchioness of Villa Rocha and Solanda, who was like a mother to us. It was from her that I learned my first tips about beauty and fashion. I still remember how, as children, my sisters and I would get up and run to our grandmother's quarters just in time to watch her do her toilette. We would sit next to her vanity and watch how she would prepare her skin and apply the makeup. One of the things I remember the most is how she applied powder to her face, neck, and shoulders (for evening occasions) with a puff attached to a long sterling-silver and mother-of-pearl handle. I still have and use it.

When it was time for my coming-out party, it was grandmother who took me to Maison Chanel to have my dress made. I chose a beautiful creation in heavy white satin at grandmother's and Mme. Chanel's advice. I still have that dress and the long white opera-length kidskin gloves that I wore.

We left Paris during the war, as father thought it was best. We returned soon after it was over. It was then that we discover M. Dior. His first show took place soon after our return and, as soon as we found out about it, my sisters and I rushed to commission some dresses. We fell in love with them. After the war fashions, so masculine and dull, it was wonderful to wear his long, flowing skirts with crinolines, his fitted jackets, and gorgeous high-heeled shoes. M. Dior was a darling little man, and we had a wonderful relationship with him. By then, we relied on our own judgment and, on some occasions, on the advice of our friends: Baron Alexis de Rédé and our Chilean cousin Raimundo de Larraín Valdés.

I have always had a fascination with hats and gloves, and still wear them. I believe that one must always find one's style and be true to it. Clothes are important as they tell the world who you are and your philosophy of life. With age, one can no longer follow fashion whims. One's makeup and clothes should remain true to one's style.

As for beauty advice: never go to bed with makeup on and always buy the best products you can afford. Keep your skin hydrated and away from the sun. And finally, smile at life, it is wonderful to be alive!

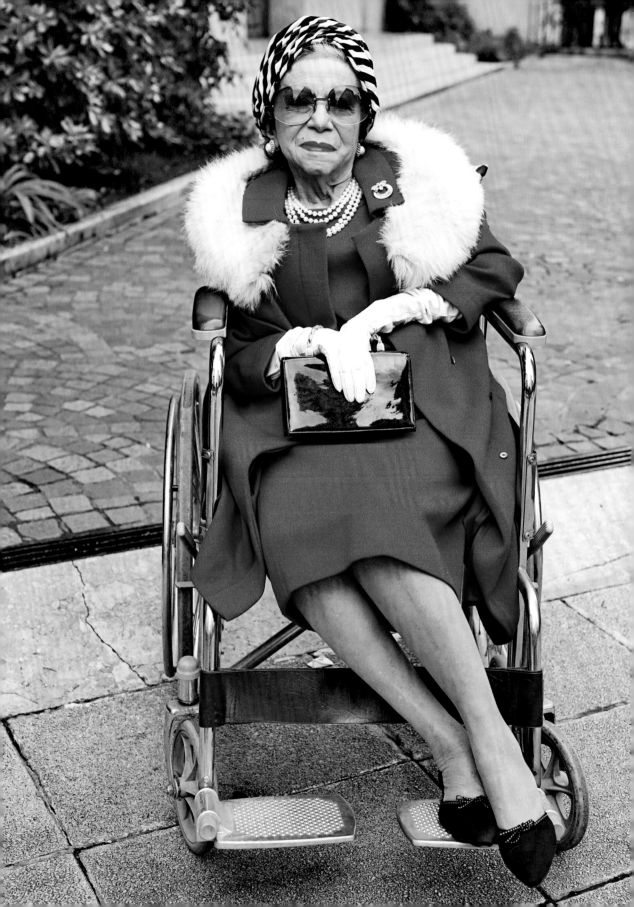

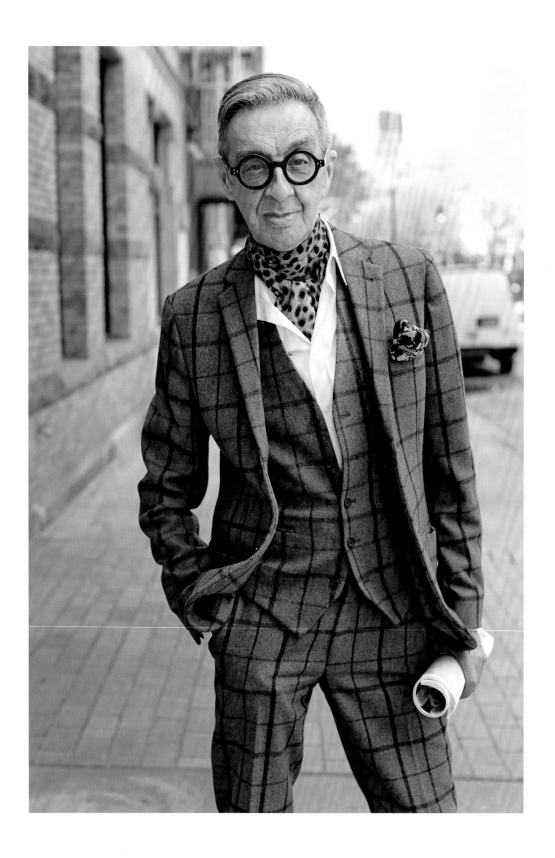

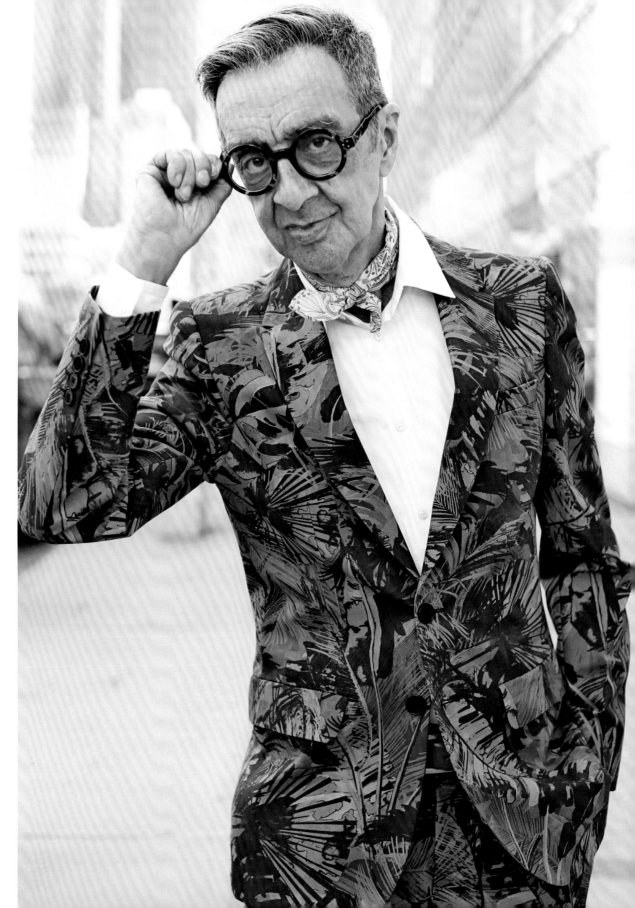

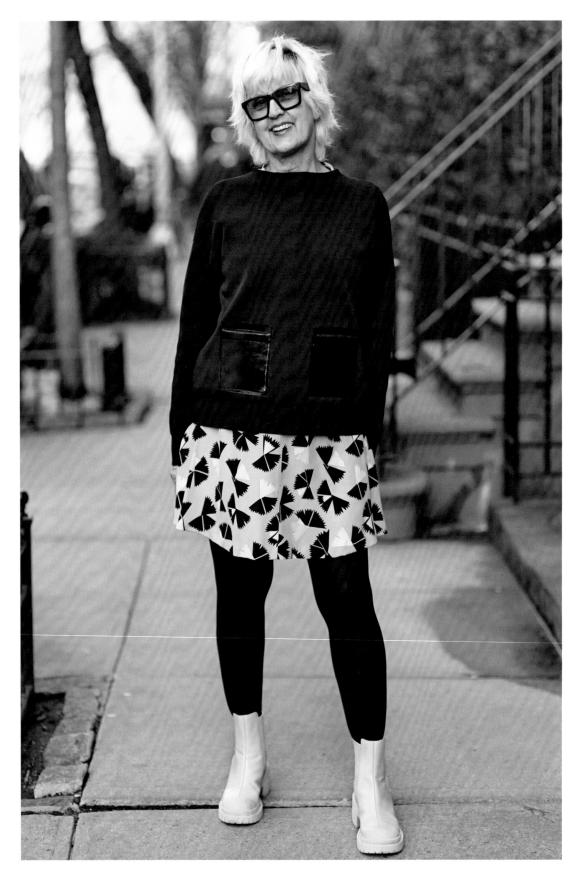

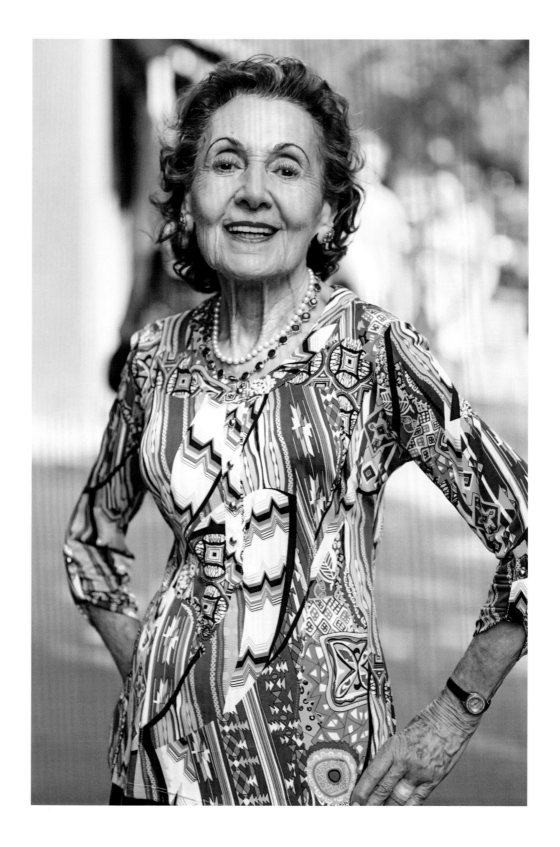

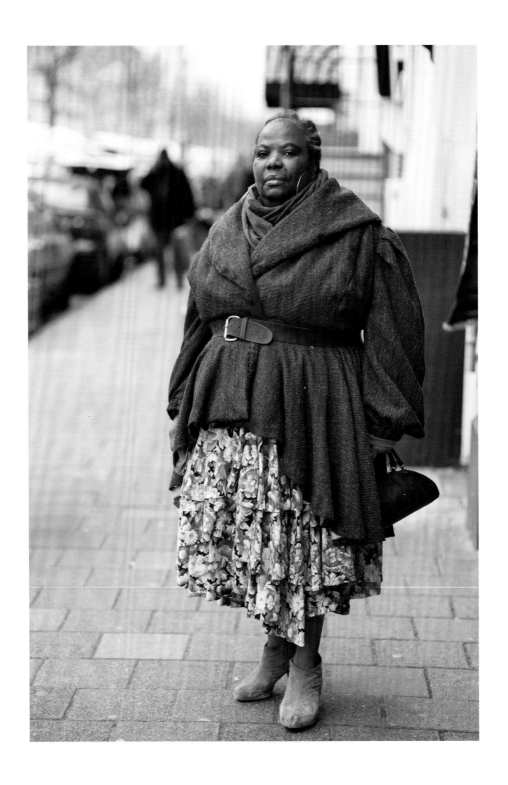

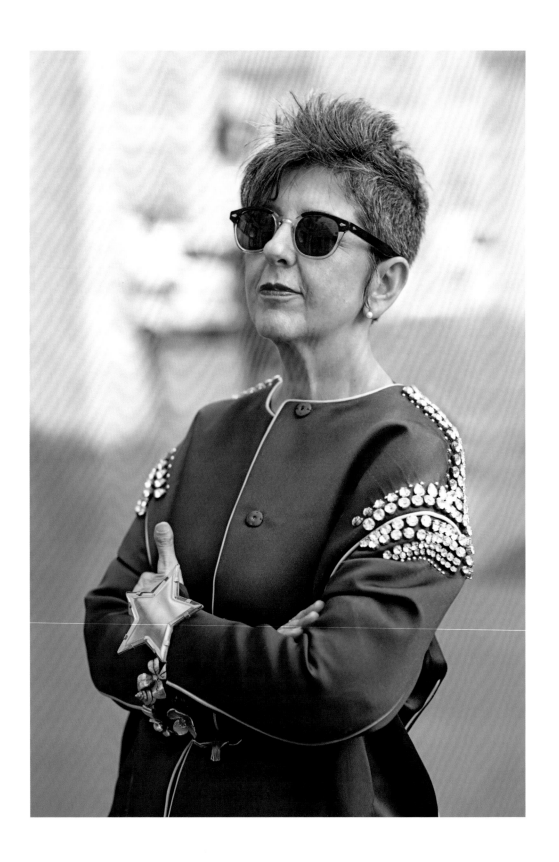

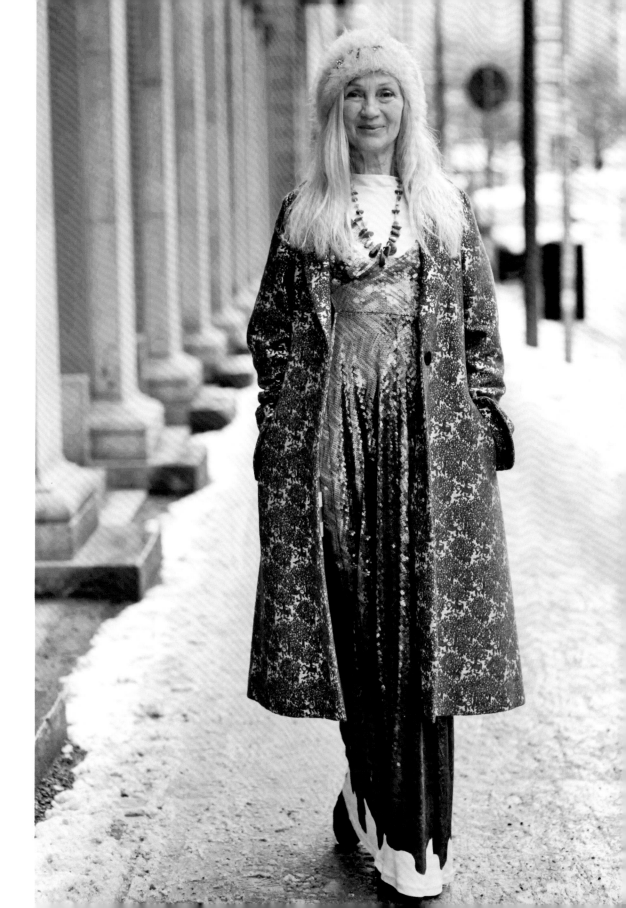

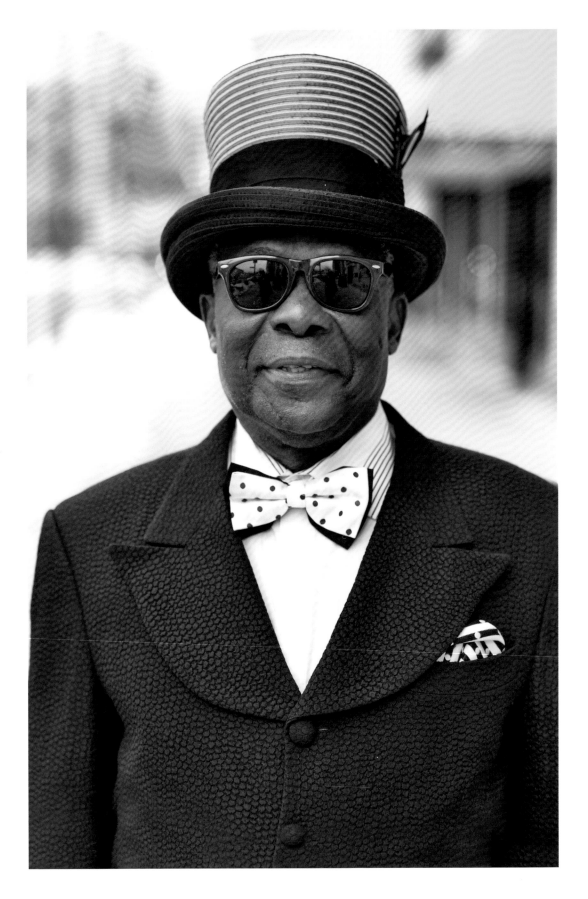

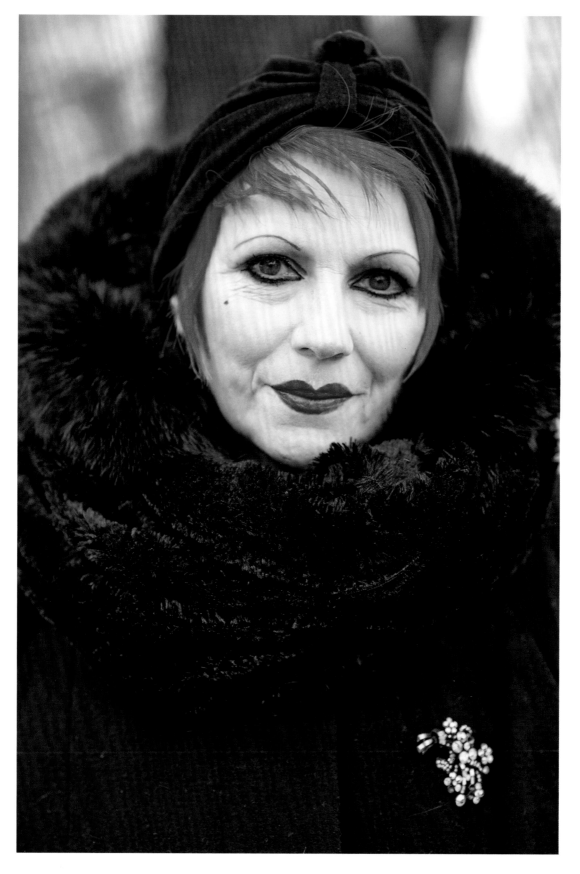

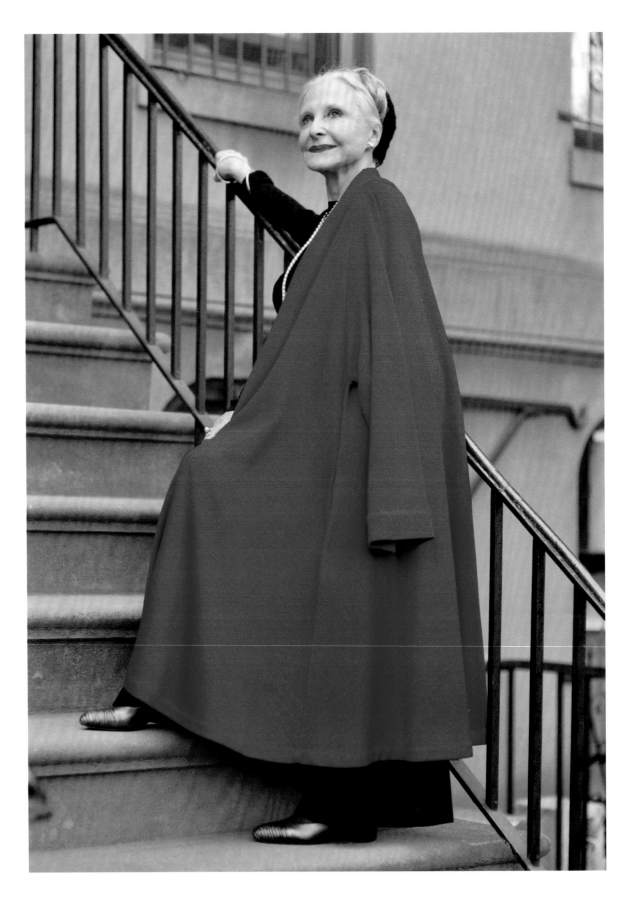

Joyce Carpati, 83

Alas, alas, most women as they age lament the loss of their youth and beauty. I never wanted to look young. I only wanted to look as lovely as I could at any age. Now at 83, my feelings have only become stronger.

The French say *vieillir est un privilège*, "to grow old is a privilege." This is also my feeling and attitude.

I dislike the term "anti-aging," which seems to be cropping up in so many beauty ads today. This word is demeaning and has no meaning. Here is my formula on how to look great and feel good about yourself with every passing year:

Find a distinctive style and make it your own.

Start with a great hairstyle. Visit a wig or hair establishment and try on every style that appeals to you. Look through hair magazines and hair websites. Ever think of bangs and short-cropped hair?

When you have found your style, check out the many bead shops and find barrettes in different shapes and colors. Wear one every day in the same visible place in your hair. *This is now your style.*

I have worn braids and pearls nearly all my life. When I worked at *Cosmopolitan* with Helen Gurley Brown, everyone in the magazine industry knew me as Joyce Carpati, the lady with the braids and pearls. This was my style.

You can apply your own style when wearing scarves and jewelry. Arrange it your own way so it belongs to you!

Wear shoes with mad stockings; no one will forget you!

Ladies, at this time of our lives, dare to do and say anything you like and do it with audacity.

Worry about wrinkles and lost youth? Leave that to Goethe's Faust and remember what happened to him!

Embrace your age, have fun, and try some false eyelashes

Thank you *Advanced Style* and Ari Seth Cohen.

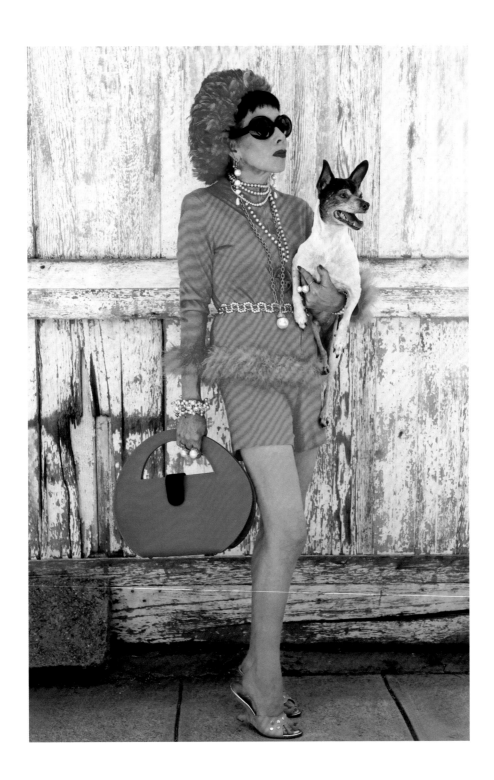

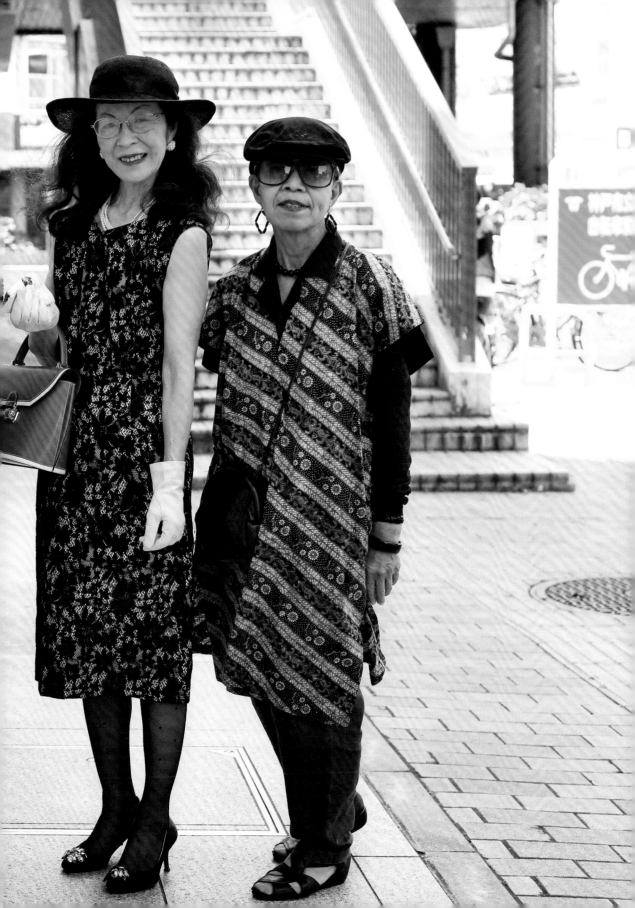

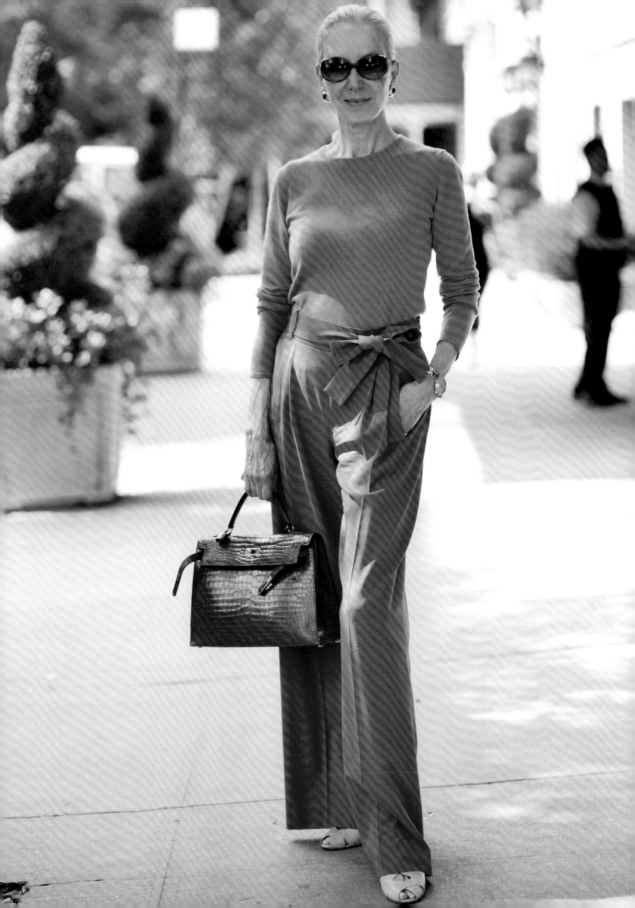

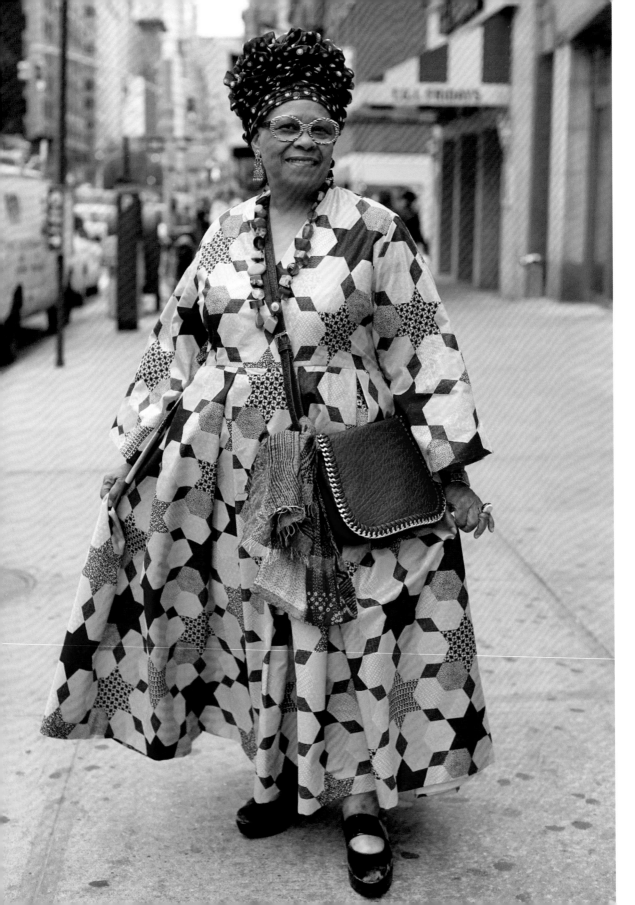

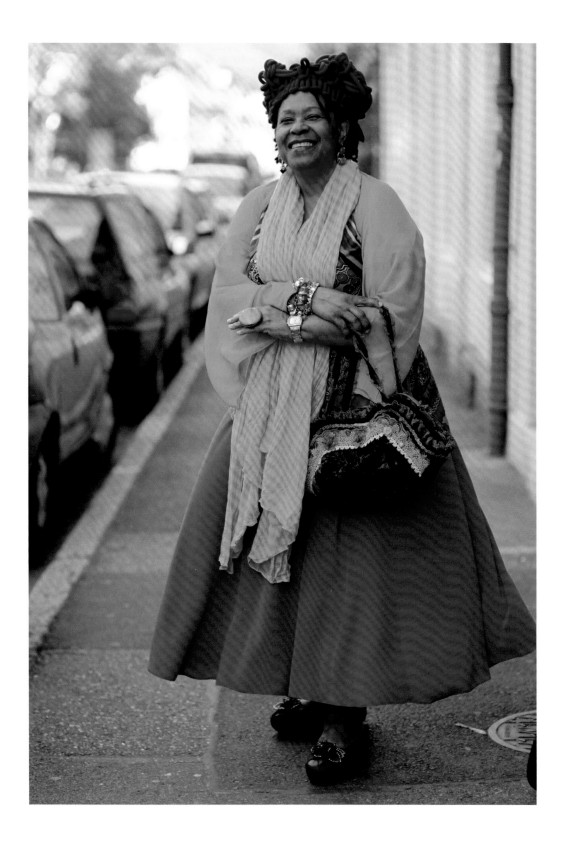

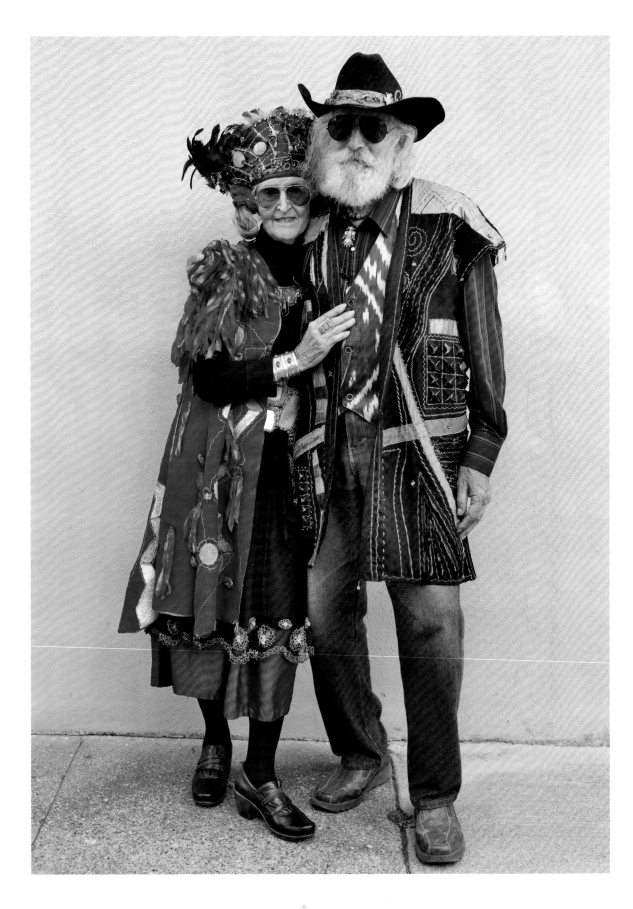

Morton and Virginia Linder, 77 and 76

Virginia and I have been together full-time for 53 years. We feel we have been on a magical mystery tour, and are still on our honeymoon. Ginny says that the secret is to always be extra nice to each other.

Virginia grew up in Tallahassee, Florida, and attended Atlanta Art Institute. She came to San Francisco and went to the San Francisco Art Institute. Ginny is a multimedia artist, and is always working on some project. When we were first together, she fashioned velvet curtains into capes, hats, and shirts for me. When we are out and about, we are always attired in her creations, and I am proud to wear and display her colorful work.

I grew up in Philadelphia, Pennsylvania, went to Penn State, and graduated from the University of Pennsylvania Veterinary School. We were neighbors in Pt. Richmond. She had an art studio, and I was practicing in Berkeley, after returning from being a freedom rider. We moved to San Francisco and found our Sutter and Lyon St. Victorian building when I took an alternate route on a night emergency call. A fire, just after acquiring the building, allowed us to remodel and open a veterinary practice. Many of the rock stars of the era were our clients, including Janice Joplin. The area was a vibrant African American community, and the gospel church across the street was jumping with live music on Sundays, and the teenagers, with their boom boxes, sang and danced between the community center and the projects.

Living with Ginny has just been intuitive, easy, and a joy. We spend a lot of time together, and have rarely been separated. We do most things together, except for her knitting group. We did most of the work on our city building together ourselves. We painted, remodeled, did plumbing, electrical, and built the veterinary clinic from scratch. We shared the labor and ideas. The preacher from across the street would always come over and tell me what a good woman I had, because we were always working together. Ginny was the receptionist in the veterinary clinic.

The veterinary practice was so successful that we were overwhelmed. We realized that money was not primary, and that the most important thing was our time together. We moved to a minimal cabin in a rural area, and lived a pioneer life. We backpacked, hiked, and cycled. We spent two and a half years traveling with our young daughter in Europe—Turkey and Morocco—in a VW bus, and lived for nine months in a primitive stone house in Greece. We cycled from Seville to Paris, living in a small tent for three months and over 2,000 miles.

We have spent the last decade going to Burning Man with a kite-flying group, and we have done art projects each year we attended, and worn costumes that we made.

We have always worked together on many of our various projects, sharing ideas, inspiration, and encouragement. We are not competitive and support each other in our projects and accomplishments. Of course we have had our ups and downs, but as long as we are together we feel we can overcome most things. We never stay angry for long, maybe because we love and respect each other, listen to the other's opinion, and realize that we are human and make mistakes. We have spent our 53 years doing most things together, and we still love being together and we miss each other when we are apart.

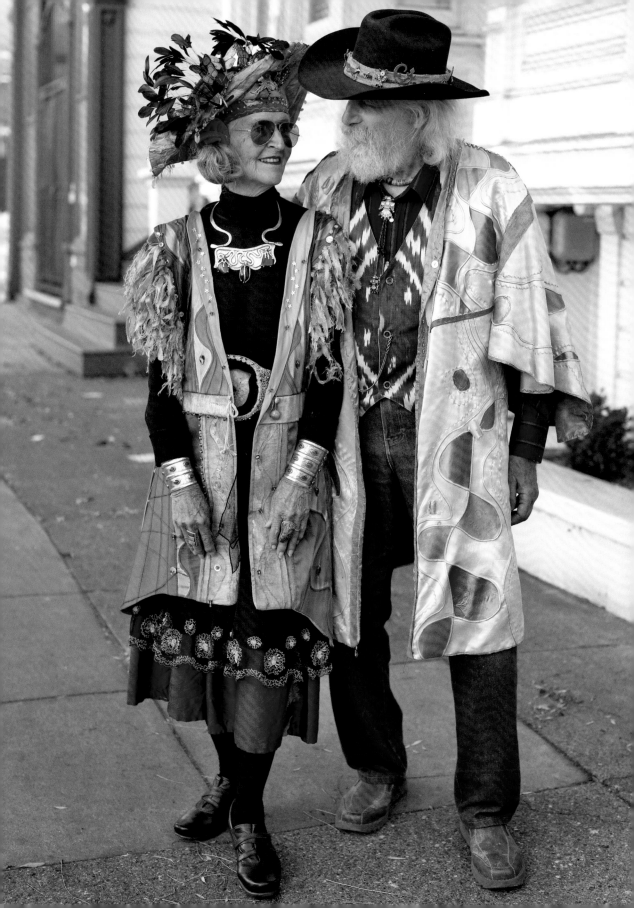

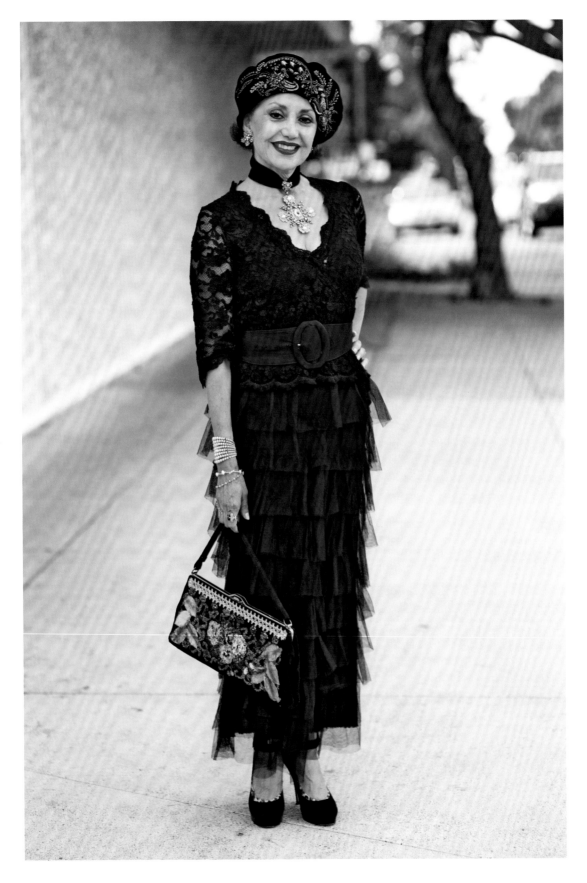

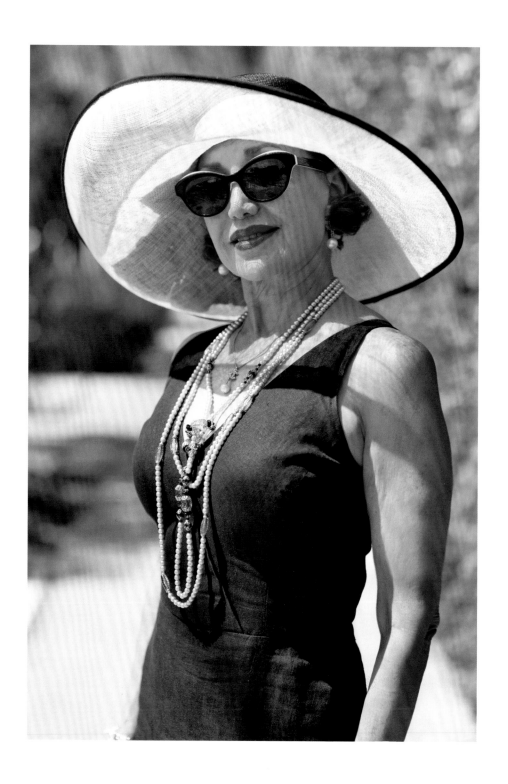

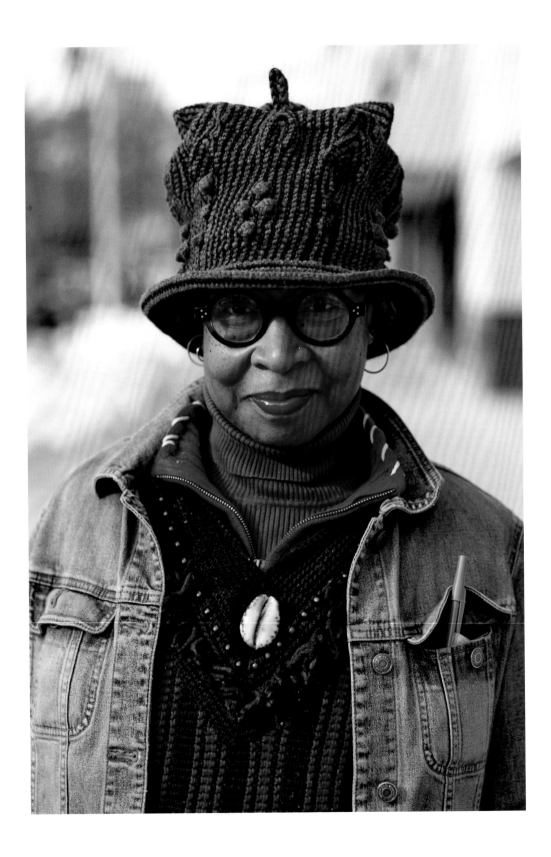

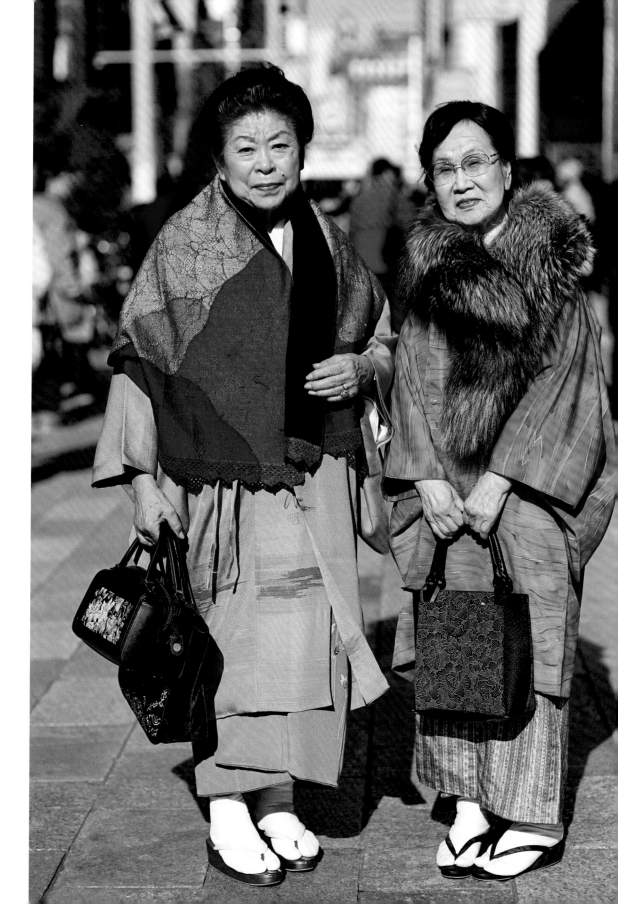

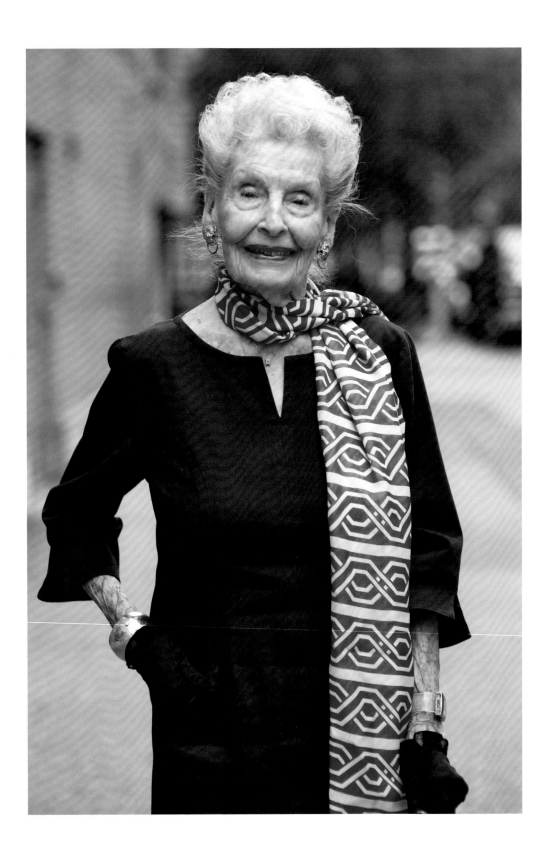

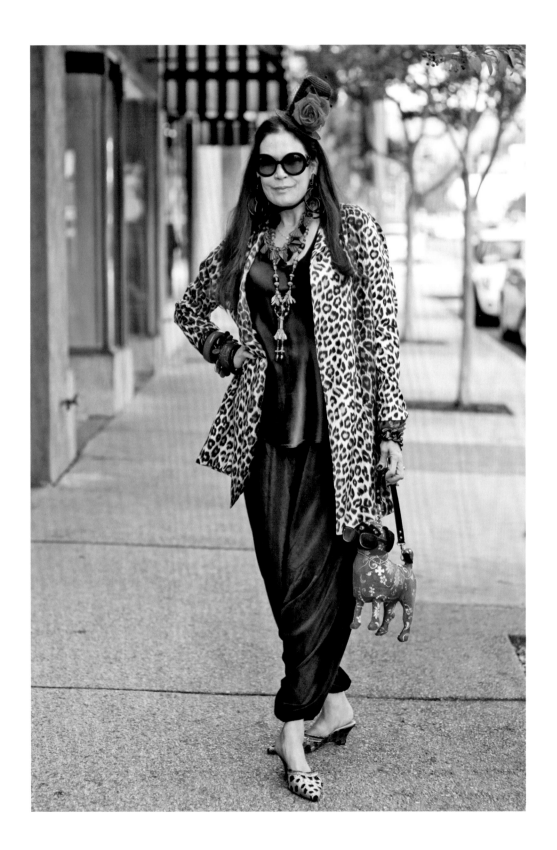

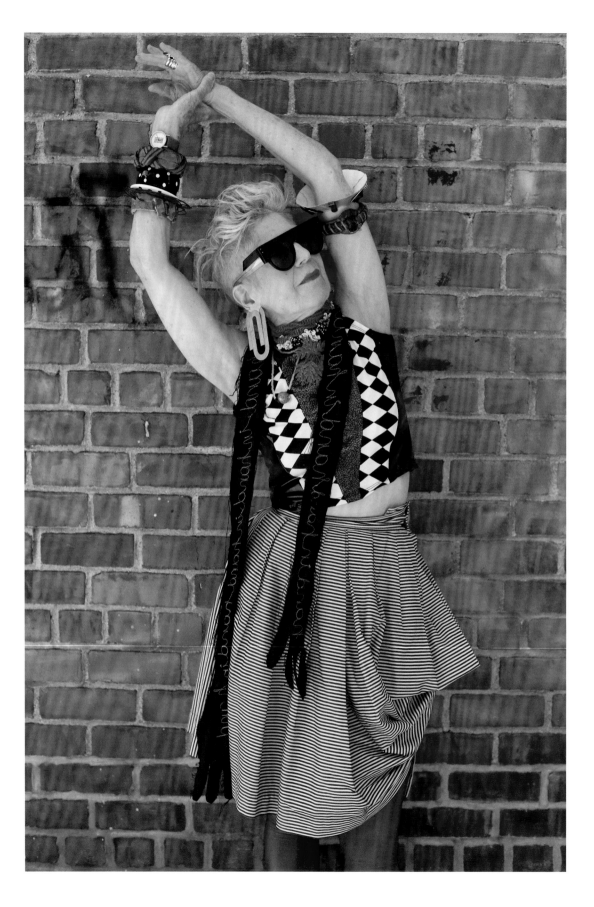

Debra Rapoport, 70

Style is *healing* because it is our way to express ourselves to the world. Trust your truth. Trust who *you are*. Allow yourself to unfold with your choices. *Allowing* is such a powerful word and it goes right to our core. We all have many parts; our physical body is only one piece. What about our smile, our hair, our expression of life, our expression of love, our interest in and attraction to other people, our curiosity about life? As the saying goes, "Be yourself; everyone else is taken." Finding yourself through play and creativity allows you to discover who you are and who you *want* to be. Remember what you truly loved when you were four or five years old, when no one interfered with your identity or your fantasies? When we are being creative there are no rules. When there are no rules there is no fear. We can then move smoothly through life. Be truthful when you evaluate yourself and allow your Self to dream and fantasize. "Fake it til you make it" is not a bad motto.

It is not about our size, shape, color or age...it's about our attitude of *trust*. When we really allow ourselves to be who we are, we are in relationship with and in the flow of our *self*. That is the highest we can go and the clearest we can be. That is when the healing takes place. We must trust the truth and not compare. We can always strive for better within ourselves but *we* decide what that is. I want/wish to be more colorful, I want to be more playful, I want to be more creative, I want to be more courageous. It all starts with the attitude—the attitude of gratitude.

As a means of expressing ourselves to the world we can present ourselves through our personal style. Look good, feel good; feel good, look good! Don't avoid making changes; don't hesitate. Making a change is not a big deal because you can always change back or make another change. Don't talk down to yourself. Really feel it and experience it in an emotional sense. The will to move is always the hardest. I think change is the most difficult thing for humans, so small ones are the way to go. Celebrate the small ones and do the small changes well.

Invest in activities that truly move you. Happiness comes to us when it comes from *us*. They add up to make an exciting life. When it is all put together you have a creative, healthy life that *you* created. That is your legacy.

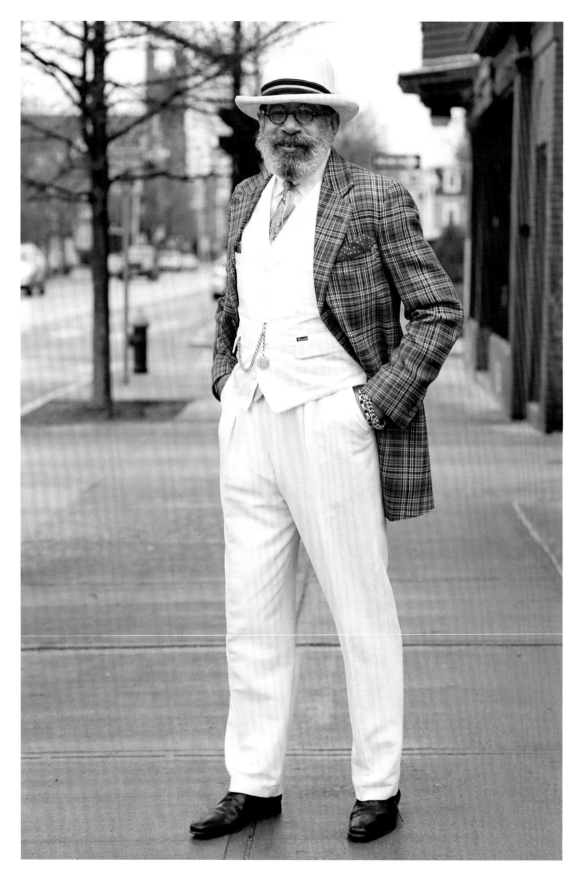

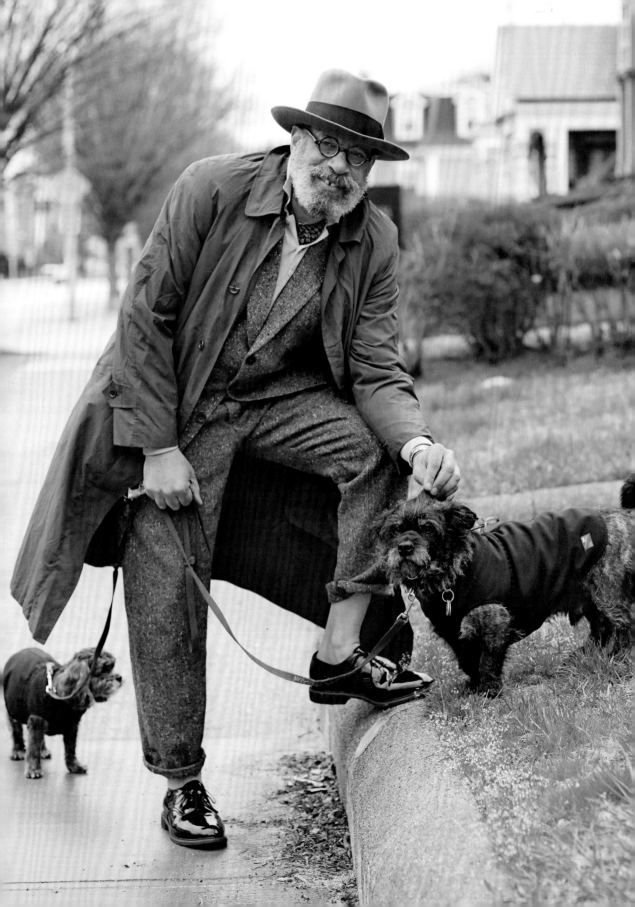

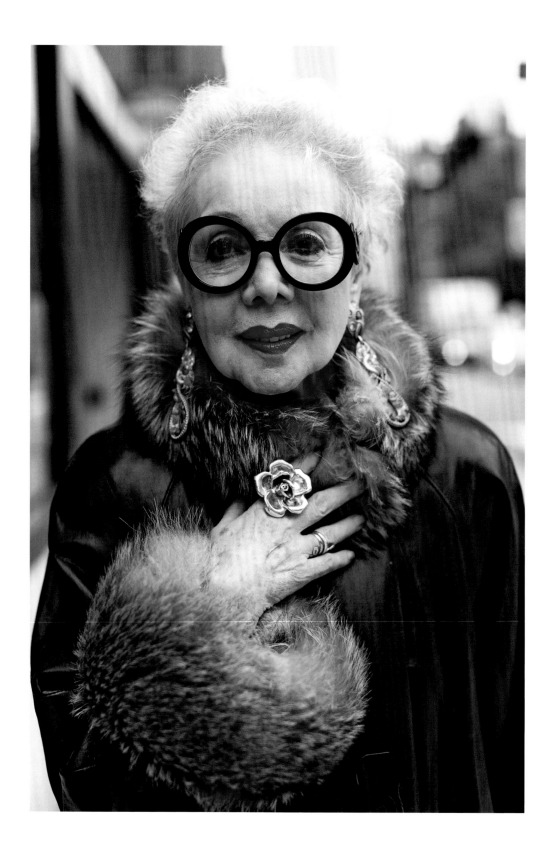

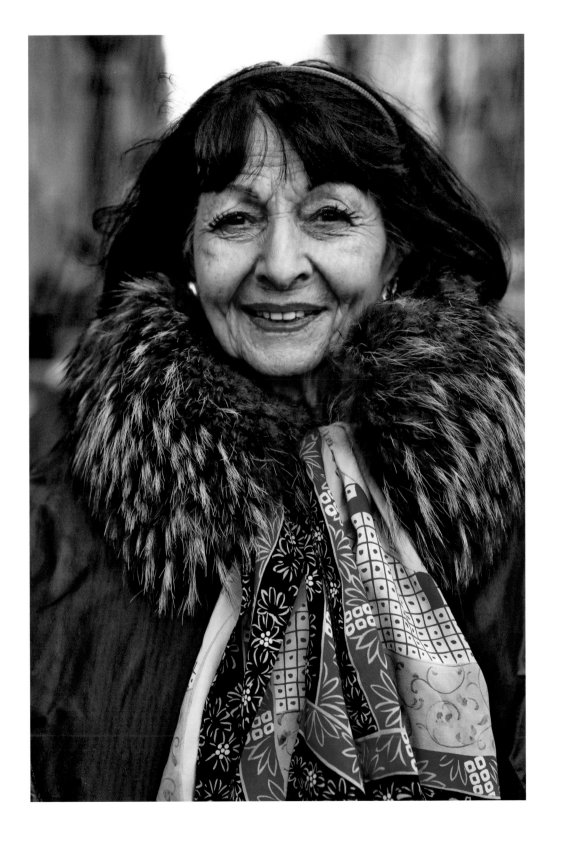

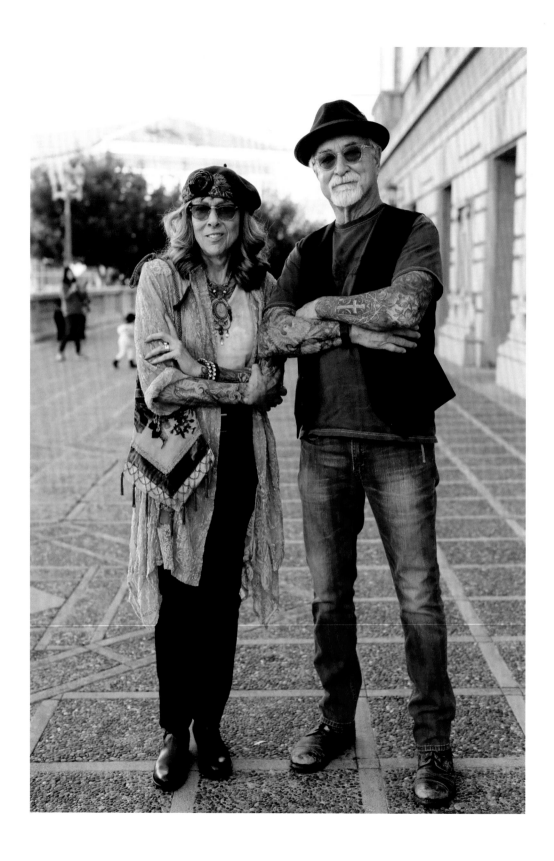

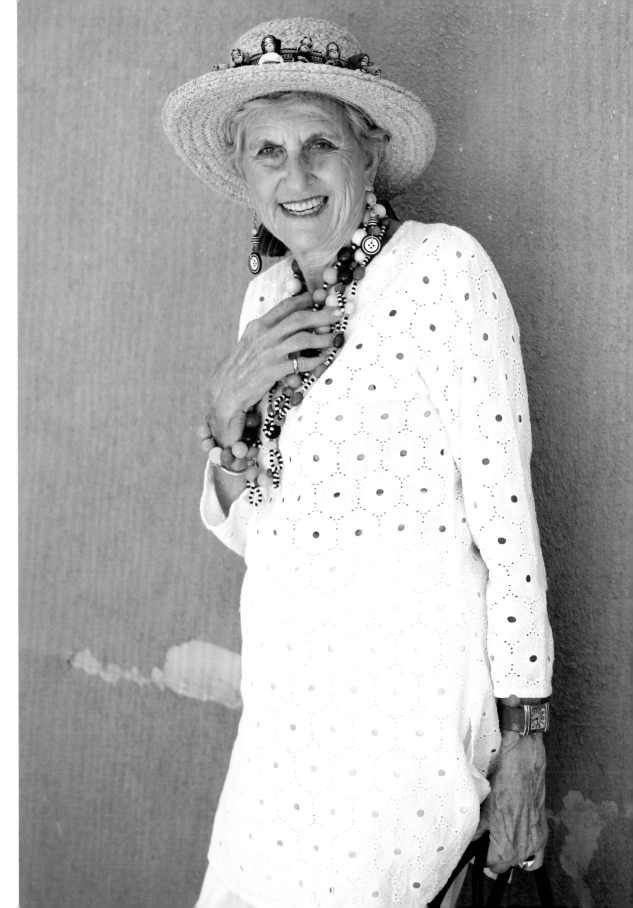

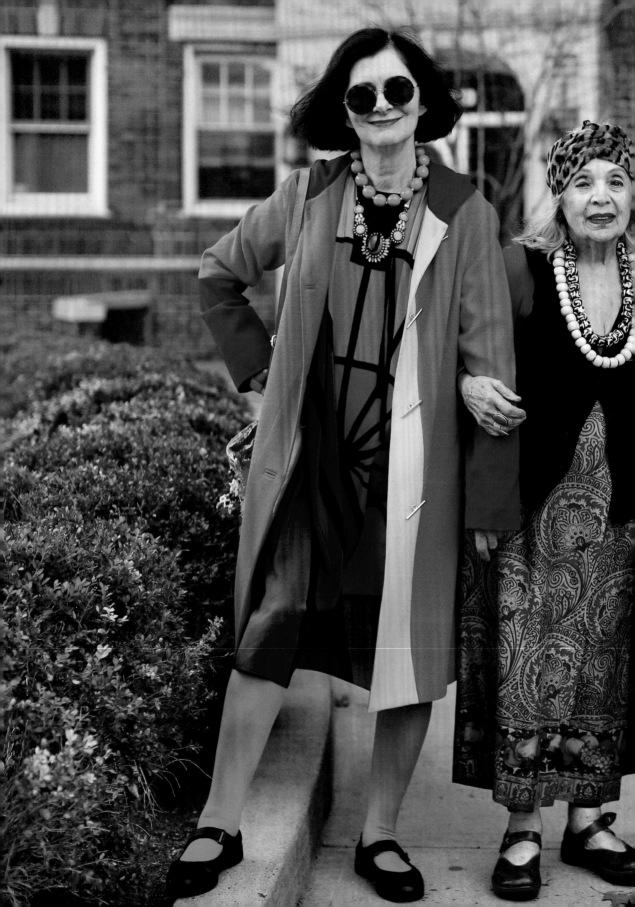

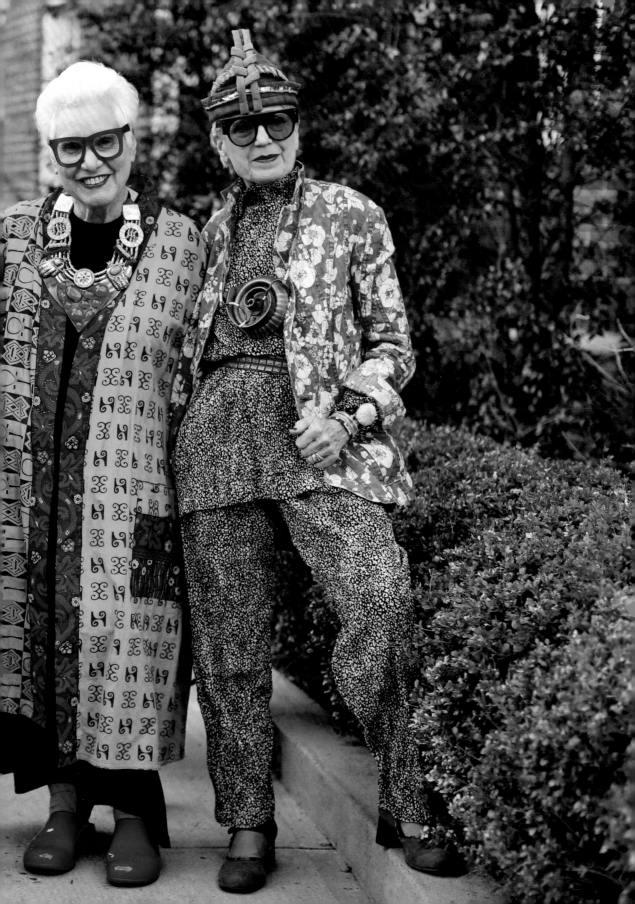

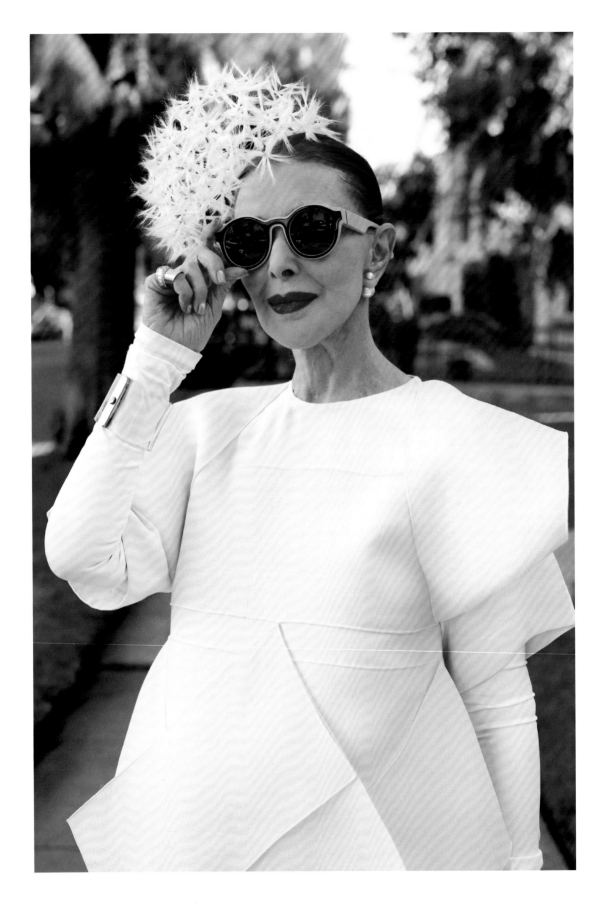

Valerie Von Sobel, 74

By the time you are "advanced" (chic or not) you have a bit to say on many topics. Life experience hones us over the years and gives us an understanding of the human condition. We have been young, we have loved, been disappointed in ourselves and others, been judicious and made titanic faux pas, have been in awe of our own resiliency to endure, and witnessed the world. The plethora of human experiences have given us more information than we can even sort through, but this has also put a burden on us: how best to use what we *know*—for our own sake and for that of others.

In some cultures life is partitioned into distinct stages: the first part is for the acquisition of knowledge; the second, they call the "householder" years. Those are the noisy ones—creating and tending to family. And the third, most magical, *belongs to you*. It makes perfect sense—you have earned it, you just need to claim it. This is when you get to act out: you can sit in a lotus position for days reaching for Nirvana, you get to play all the games you never had time for, you can mentor, or study a new subject. This fits perfectly with the western notion that we are always in a state of learning, earning, or returning. Personally I am blessed to be in a state of returning; expressing and sharing my given talent through the gifts of art and beauty, and the having the privilege of being involved in what, to me, is the most meaningful philanthropy.

I run a charitable foundation that bears the name of my teenage son, Andre, who died of a malignant brain tumor, in the same year my beloved mother and husband both also passed. The mission of the Andre Sobel River of Life Foundation is: to help single parents of terminally ill children "when compassion can't wait." Our financial assistance is offered within a 24-hour turnover, and it enables single parents to remain by the bedside of their ill child (www.andreriveroflife.org). It is less than two years ago that my spirit lifted from the deep sorrow of my losses from nearly 20 years ago, and somewhat mystically at the same time creating art possessed me (www.valeriesobelart.com). I find that my interior design background prepared me well for the gift of assemblage. I

love, love the serenity of my studio in the mountains, where I now also work in bronze. I have a daily yoga practice and I also hike. I go to my private chapel filled with delight and gratitude and acknowledge the Creator. In enthusiastic agreement with Lady Mendl, "Never complain, never explain."

Then there is also my perpetual love for *the ceremony of dressing*. If you don't make your life a bit grandiose who will do it for you? I always had the pluck to dress as I wished, and now I do it with more abandonment than ever. I dare! But disregarding convention is accidental. Fashion has a transformative power, it's self-expression and if it's genuine, it totally intertwines with other creative manifestations. It's a language that is recognizable in one's writing or design or art. Life is a costume party and getting dressed for it is simply grand. Some think it's frivolous, but I don't. It matters—and to me it always has. It speaks of you before you speak.

I started my creative life at age eight by costuming myself for school. In short order I was nearly expelled for wearing huge, clandestine, gypsy earrings (made notorious at the time by Gina Lollobrigida). I would take them off before getting home, but they would reappear again the next day in history or math classes. I loved everything about what the earrings provoked: the controversy, the attention, and the hidden envy. I thought of them as natural essentials for a leader. I would say I was not that far off. In any case I was comfortable with my audience, and when we left communist Hungary and I had my first two dimes to rub together, I showed the stuff I was made of. I acquired my first, quite perfect, and only, little black dress (for what felt like an eternity). I still applaud the intuitive choice of the very young refugee. Aghhhh the things I did to that dress with a four-seasons career. White pique collar with a gardenia in the spring, a mischievous taffeta tartan bow in the summer, but it was at its best in the winter with a cognac velvet collar and silk violets—she was a sensation. My relationship to fashion was the start of my aesthetics for life, whether for interior design, architecture, or art.

Never think that everything has been done. If you give ten people with a modicum of passion for fashion, seven diverse pieces of clothing and accessories, they will produce from the identical elements combinations that are gloriously different. This is the rub, as well as the point: creating out of creations is creating.

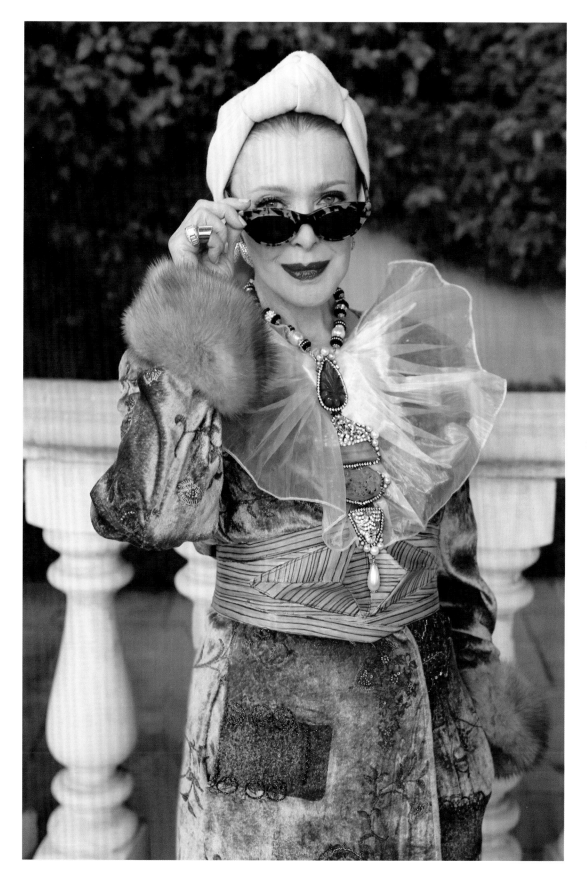

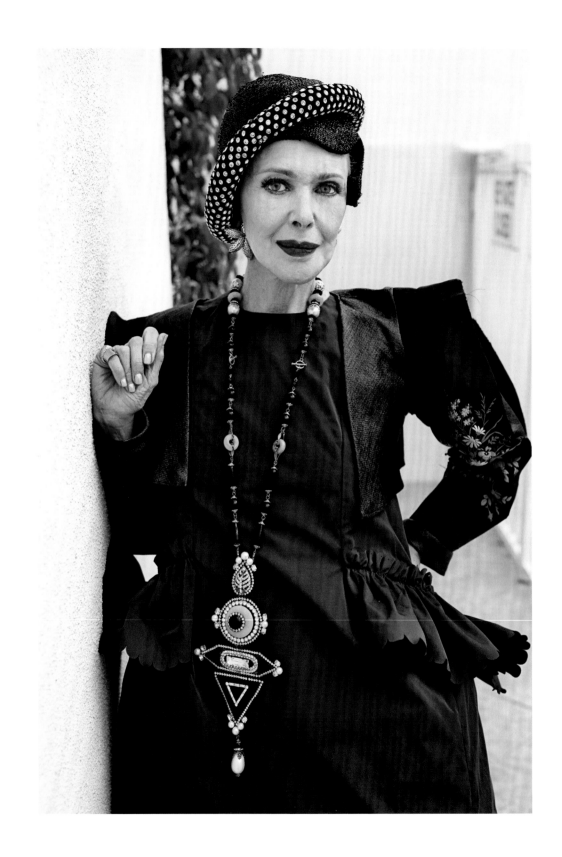

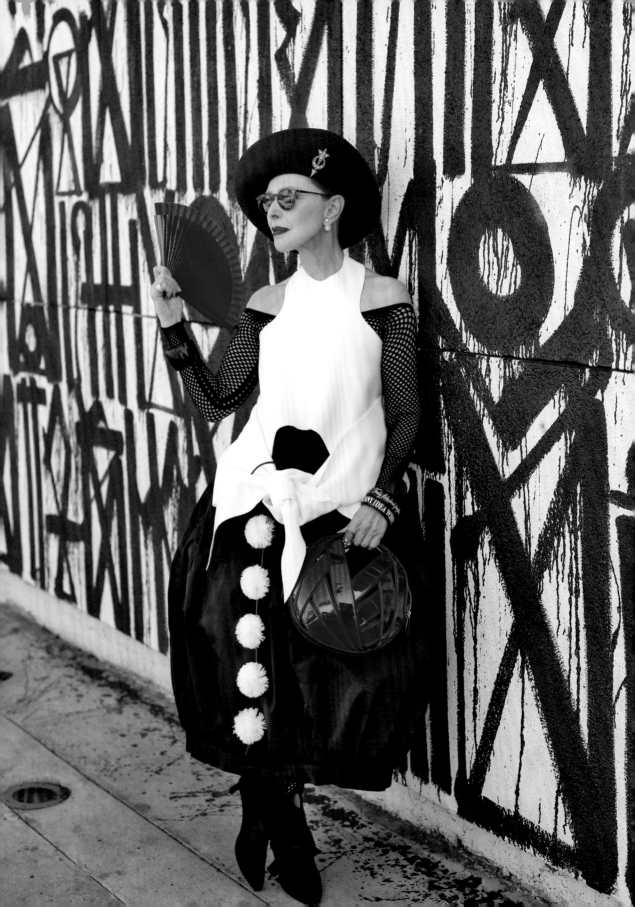

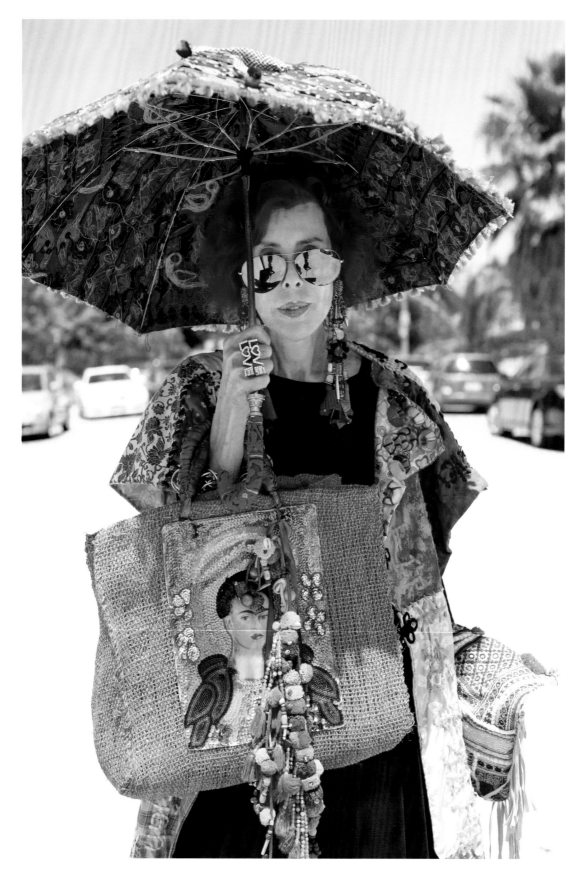

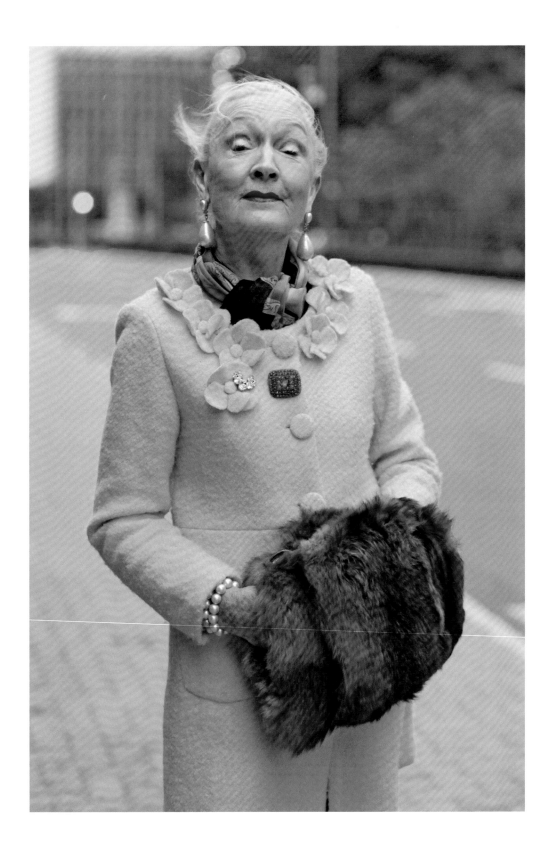

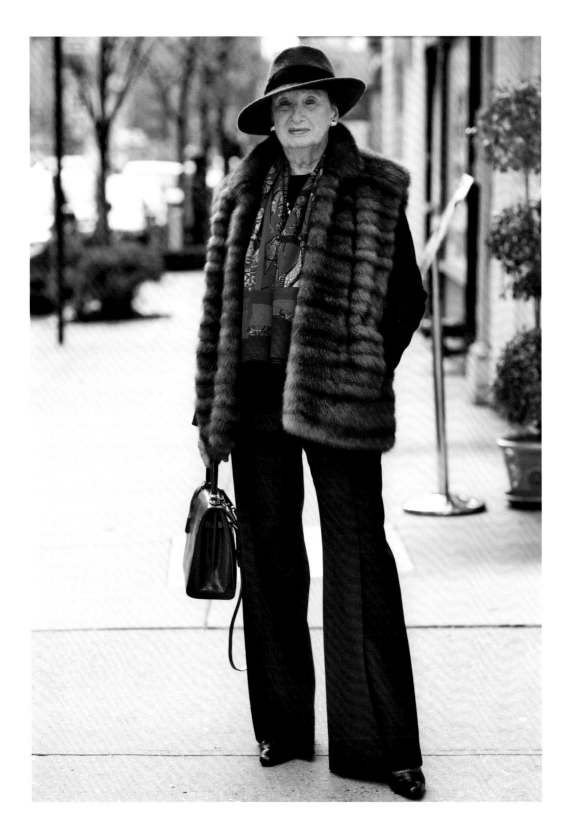

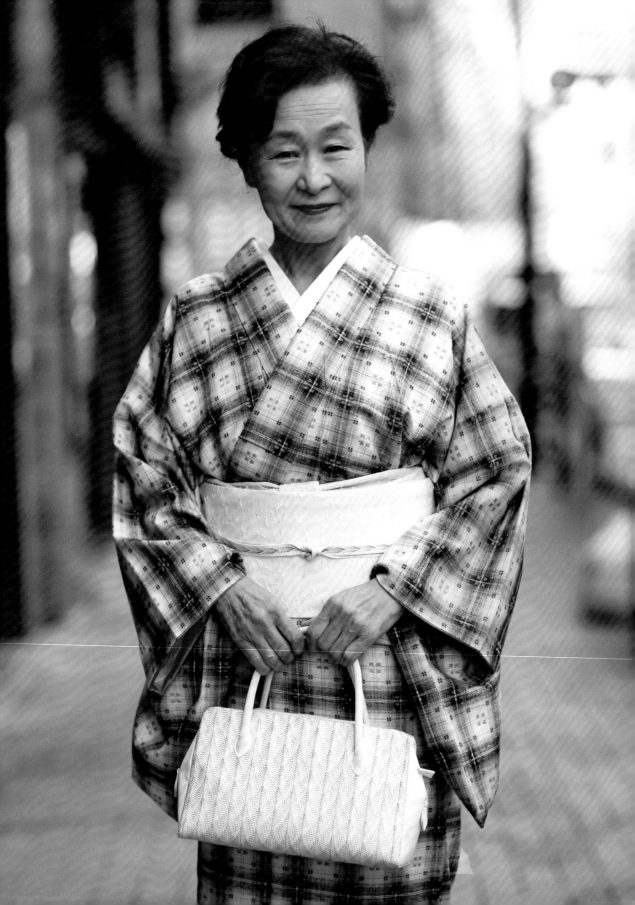

Judith Boyd, 72

The first time that I clicked *PUBLISH* on the dashboard of my blog Style Crone, I was flooded with feelings that I often experience when launching a new adventure, having no idea what I'm doing or the consequences—a touch of fear alongside a rush of excitement, a hesitation as I challenge myself, a sensation of throwing myself off into the abyss and not knowing where I will land.

But what could be more difficult than watching my husband of over 30 years dying before my eyes? As it turned out, he lived nine more months. And a blog that emerged from cancer caregiving, death, grief, and transformation was born. My husband Nelson was my photographer, and Style Crone became a lifeline for both of us as we navigated the unpredictable and intense world of loss, fear, and the intimate moment of death. We had found a way to connect through the lens and even discovered levity by featuring an ongoing series, "What to Wear to Chemo."

For many years I enjoyed composing outfits that I discovered at estate sales, consignment shops, thrift stores, and yard sales. I loved the thrill of the hunt, as I ran my fingers over the fabrics in a pile or on a rack until I found an item of beauty and pulled it out, admiring the treasure and reward that my tactile and visual senses provided.

I spent most of my career working as a psychiatric nurse in an emergency setting. Choosing my outfits, which always included a hat, was a way to express myself creatively and was a form of meditation as I approached my day, which usually included extreme and painful stories told by interesting and traumatized people.

I continued this practice as I moved through the process of loss and major life change. As a yogi, I could feel a similar inner peace, as with a warrior pose or tree. A flow. A dance. The joy of movement, self-expression, and life-enhancing calm.

As time went by, I discovered that writing was itself an art of self-expression. It was a muscle that became toned with practice. Working in mental health, I would document how my patients were feeling and how they talked about their experiences emerging from crisis and chaos. Only now I was talking about

my own feelings and experiences, and living my life through the composition of outfits as art.

And then the biggest gift of all! I found an entire community of older people who love to express themselves through style. The first was *Advanced Style*, which inspired me and gave me the courage to begin. And then I found more! It was life changing, encouraging me to be as creative as I wanted to be and to accept myself and my aging process as positive and life-affirming. I believe that these beautiful connections and my love for self-expression contribute to my health and quality of life.

So here I am at the age of 72, aging, creating, changing, and growing. Now when I click *PUBLISH*, I look forward to the exhilarating feeling of expressing myself through the art of writing and style. I plan on continuing until the day I wear my last hat!

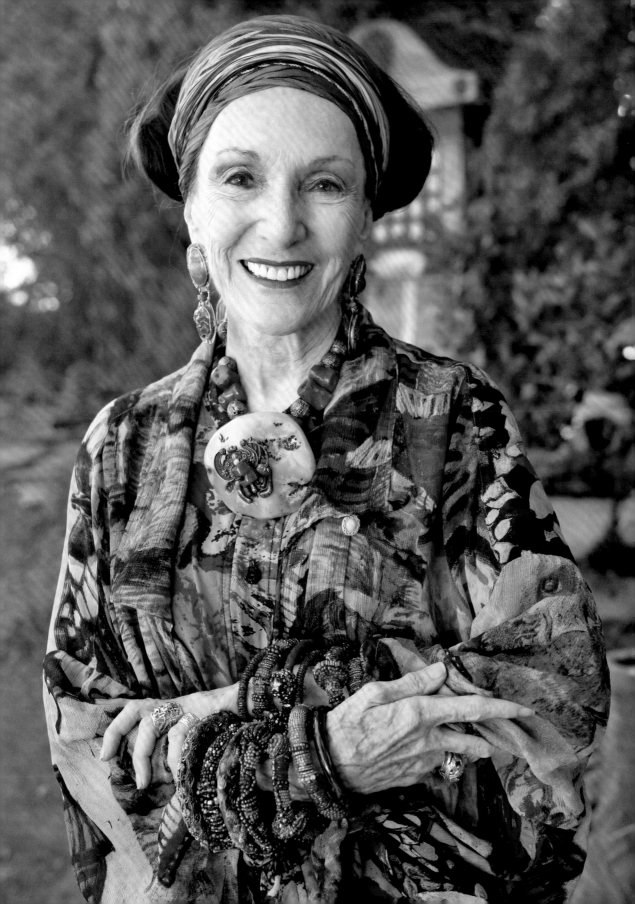

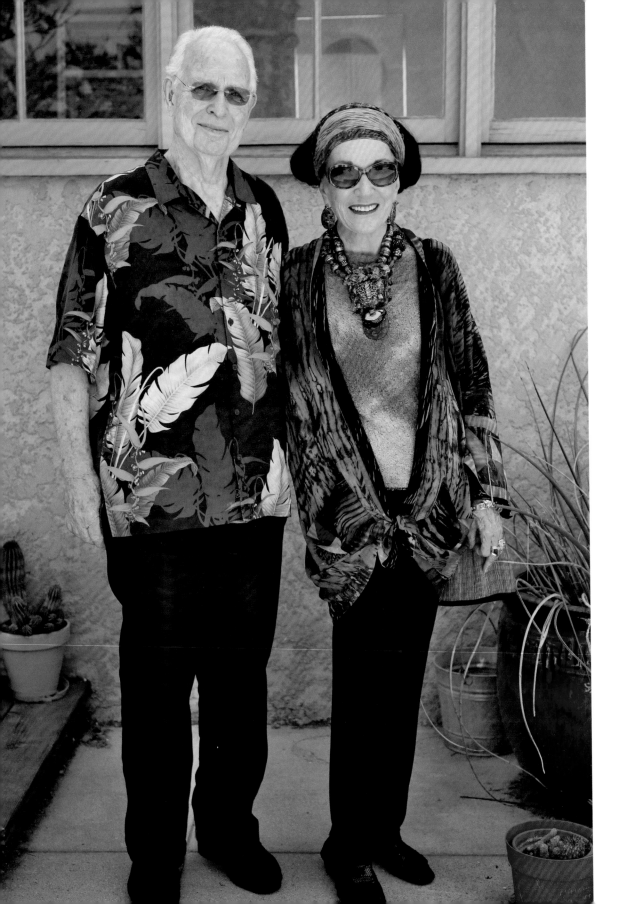

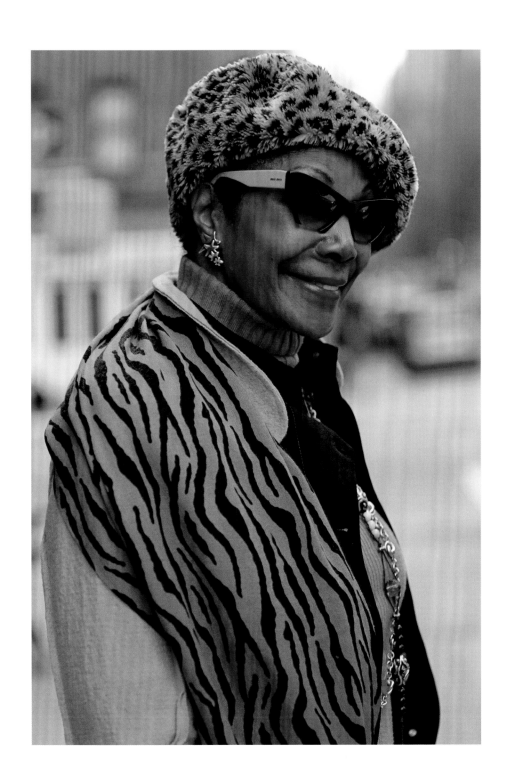

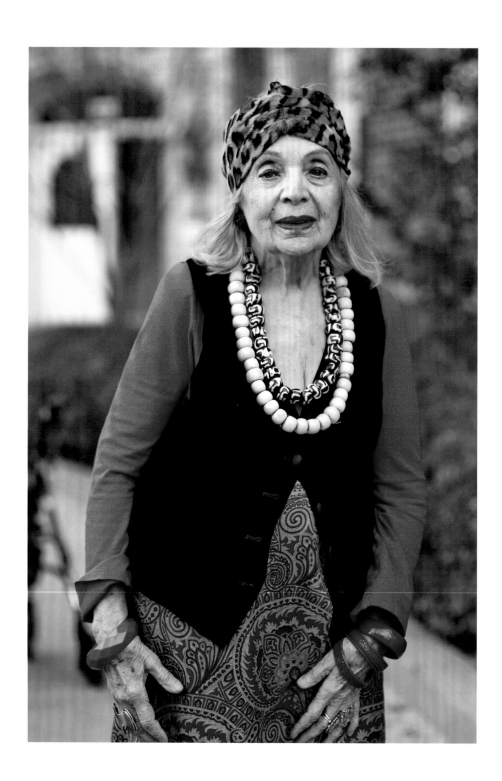

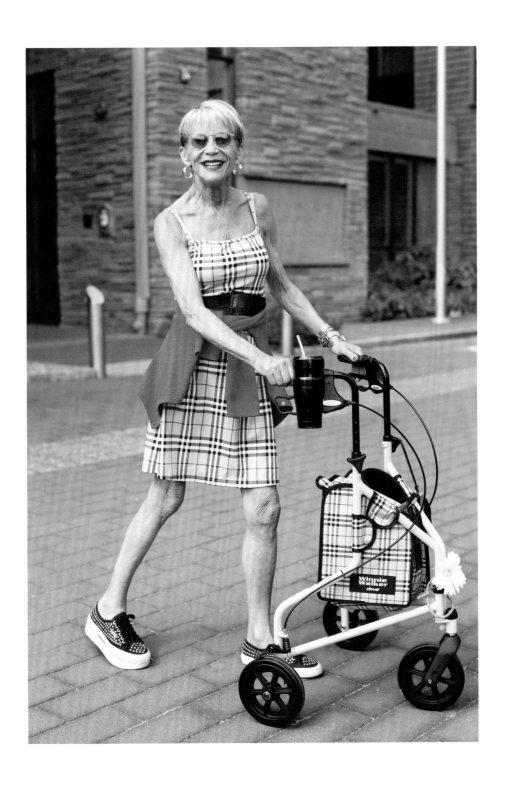

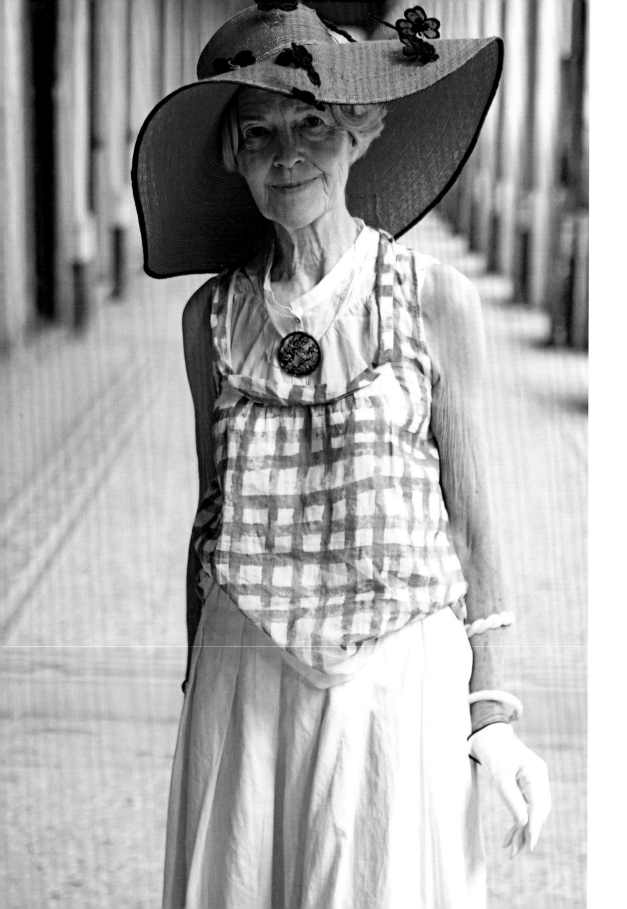

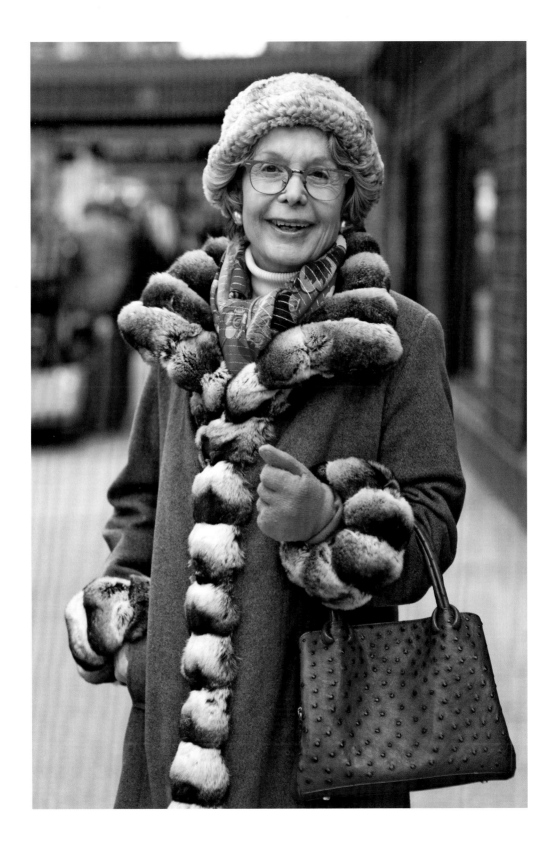

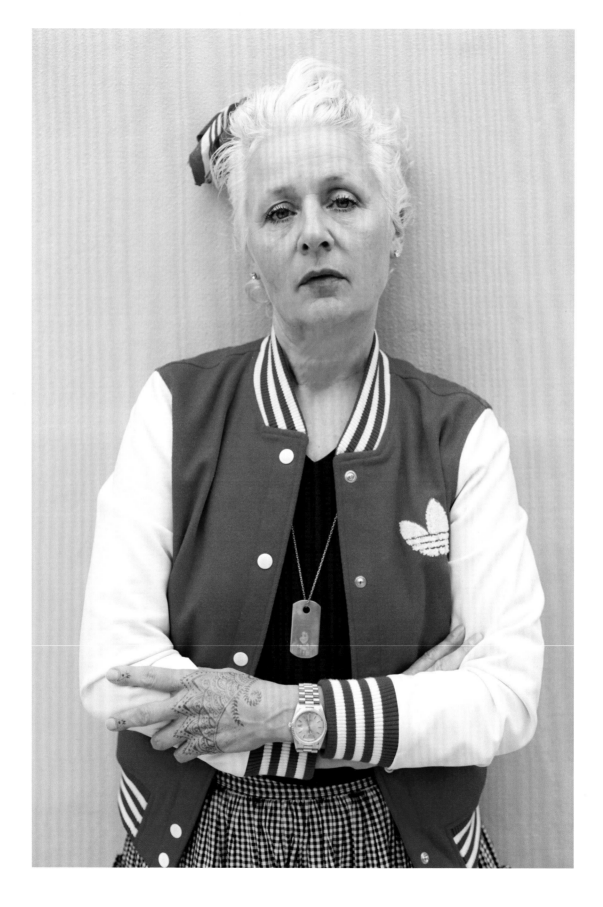

Sarah-Jane Adams, 60

When I was 59 I had it all: the big house, a family, and a successful jewelry wholesale business.

Life seemed pretty good, and the future looked comfortable.

But rather than making me feel fulfilled and secure, this state of affairs actually filled me with dread and anxiety. I could not envisage my life continuing happily on this same path ad-infinitum, so I decided to make a few changes.

These involved selling the family home, and streamlining my business. Both tasks took time and energy to achieve, and I was eagerly looking forward to a simpler, quieter life. Throughout this process I began to feel stronger, lighter, freer, more energized, and more positive. I began attending yoga classes, travelled again, and spent more quality time with friends.

Life throws us curveballs. The day I met Ari was one such ball. I caught it and ran. Somehow I seem to have become known for my attitude, style, fearlessness, and desire to live life to the max. We must try to have the foresight to recognize opportunities, and the courage to follow our hearts. Young and old, we can, and should, make considered choices in our lives. Yes it is challenging, yes it is scary, and yes there are always many unanswered questions.

As I said, I was simplifying things in order to have a "quiet life." That was the predictable path for someone my age. Clearly, however, that was not meant to be. I am meeting people from all walks of life and in every age group. People who have enriched my life more than words can express, and who have taught me things I foolishly thought I already knew. The path I am exploring continues to change and to challenge. There are risks, and there will be pitfalls along the way.

But this is not a dress rehearsal. I intend to pack as much in as is humanly possible. Take good care of yourself and those around you. Prepare and be ready to take on the challenge.

Now I'm 60 and the future looks oh, so bright. My wrinkles are my stripes, and I intend to gather a whole lot more and wear them with pride. Hopefully there is a little wisdom that comes with these

stripes. My wrinkles do not scare me. I see them as a badge of honor and a mark of roads travelled and experiences had. Why would I not be proud and happy to show them? I am growing into the face I deserve and a face that reflects who I am and what I have been.

It is not a mask. I am not a puppet.

Thank you for this opportunity.

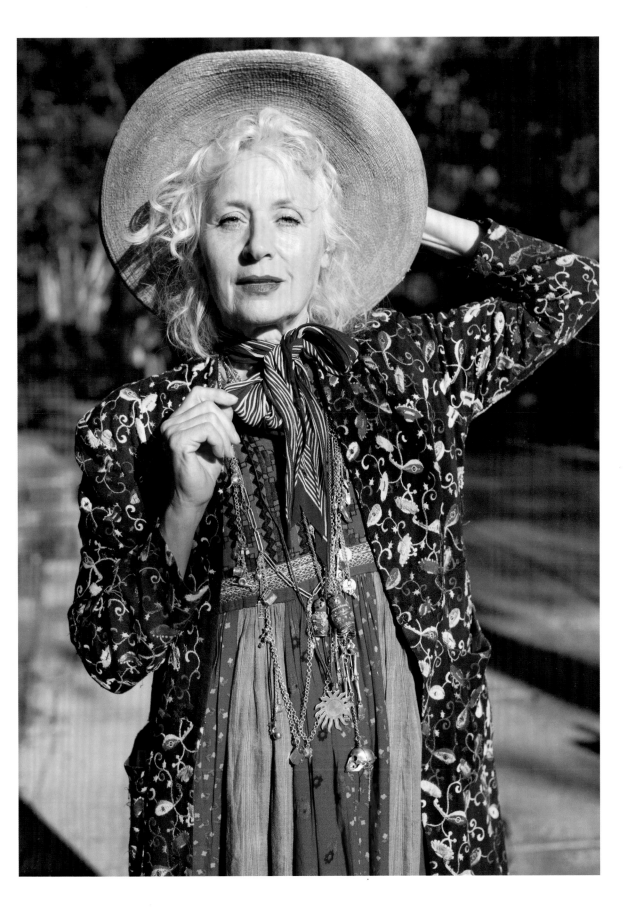

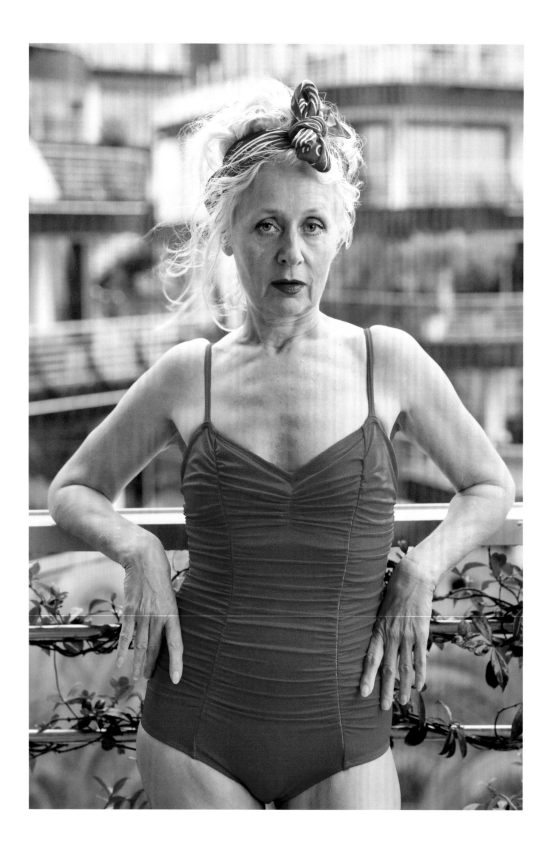

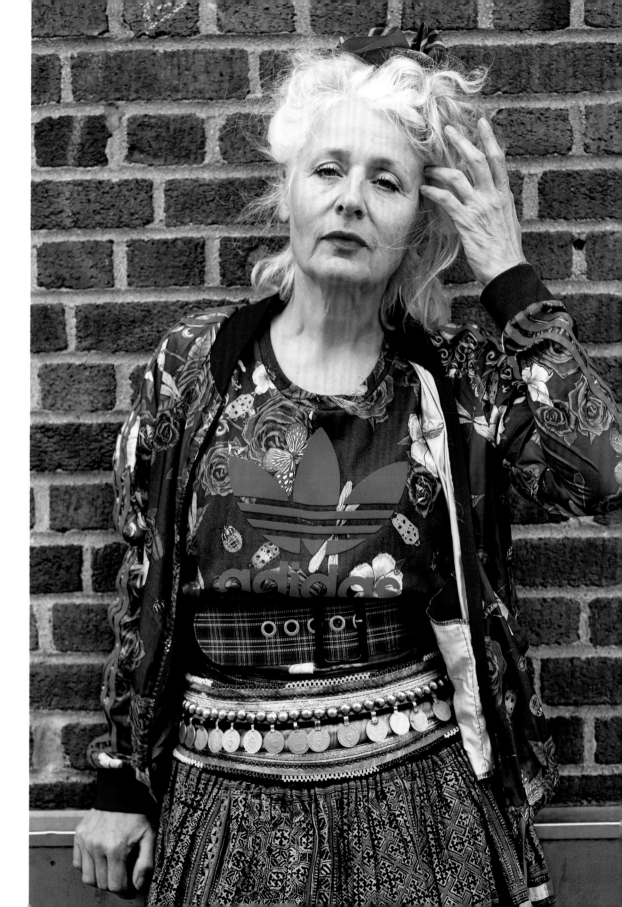

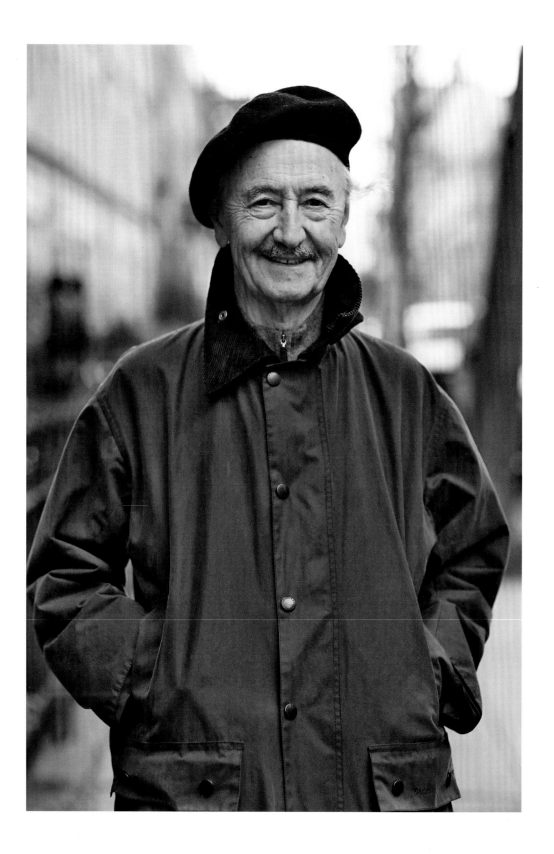

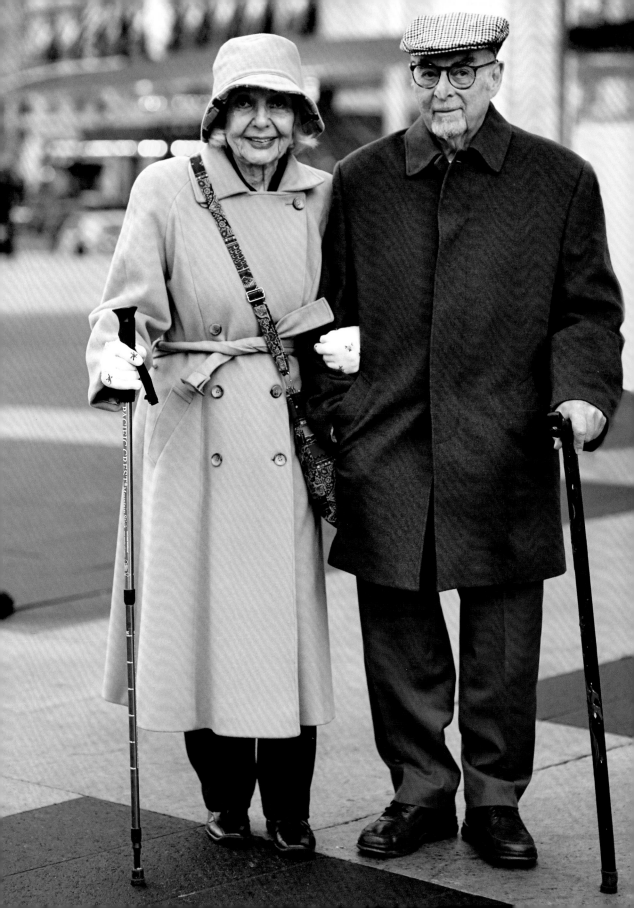

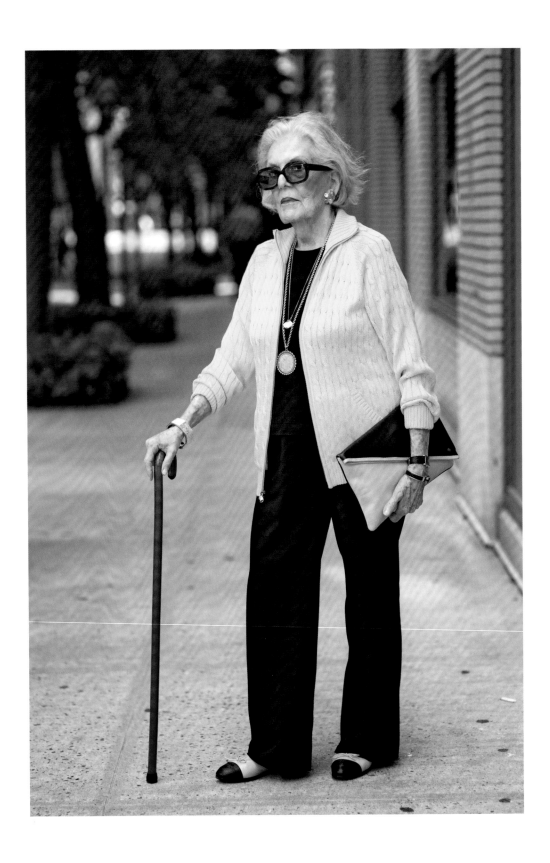

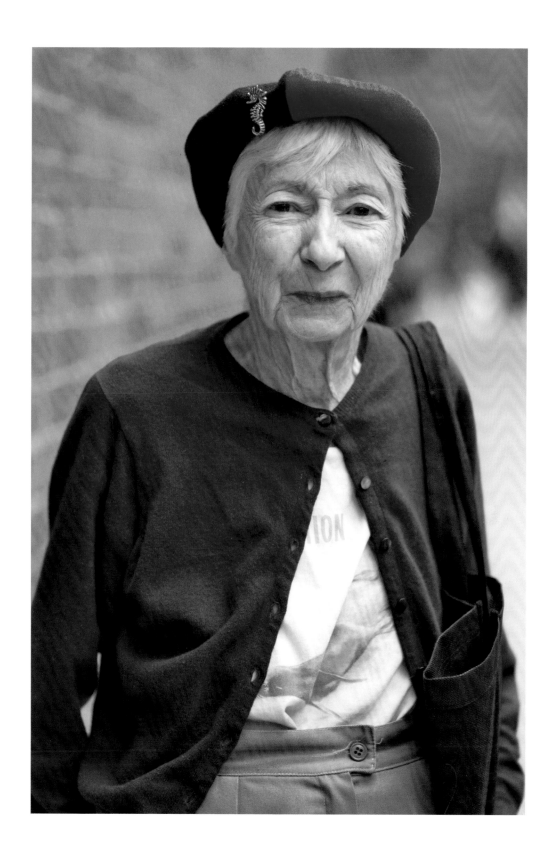

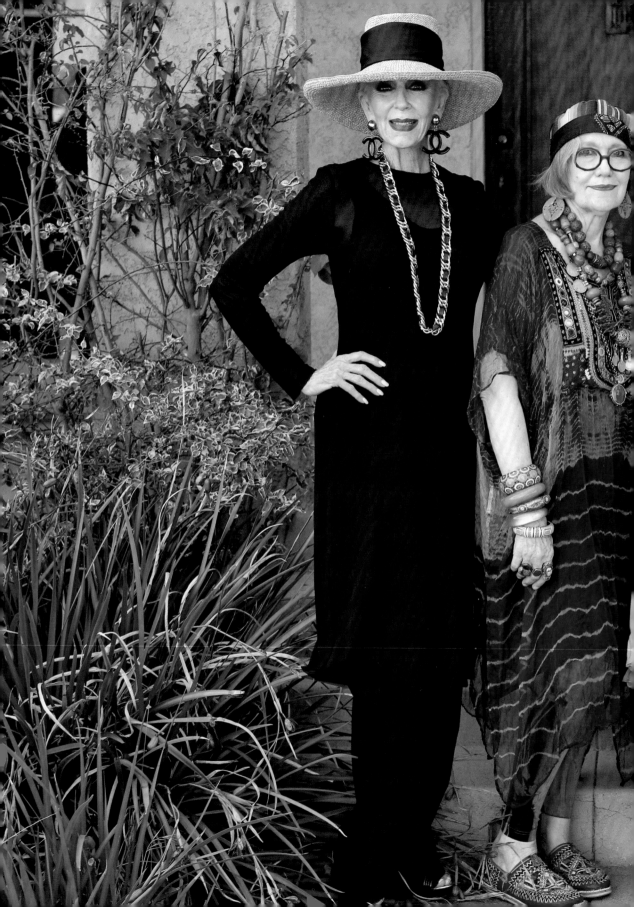

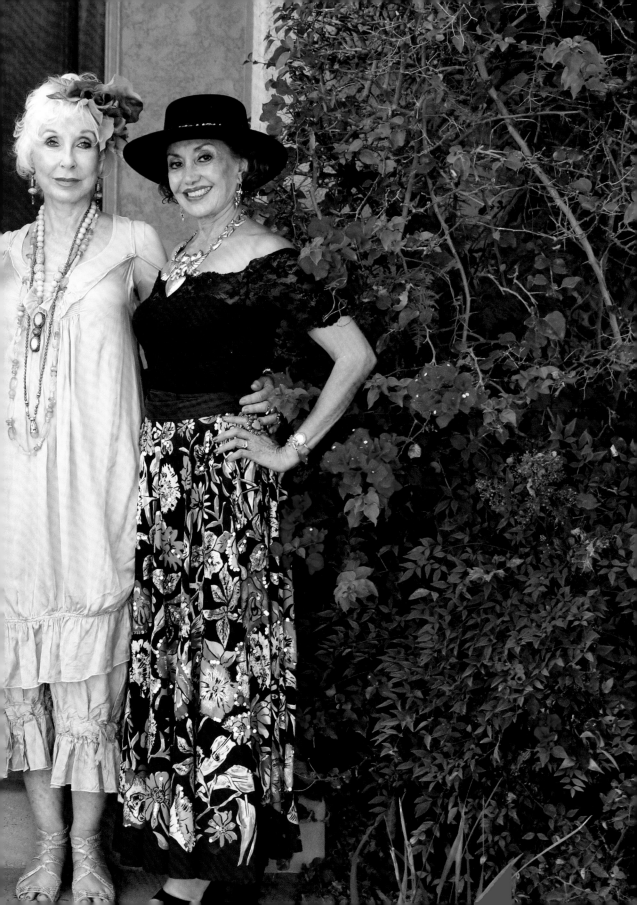

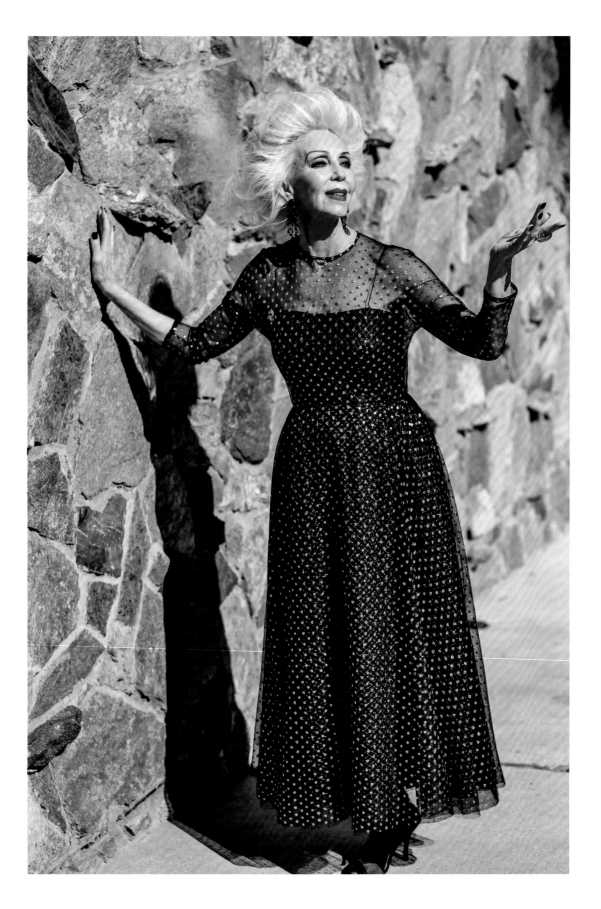

Colleen Heidemann, 67

He is Ari Seth Cohen, 33 years of age, person, photographer-extraordinaire, man with a deeply held belief in the captivating aura, critical relevance, and supreme value of the *Advanced Style* persona. Ari coined this lovely phrase in recognition and celebration of his two most special grandmothers. So important a personal, so impressive a visual influence had they throughout his life, that quite early on he came to realize the enormity of the impact that is so closely associated with the presence of style, grace, and flair.... That each and every day, there exists within the human spirit a primal interconnectedness, a common thread dictating, and therefore motivating us to present ourselves to one another and the world. And too, Ari learned, that, quite importantly, we are often first introduced by our appearance and that which we choose to wear. A valuable statement can lie within those choices, resulting in the initial significance of just how we might be perceived and thereby relate to one another.

My name is Colleen, or simply, C. I am 67 years of age. I entered the realm of *Advanced Style* approximately four years ago.... A Saturday afternoon, a gentle nudge, some friendly persuasion, and a life, my life, forever changed. Ari photographed me for his first book. Never did I imagine the wonderful people I would meet, dear friends I would make, warm and touching phone calls I would receive. From an 19-year-old university student to a great-grandmother of 81, from Germany to Ireland, San Francisco, and Des Moines...so many people feeling so strongly about voicing their immense support and appreciation for this man and his camera. In the writing of my thoughts, I have carefully come to examine the experience this has become for me. I have been brought to realize something utterly unexpected, yet echoed from each and every person who has spoken with me: Ari Seth Cohen's photographs have changed lives! And I have been but one of many of the fortunate recipients of notes, cards, letters, telephone calls, personal visits—from myriad generations—persons expressing such joy at *someone* willing and wanting to promote the beauty, joie de vivre,

particular strength, and unique sensibilities of the "older" set.

Today, it seems that those over the age of 55 or 60 simply vanish, only to receive celebratory kudos upon turning 100. Women, in particular, feel utterly invisible and entirely dismissed. Unless of celebrity stature, few models of age are ever selected for prominent usage in advertisements, yet the older segment of the buying public numbers within the many, many millions throughout the world. The "everyday" person truly wishes to see, as well as purchase from, those to whom they might relate! It is well time that we must address a most significant and valid form of prejudice: that being the bias against those we label as "elderly." Ageism simply must be addressed, exposed, recognized, and vehemently eliminated. These last years have seen many positive changes in how we might all coexist within our world. When might we confer and successfully alter the status of how we accept and relate to our older population? The splendor and majesty of a grand symphony lie within the presence and participation of its myriad components. The "plus-agées sect" are the violins of the orchestra. Their music is fanciful, fearless, feisty, and fun. Their flair has it's own form of beauty and majesty, and they have a right to be a visible, viable part of the world in which they live. Their gifts to humanity must not be relegated to an inconspicuous imperceptibility, but proudly shown, welcomed, included, and celebrated...mustn't they? And if not now...*when*?

We are immensely fortunate to have Mr. Cohen spearheading one more extraordinary and most important advancement within society and towards a way we might so much more successfully be willing to recognize, welcome, understand, and appreciate the many parts which we *all* contribute to this world. We as a people, all distill to a most common denominator: each and every one of us is a uniquely special, important, and eloquent part of our humanity.

With love and appreciation to you, Ari.

C.

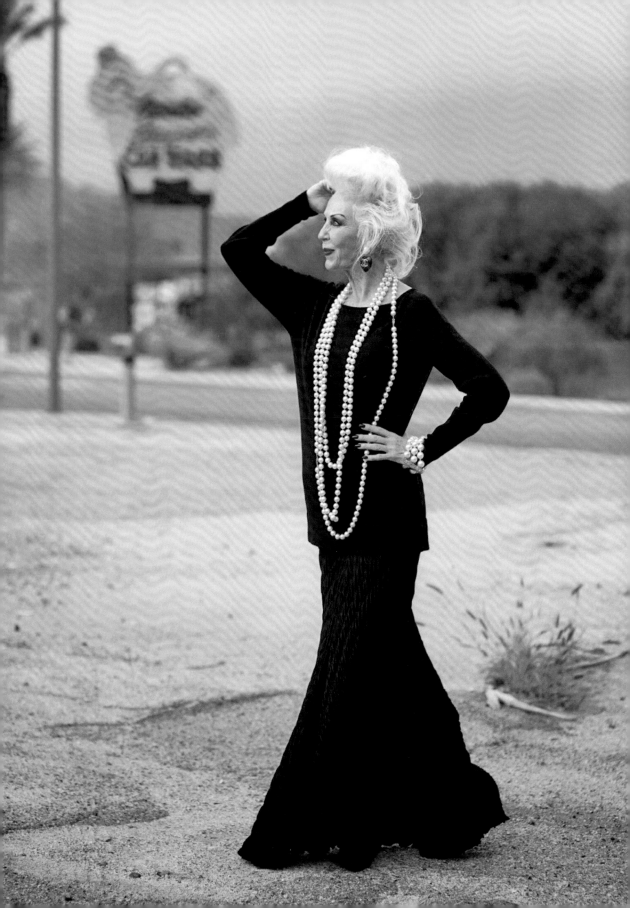

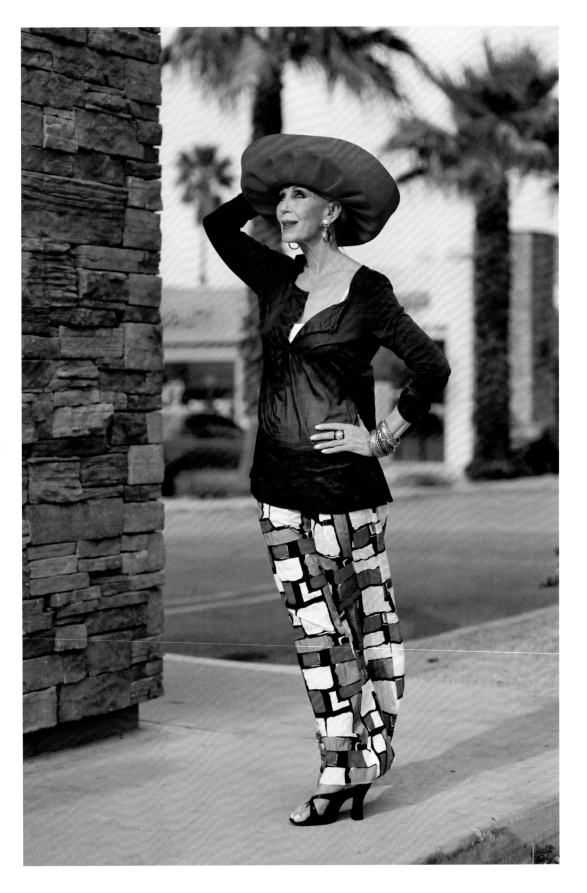

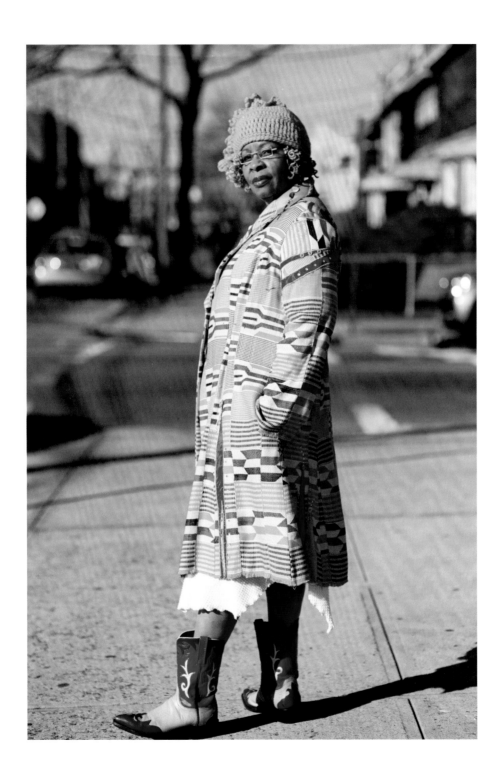

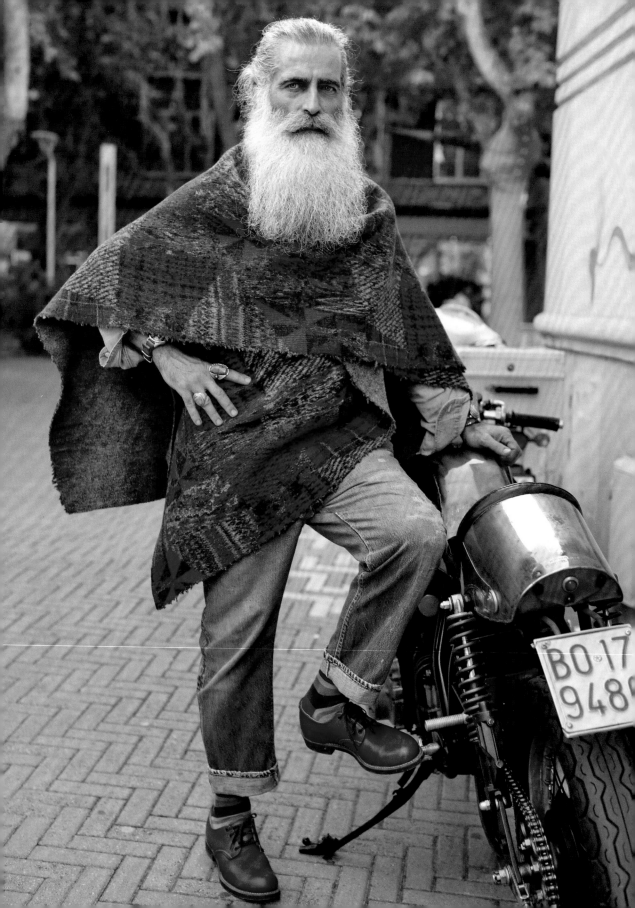

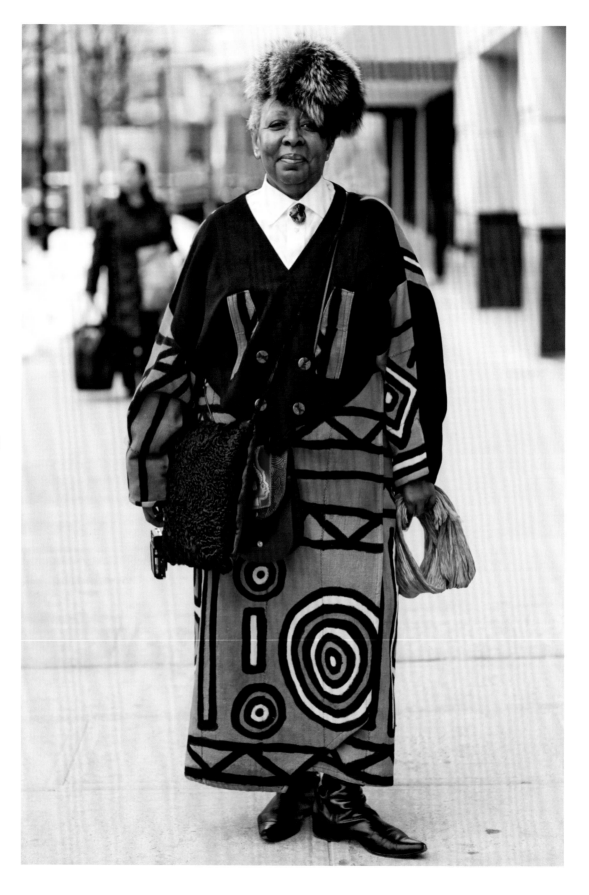

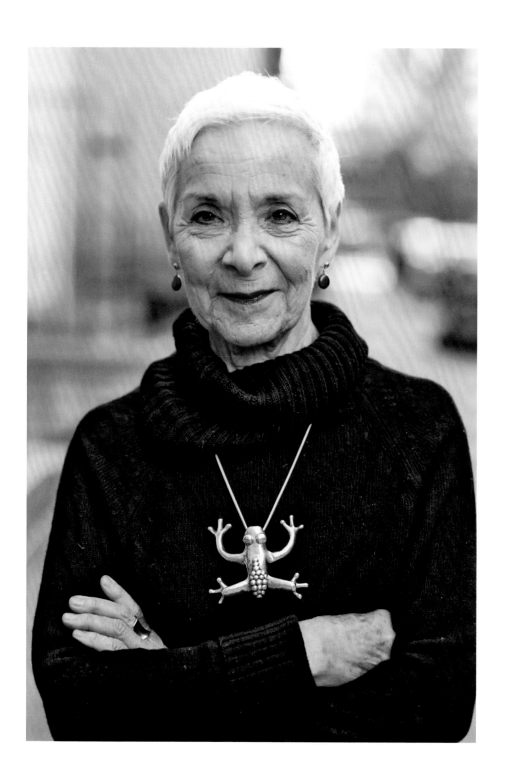

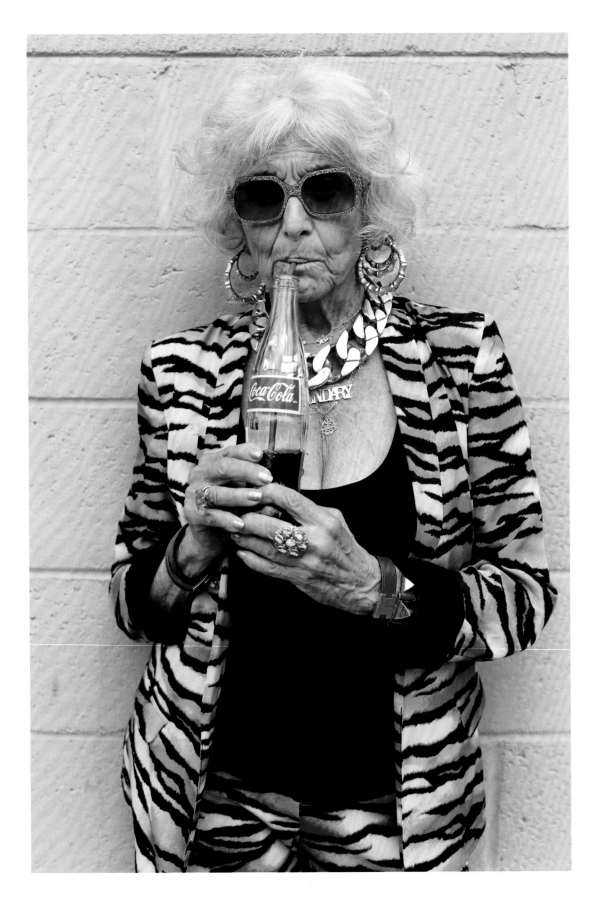

Roberta Haze, 78

What makes me furious is how aging and sexuality is depicted in the media. Even when it's a major star like Betty White, it's treated as a joke—either they are a predator, a cougar, or the thought of an older women fucking is hilarious. My doctor, Dr. Uzzi Reiss, the renowned gynecologist, longevity expert, and author, advised me to have sex every day until you croak for health, fitness, and happiness. Trying my best to follow doctor's orders!

No one looks funny at an old fart with a young woman, but if I'm with a younger guy it's a stare and a giggle. People always say, "You are so lucky to have a young guy." My response is, "He's the lucky one." At the moment, I have a friend with benefits and it's quite lovely for both of our lives. I am happy with or without a man! Aging gracefully is mostly about acceptance, not dwelling on the past or trying unnaturally to look younger. Beauty and sexuality is an inside job. As far as style is concerned you either have it or you don't! No rules! Fashion is not style! The biggest thing I have learned is to have gratitude for what I have in my life, and to not dwell what I think I want or need!

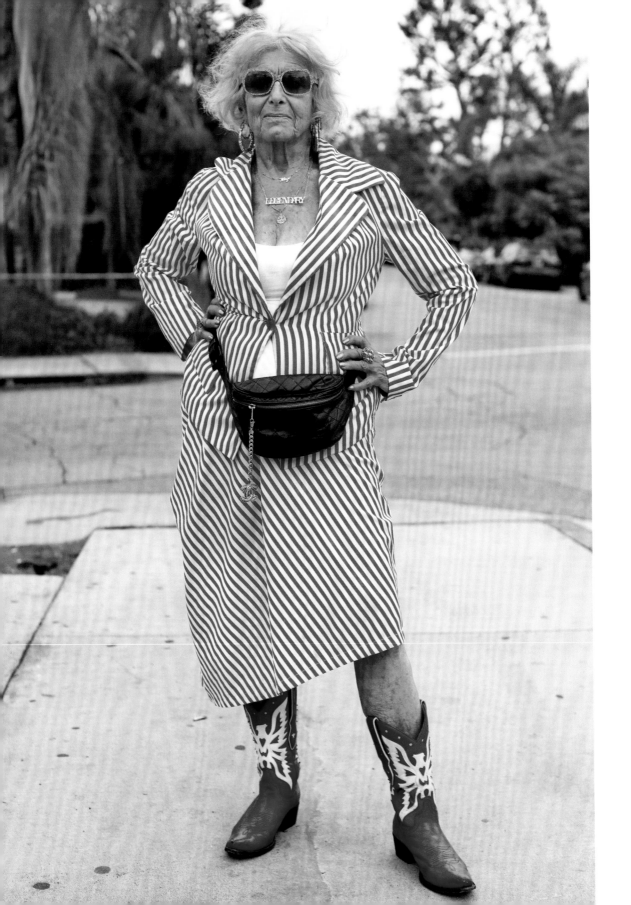

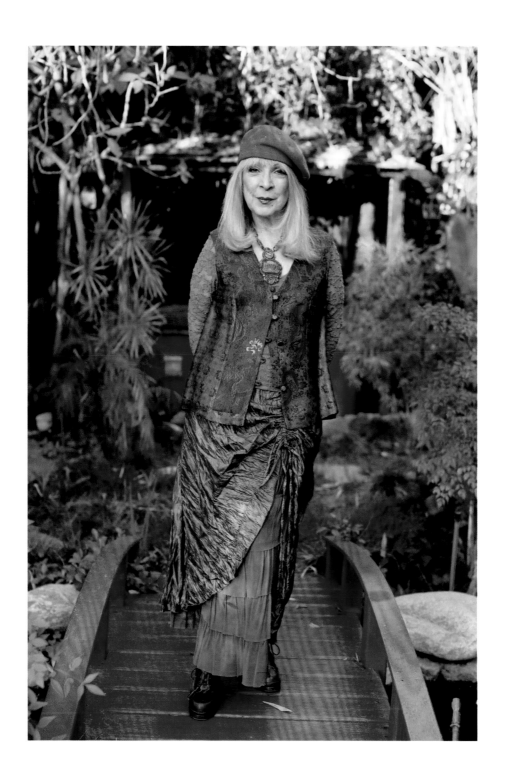

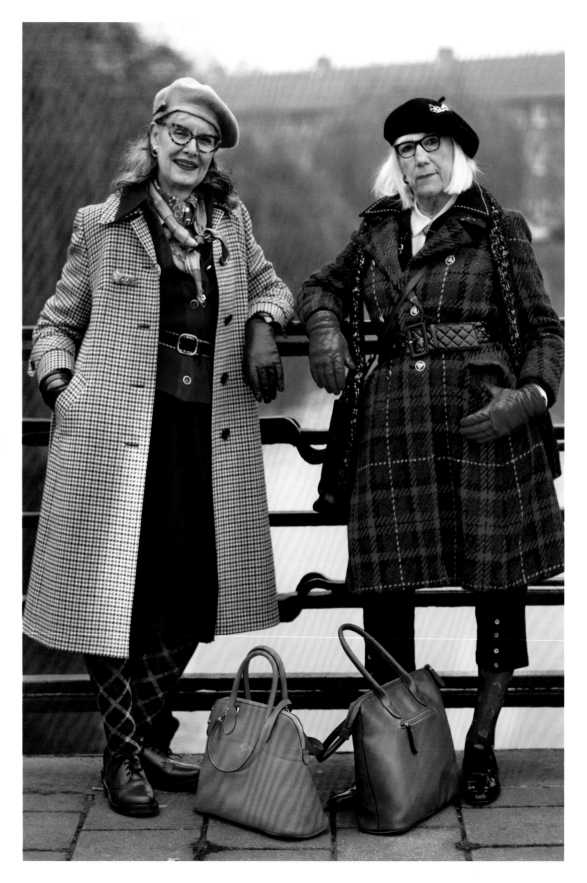

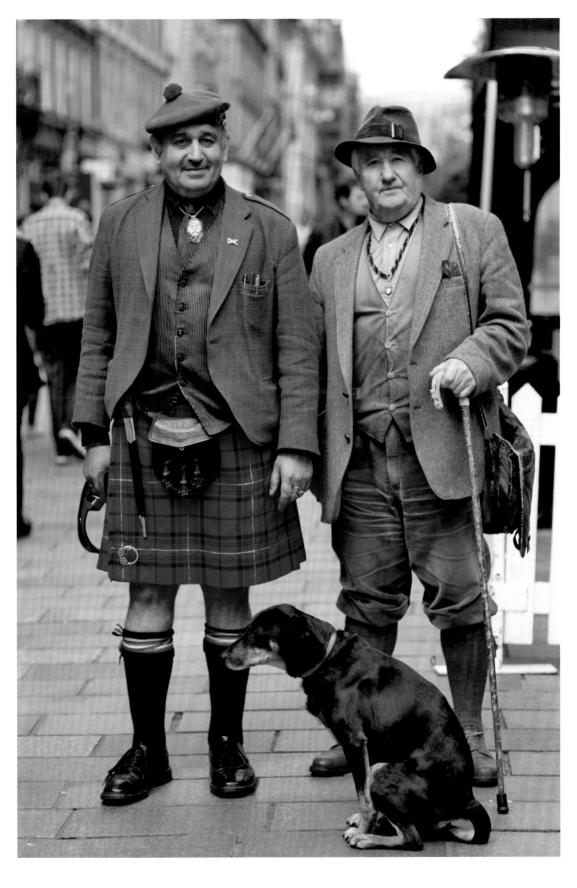

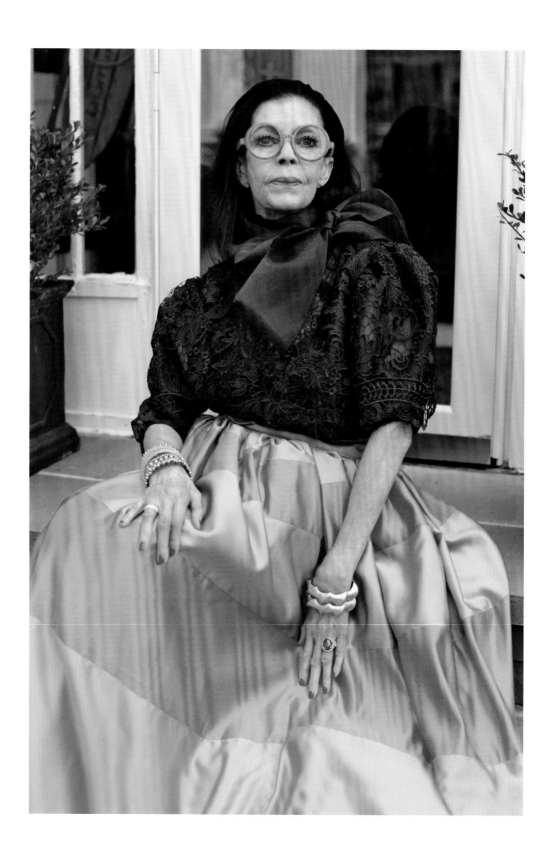

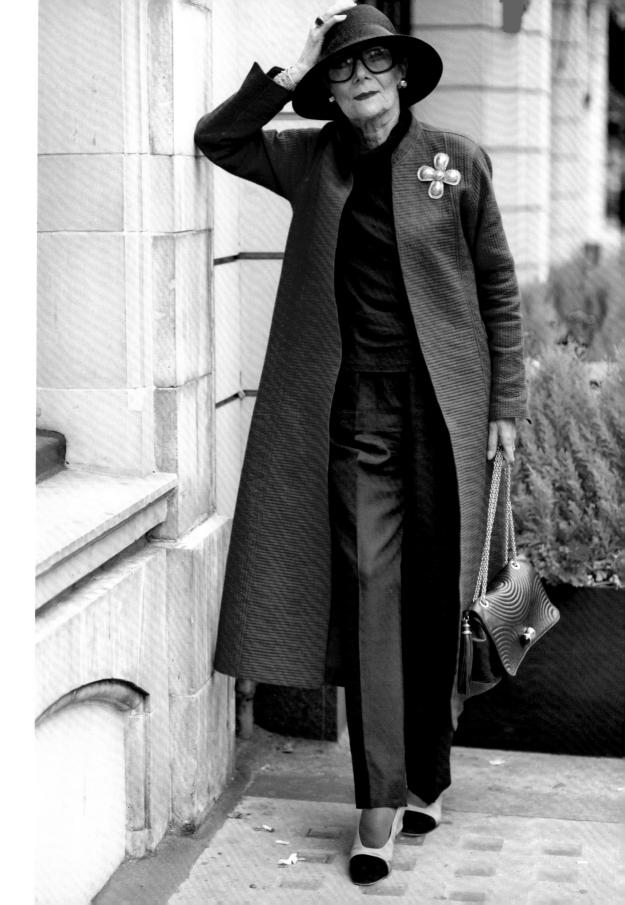

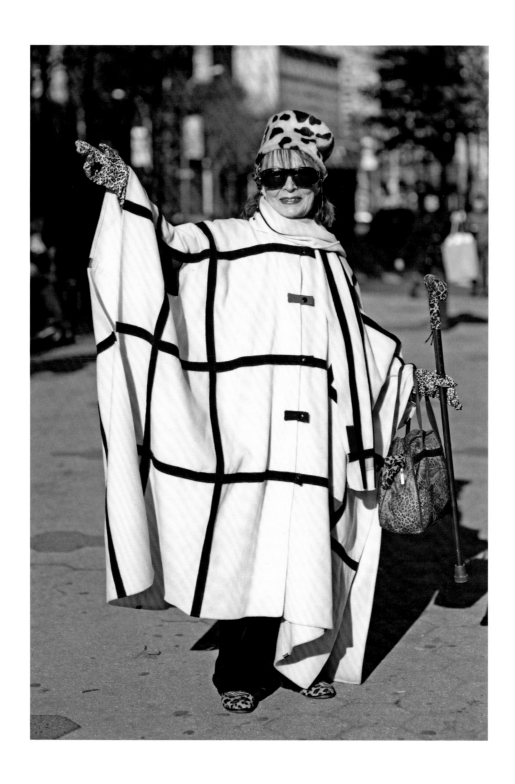

Alice Carey, mid 60s

It's nearly midnight, July 1969, and I see my younger self in Sheep Meadow, Central Park waiting for the moon landing. Park commissioner Thomas Hoving has invited everyone to celebrate this historic moment projected "live" from the moon, on four huge screens. He says we must party—and I do.

I'm wearing a dust-the-ground-long yellow dress with shiny orange goldfish on it. My hair—not as flaming red as it is now—is long and curly, courtesy of those tiny, pink rubber curlers. Remember them? I'm with two boyfriends and a pack of pals, all of us smoking marijuana right under the cops' noses. But the vibes are so mellow they look the other way.

"All you need is love," sing the Beatles, and I'm a believer. Dancing in the rain to music in my head, wearing neither makeup nor shoes, is one of the happiest moments of my life. I'll never be that young or innocent again. I miss it.

My generation—"baby boomers" they call us—never thought we'd grow old. Old was for our parents. We'd be forever young. Sex, drugs, and rock and roll would see us through. And it has, for the likes of Jessica Lange, Charlotte Rampling, Twiggy, even myself.

I know I look different than that girl in the park. Yet in some ways I look better. Age and a rare illness have given me cheekbones. Henna keeps my hair red, and "time, that old gypsy man" hones and strengthens my style.

Baby boomer indeed! Accept that moniker and you're done for. I am not old. Do I dare add, yet? My generation has only just entered into a new stage of life, what I call the "adolescence of old age." Think of it as another shot at youth, with all its pitfalls and pleasures, with you (and not your parents) at the helm.

What keeps us young is our freewheeling, turbulent past—like our political commitment to end the Vietnam War that transmogrified itself into an even stronger commitment to fight

AIDS, stop sexual discrimination, and become feminists.

If Bob Dylan could be "like a rolling stone" we could as well. Joni Mitchell became our goddess, Leonard Cohen our god. We heeded Dr. Timothy Leary's advice to "turn on, tune in, and drop out"—even those of us who never dropped acid.

With early mentors like these, we will never "go gentle into that good night," much less join AARP to get what? Reduced bus fares? Be viewed as old? Yet, that old gypsy man hovers. Curious what I do to stave off the ravages of time? I'll let you in on it.

- Never leave home without lipstick.
- Embrace an intellectual project like writing. Tackling Shakespeare works well too.
- Sleep longer and better, without pills or liquor.
- Cut that long hair. Keep it short, stylish & chic.
- Determine what you look good in. Call it your uniform and wear a variation every day.
- And sex: never give up on it, in whatever shape or form. It keeps the roses in your cheeks and the gleam in your eyes.

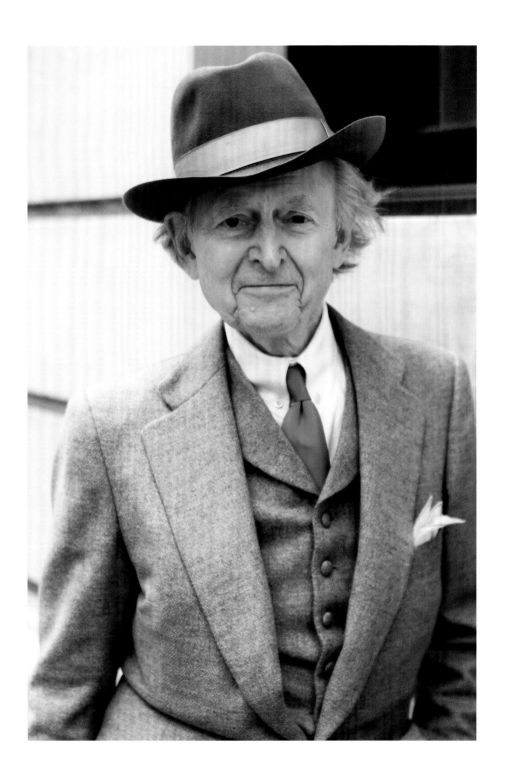

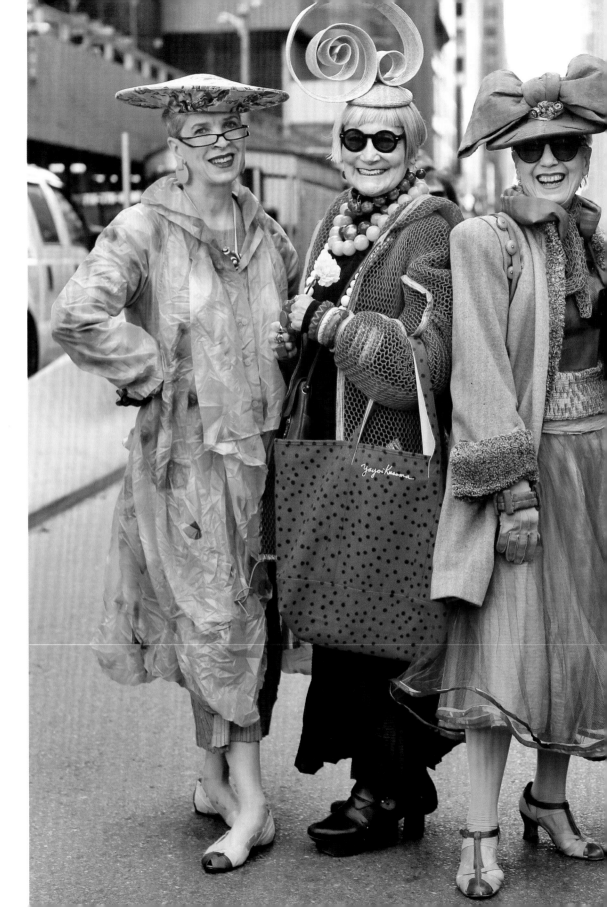

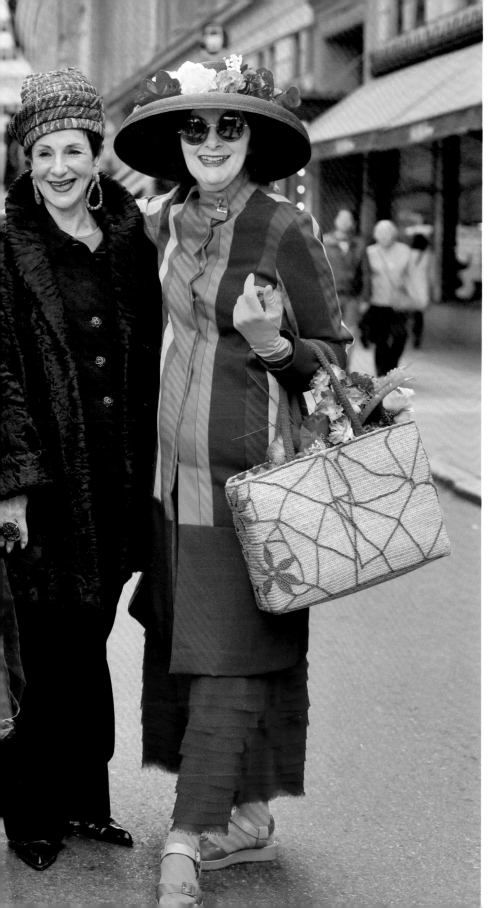

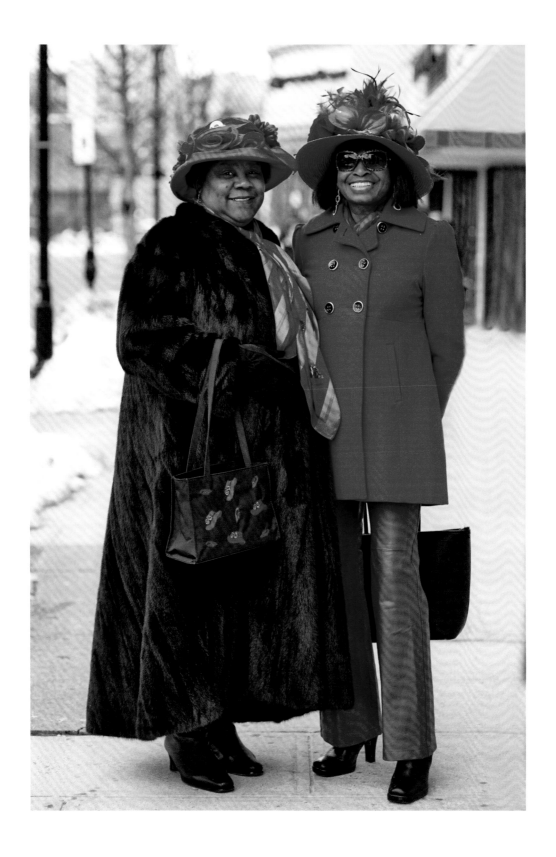

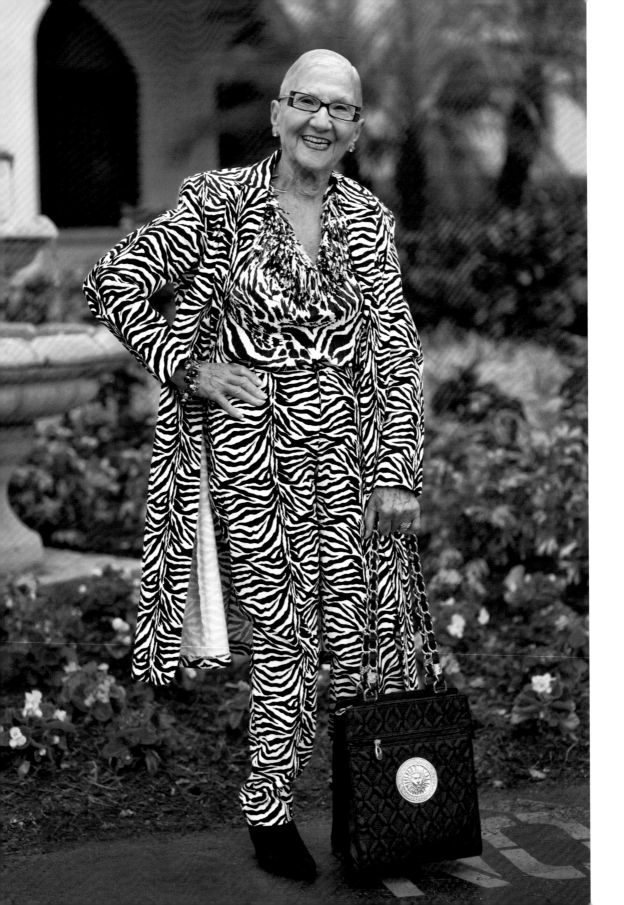

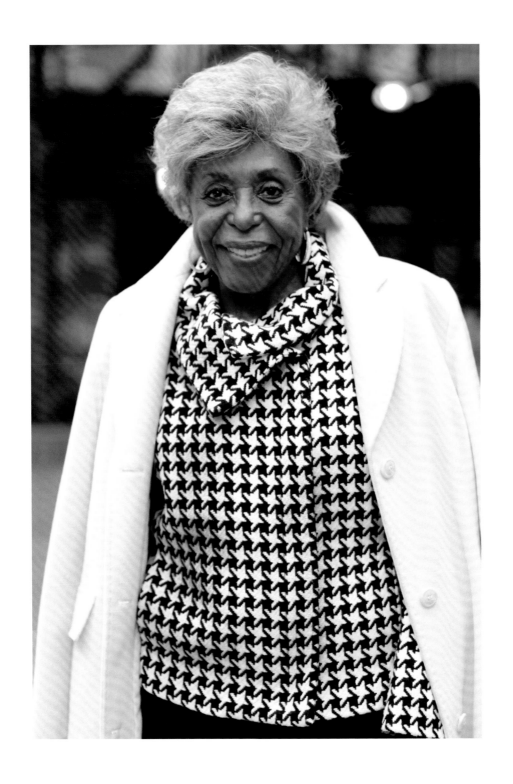

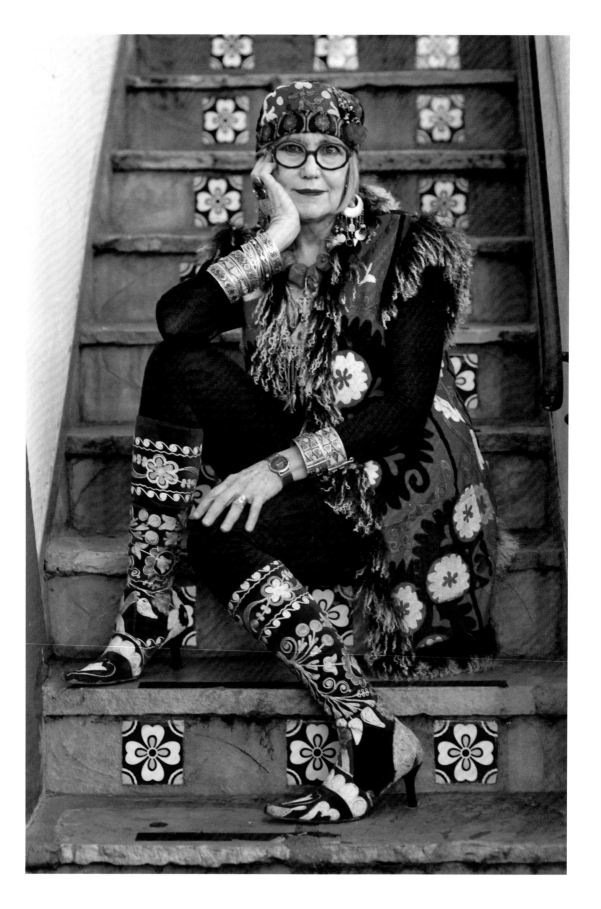

Suzi Click, 66

My fascination with fashion began in childhood when I loved playing "dress up" in my mother's clothes. The most embellished, intriguing garment in her closet was a jacket that my Dad had purchased as a gift for her at the Khan el-Khalili bazaar in Cairo, Egypt when on military leave during World War II. I fell in love with that jacket, even wore it to my third grade piano recital, took it to college with me, and later to New York City where I wore it to the symphony.

It is a *taqsireh* jacket—a short sleeve, bolero style made of black velvet and embellished with metallic gold embroidery. Several years ago I saw a similar one in an exhibit of Palestinian embroidery at the Los Angeles Craft and Folk Art Museum and learned the story behind the jackets. They were made in Bethlehem using an embroidery stitch called couching and were worn layered over a long dress as part of a bridal costume. Young girls started learning embroidery from their grandmothers at age seven and by the age of marriage had a large wedding trousseau of lavishly embroidered clothes. The personality of the girl was thought to be reflected in the workmanship, color, and detail of her designs, and this is true for me. My designs reflect my personality and my passion for ethnic embellishment.

This is how I dress—expressing the power of adornment in my own unique mix of textures, colors, and patterns with bold jewelry for a luxe, bohemian vibe. It is basic to my work as a designer of artisan apparel and accessories, mixing together textiles and trims from different countries.

I have traveled to far-flung countries including India, Morocco, Peru, Uzbekistan, Thailand, Cambodia, Laos, Burma, Bali, Java, Turkey, Romania, Egypt, and China, collecting textiles and trims to wear and use in my work. But I also go to learn about the people—mostly women—who continue these ancient crafts of embroidery, dyeing, and weaving. Many even still wear their costumes every day and most of these women are the older ones who are so beautiful wearing their styles. To discover the meanings

they put into these designs and the laborious process, plus the heart and soul, that goes into them is so inspirational. My hope is that in some small way, by designing with these textiles and wearing them myself, I can honor them and help to keep their art alive.

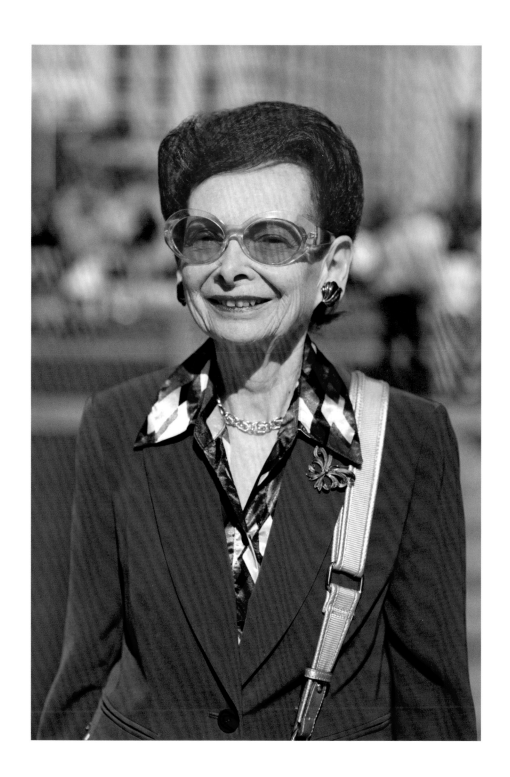

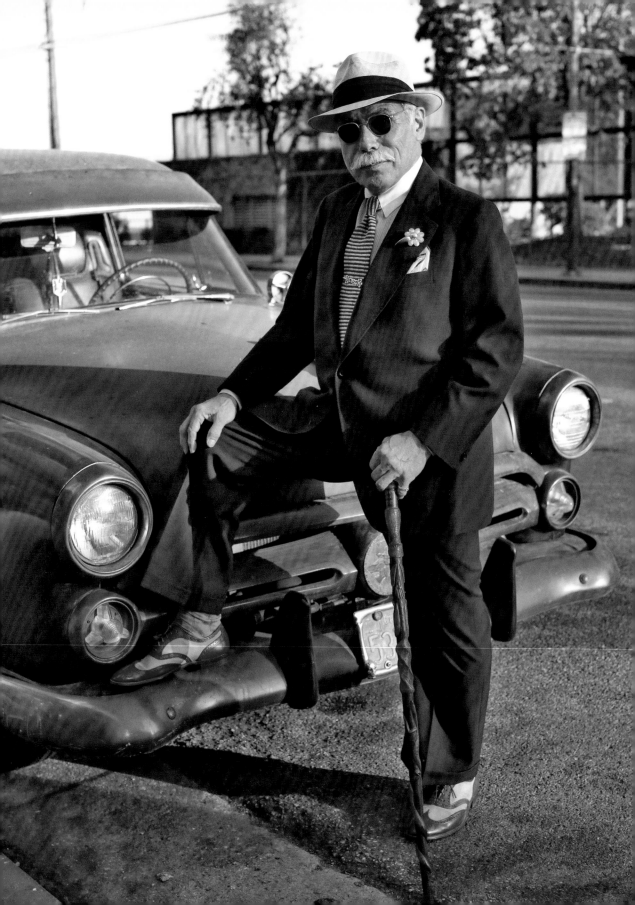

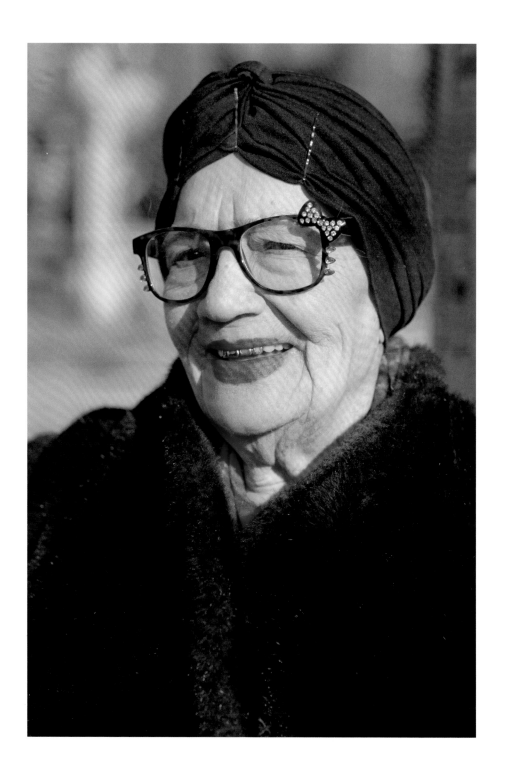

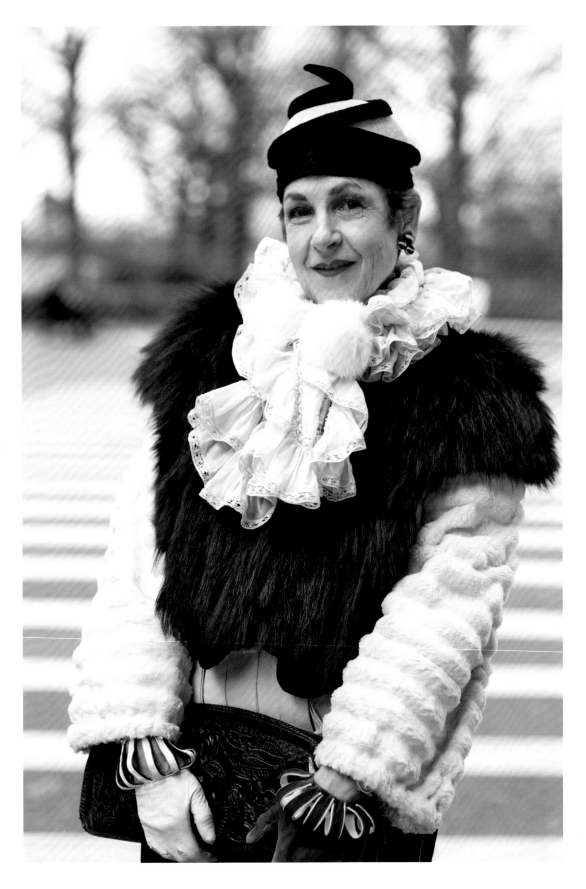

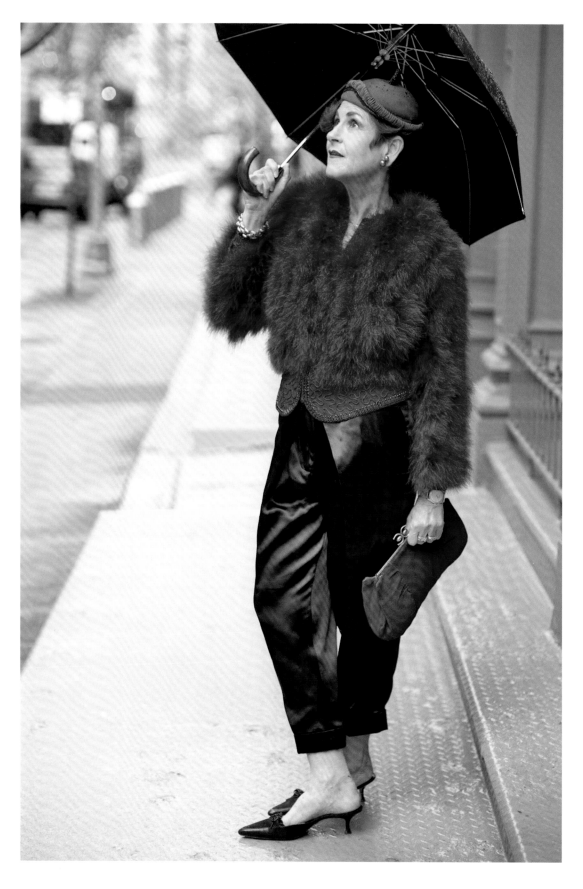

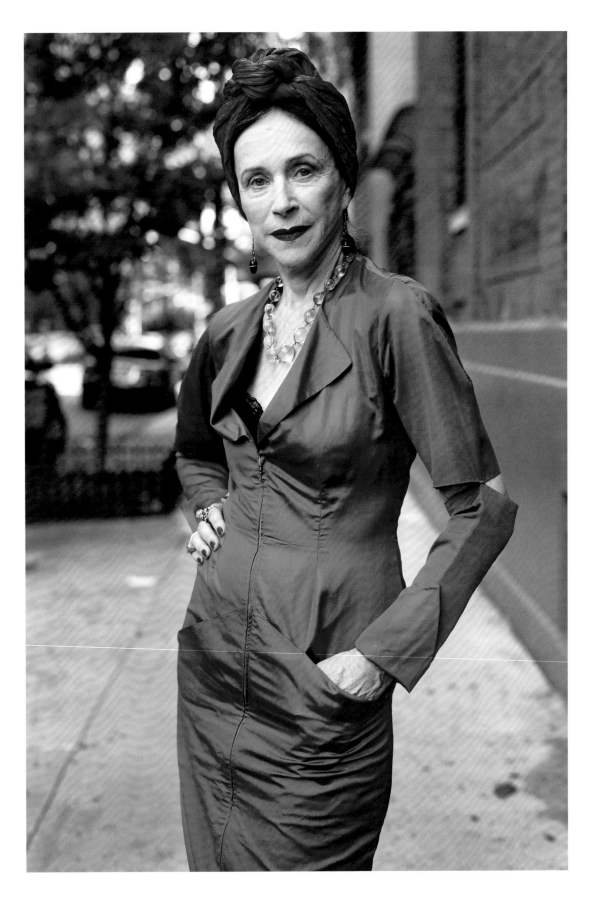

Beatrix Ost, 75

*I'm hanging in the balance of
the reality of men.*
　　　　　　—BOB DYLAN

"Will I see you again?" my mother would say to that gigantic tree next to the pool, where you look out into the Blue Ridge Mountains, their blue profile, tinted in autumn indigo, defining your view in the west. A ribbon of ionized air.

Perpetual farewells: *Servus*, as we say in Bavaria.

Of course, we humans live an illusion. It's not us; it's the others who fall ill, or have an accident, or die. It is unfathomable. And of course we would lack every incentive to act did we not live in the bubble of tomorrowland. And then there is an exhilarating joy in being aware of *time*, precious god of existence.

To love with all one's soul, writes V. Nabokov, and it feels right to me. I do love. I have nothing and no one I loathe.

All I need is to stay a bit to the side. But I have no capacity to be otherwise. I love every day, even if others find it dreadful. I cannot sympathize with them. I don't hang on the fickle weathervane of moods. Of course, I do not have to labor in 95 degrees of moist heat.

Last year I fell in love. I was not interested in the man, not at all. He felt like a trivial souvenir. But then he convinced me; or rather, the situation persuaded me. There was a sad, metallic poetry about him. He both approached and fled the moment. He was perturbed by the personal problem of aging, despite being only half my age. And yet we looked fine together; the age difference did not bother anyone, certainly not me. I found it rather intriguing. Of course, I couldn't help seeing a son in him. And then my curiosity led me through this imprisoned addict's labyrinth, for months of discovery fueled by real love. And yet I was not really in it, I was an onlooker, a guest, a visitor, still in my own galaxy.

I just let what happened happen, because there was nothing to gain or lose. And yes, the kaleidoscope of emotion traversed a spectrum of sensations I had not felt in some time. Love is like rain; there is nothing you can do to stop it. And we have that inert need to belong, if only briefly. We are solitary heroes of our

days. But the feeling we attribute to love makes us belong. Of course that is easier with the dog you belong to, or vice-versa.

Game of Texts:

Sabine: Tomorrow I see Peter at 7 p.m. We are meeting to plan a fashion shoot. How should I act? I am quite calm, but something is boiling and I want your suggestions, my dear. You always know what to do. Love, S

Beatrix: Be gorgeous and light and sweet as if nothing ever happened: only react to/don't give out anything—"So nice to see you"—But remain a sphinx.

S: Thank you so much. That's what I needed! You are the woman every woman should be! Love you, thank you.

Yes, I now know better what to do, what advice to give. But did I know that when I was young, much younger? No, I didn't. I made enemies and friends like a magician with his wand, but one single movement could destroy the skillfully built towers of my relationships. I once drove my little VW cabriolet across a lover's foot when he had deceived me the same way Sabine's fellow had done. But on the other side was always my immense ability to care and love. Now I am free to bid my radical side adieu.

There is such a broad landscape to survey, to observe closely through one's own prism, to split into as many enchanting colors as one pleases. Outside, the afternoon is holding its breath. It has not decided what to become. Up above, in the crowns of the trees, a teasing wind is dancing the leaves, holding the skirt of a poplar, then rustling the linden crown, then over to the tassels of a cedar. No rush. Far away, a car zooms through a canopy of woods. The noise intrudes and makes me feel safe, as if I were in a citadel. I can invite you, too, if you so wish. The melancholy chirping in the grass rises to a chorus thick with a myriad of shrieks. One could almost lie down upon it, fall into a most devout dream. It is an illusion, like all singsong. A magpie has made a sloppy nest in a small potted tree. It is down too close to the steps, the cat will get hold of it. Ah, nature, that master of the law.

And then, without any astonishment, the sounds cease to exist. It's as if a stroke has hit the park. This is the fomenting moment. Some growling from below, a place of no home. An iridescence flickers across a billow of clouds. Dark, tinted, they merge with the mountain blue.

A strong wind rips through. The sound of running feet on

wood, to the terrace, to take down the awning. Some hollering, more running feet, down to the pool, to fold the umbrellas, lie them flat so they will not turn into sails.

The treetops are besotted with dance. They beam and bow. Will they hold up? Will they twist? Will they break?

A few warning drops, heavy as lead, and it cuts loose above, with the anger of a dark, gray galaxy. It rips downward, as if regretting the previous idyllic day with a vengeance one could not have foreseen.

Witnessing the unexpected drama of a robust reality makes a ghost of the afternoon. What we know is but a reflection in our brain. This is how it will always be. None of it is foreseeable. The farewell is in every gesture.

Say it to your beloved; to your skin, that witness of decades; to the dog; to the milk in the pitcher; to the day: *Nothing will ever change.*

And yes, Dylan Thomas...

Do not go gentle into that good night; Rage, rage against the dying of the light.

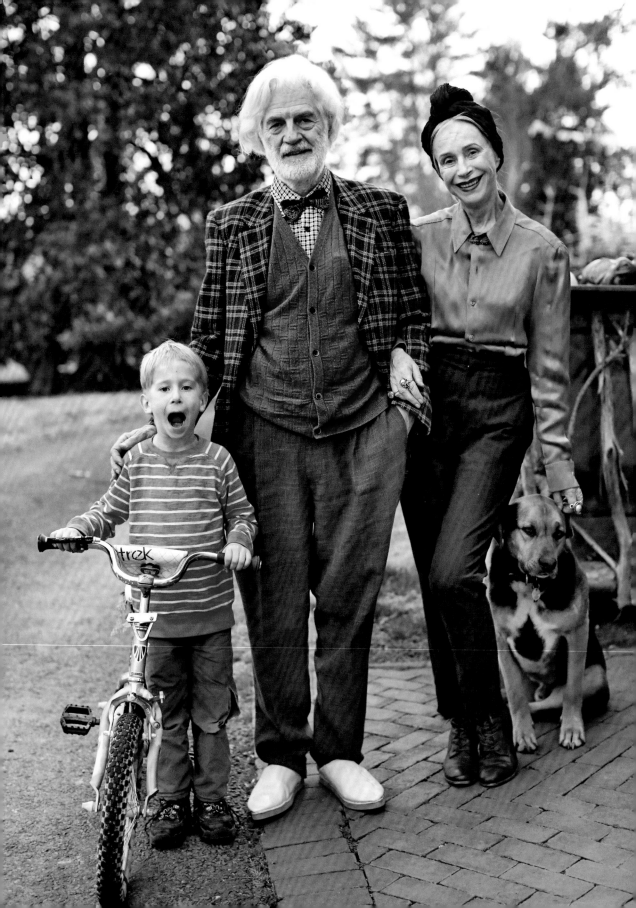

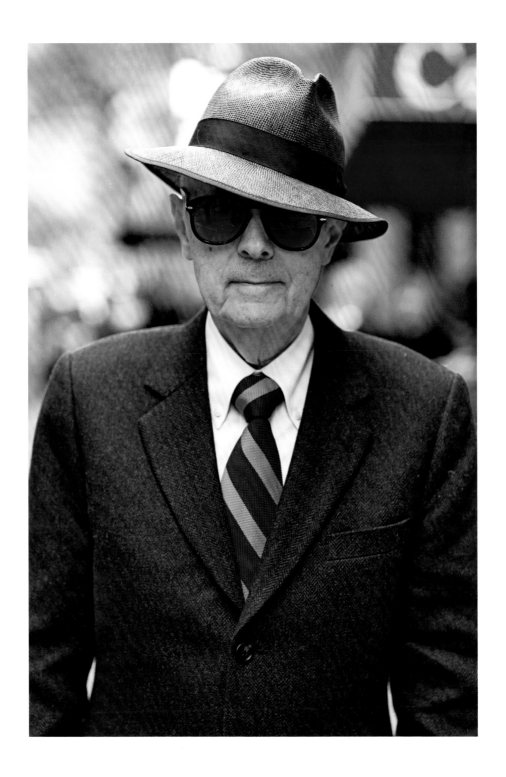

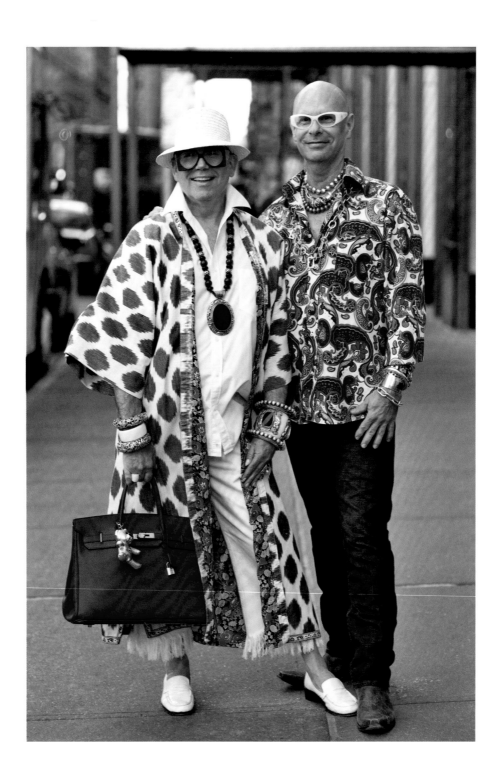

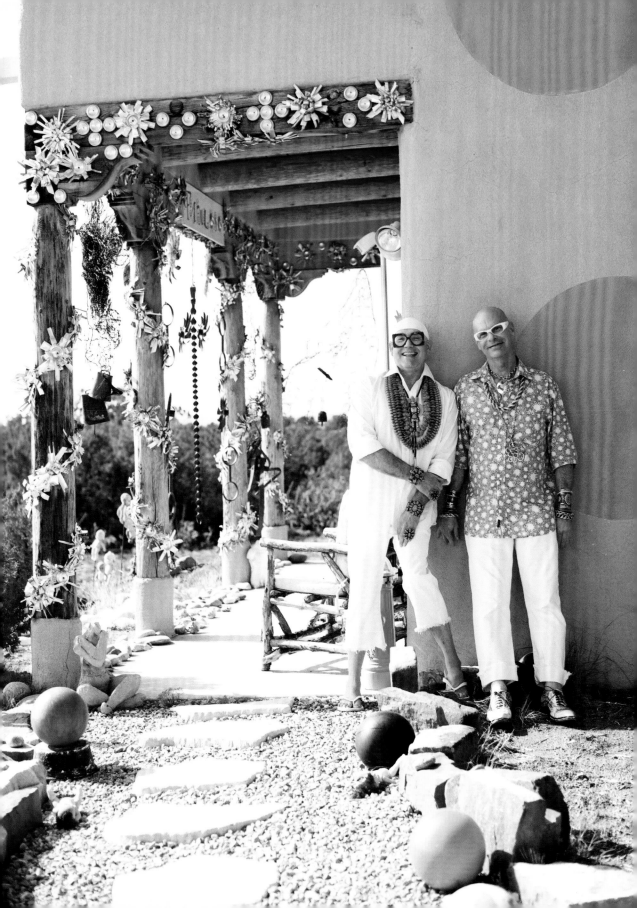

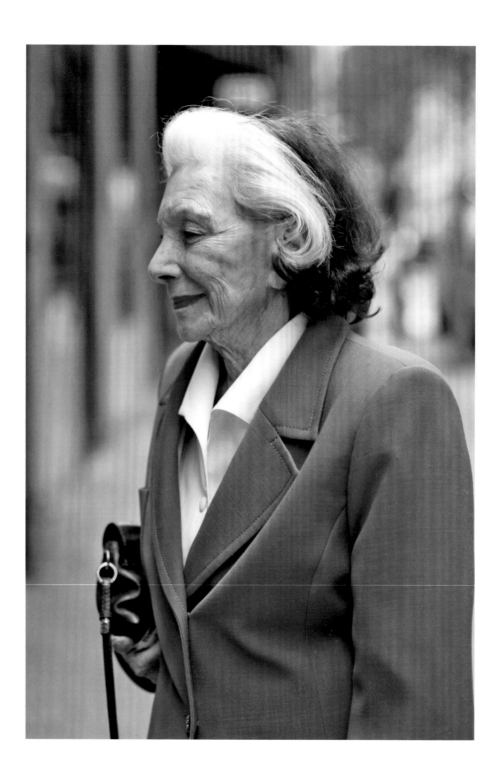

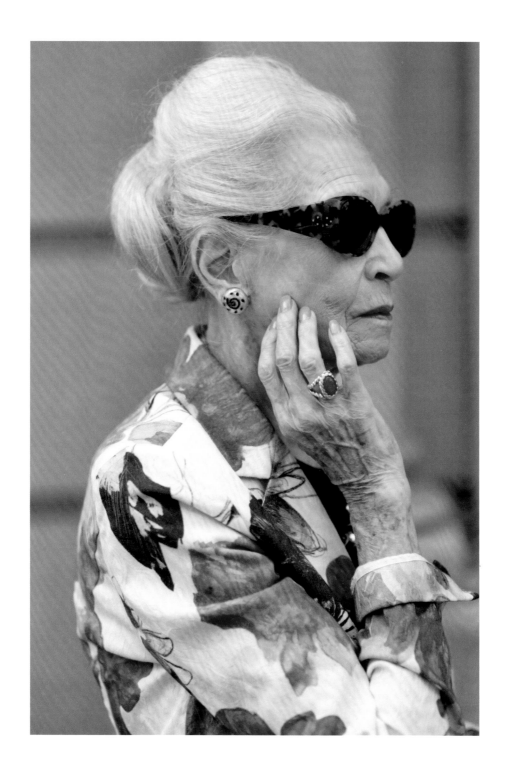

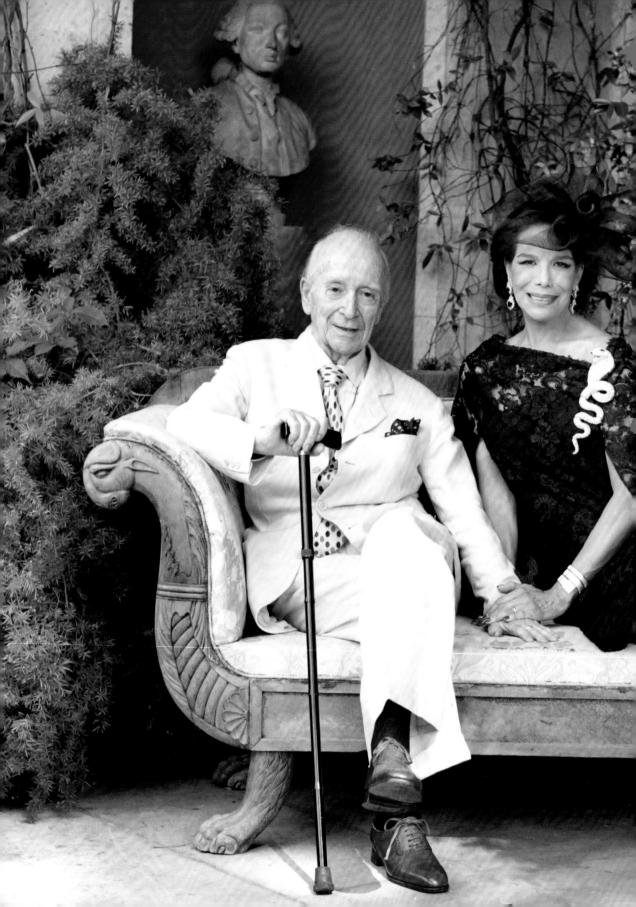

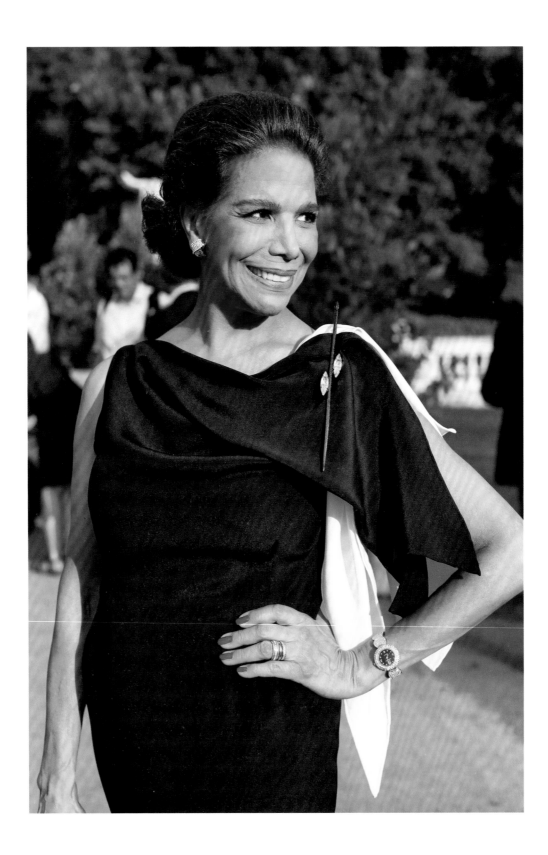

Lana Turner, 65

I didn't grow up enamored of fashion, clothing, or even style, but there were things and people all around me slowly and quietly seeking my uniformed attention: my father, a lean immaculate man in dark suits, white shirts, ties, wingtips and a Stetson hat, always cut an impressive figure and was sure of his ground; the buxom black waitresses in starched white uniforms with exaggerated hankie corsages pinned to a left pocket above the breast who took orders with the lilt of vocal melody asking, "Baby whatcha want?"; the church, a bastion of theater—choirs in swaying robes, deacons in Sunday suits, ushers in crisp uniforms, nurses in capes marching and strutting on a holy runway with precision and aplomb, church ladies for whom no single color from hat to shoes would ever seem so gauche as not to be pleasing in the weekly sight of each other and, of course, the Almighty. Pulling it together, making it work, stepping out, and loving themselves and each other with humor and affection, these African American tastemakers would become a subtle and impressionable influence on me. Carriage was language. Color found purpose. Clothes danced.

When I was a young girl I suppose the rage about what to wear (pea coats and Russian boots) and how I should look (my hair in a French roll) were notions I could with some ease follow. In the process of becoming I quickly realized I was not a good candidate for fashion's shifting air. Aesthetics in outward appearance, inner life, and sanctuary would find instruction through synthesis abetted by the prisms of art, music, dance, theater, and literature. One morning I awakened thinking that everything should be beautiful *and* functional. Out went the mahogany dresser and night table. Of course there was not an immediate surface on which to stack the contents. The importance lay in placing trust in a new paradigm, visualizing the outcome, and, of course, creating the composition. The outcome was deeply satisfying—a delight without alloy. That moment was a harbinger of things to come.

Before the advent of six layettes over the span of nine years, my parents Lee Arthur and Ida Turner had 13 years to bask and

revel in each other's company and that of their friends. In 1937 Harlem was their home. While the Great Depression cast blight everywhere, they eschewed the gloom and got dressed. They celebrated life in communion. A steady stream of black-and-white photographs of them flanked by friends posed in social clubs and dance halls attired in gowns, tiaras, gloves, bow-ties, and formal suits stand in testament to the self-assurance, the inner strength, and the conviction to define themselves. The burdens of circumstance would be allowed slim margins. This would be a takeaway lodged in my DNA.

Leaning against a 1950s open-air convertible, driver's door open to expose lush red leather seats, photographer Annie Liebowitz captures the sober excitement of jazz legend Ella Fitzgerald as she stands relaxed, poised, and inviting. Wearing a two-piece, red, 60s-ish vintage suit, red pillbox hat atop an "Ella" flyaway hair style, white cat-eye glasses, leopard jacket casually tucked under one arm, hands on hips, legs crossed, and wearing round-toed, short, black pumps, Ella is my pin-up girl. There is so much to see in this frame. What draws me in is the inner pleasure of being *and* looking great. She is the aunt you can't wait to see, the one whose tales always elicit wonder, the one whose genuine warmth is there for the taking, the one who has made her way by just being herself. There is no subordination between the interior and the exterior self. This is style without artifice.

My son Eric rarely joins me at evening galas. One night he accepted a white-tie invitation and wanted to know immediately if I would dress as a "normal" person or would I be myself? "Why," I asked, "would I go as someone else?" Two days before the event I decided on a black, vintage Vera Wang wedding dress with a satin-ribbed bodice and skirt bathed in tulle. Displayed and hanging from the chandelier in the dressing room, the dress commanded anticipation. Carefully laying out the accessories along with a feathered headdress, the setting rendered one mute. It was a still life painting in real time. Privately and personally, I was content with just seeing the assemblage.

I have unwittingly become an artist. It is a self I would not have recognized as a young woman. I think about texture, rhythm, and balance. I align my thinking with a breath of new energy while I celebrate and think deeper about pasts. The art of the body as canvas

presents new ideas of how I want to be and live. Sometimes it starts with a hat; other times a pair of gloves. Sometimes I just want to make the raindrops happy. Sometimes I can hear Ella sing all the way back to where she started. Sometimes its color; other times, light and shadow. How delicious it is to discover a new palette every day. Potent forces are always at work.

Time is elastic and tinged with a sense of humor. It allows me the unhurried grace and passion to live expansively while I mark out the traces of being alive.

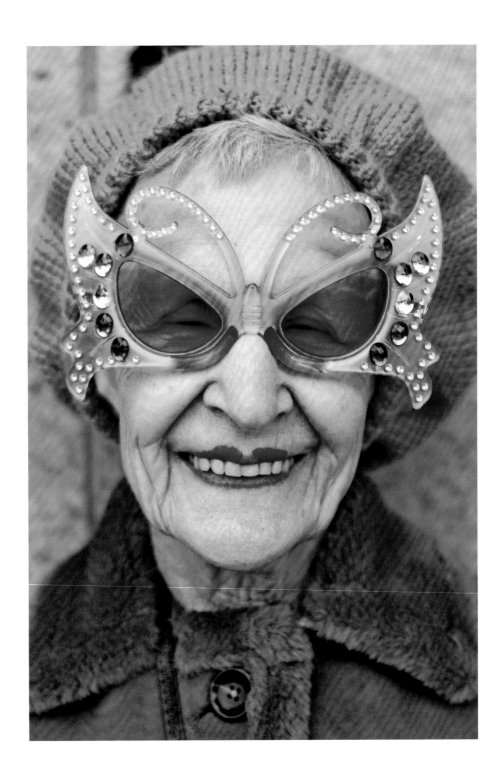

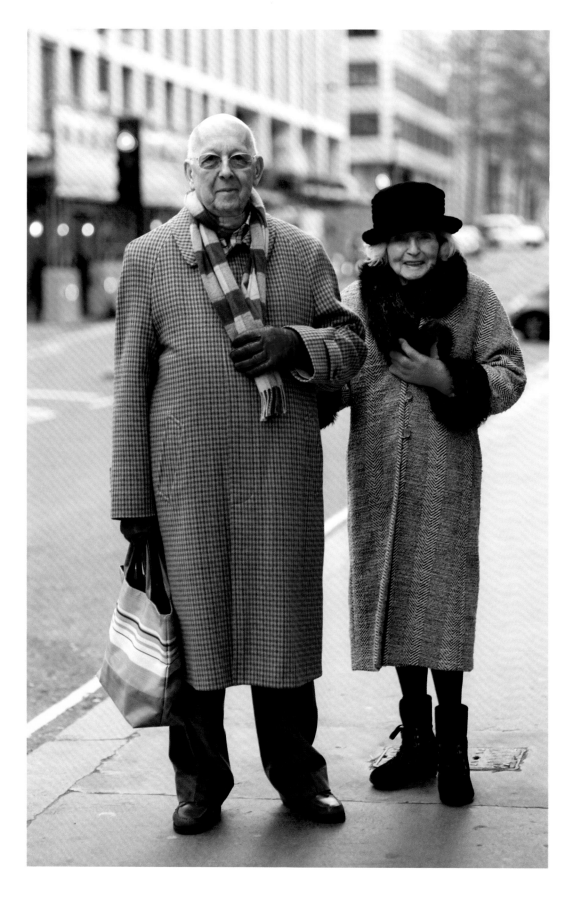

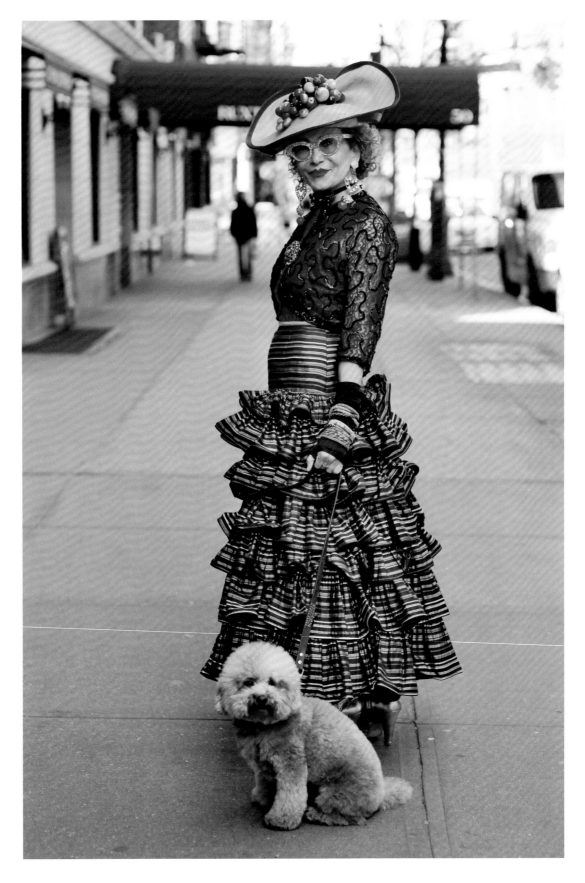

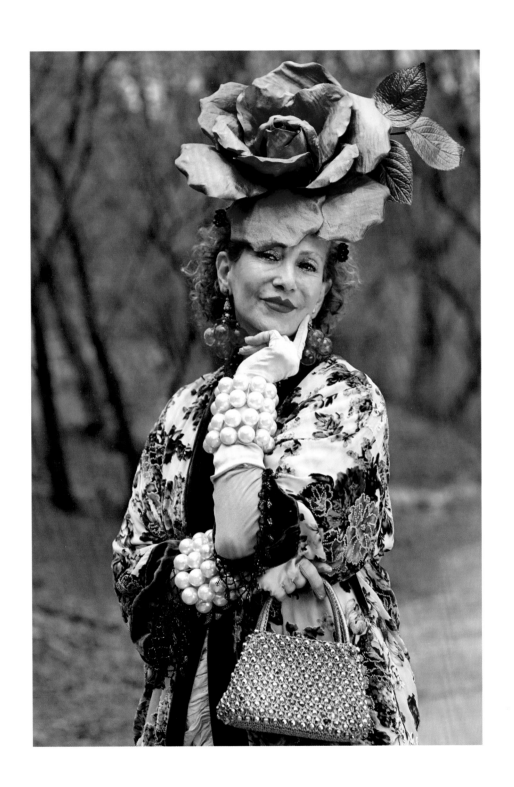

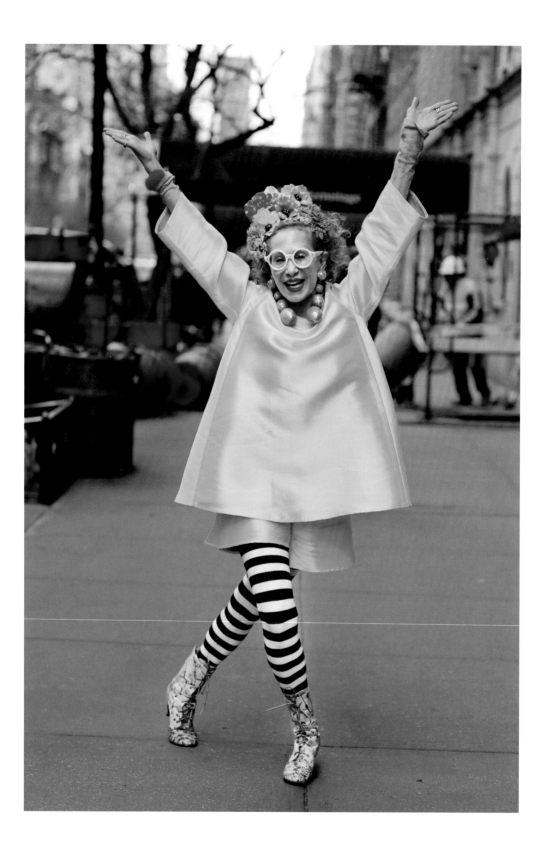

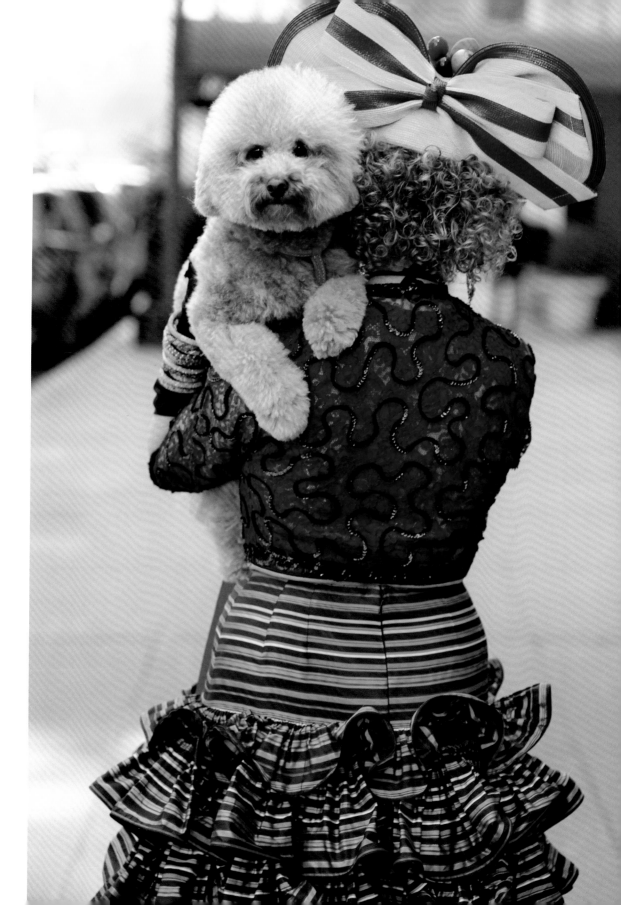

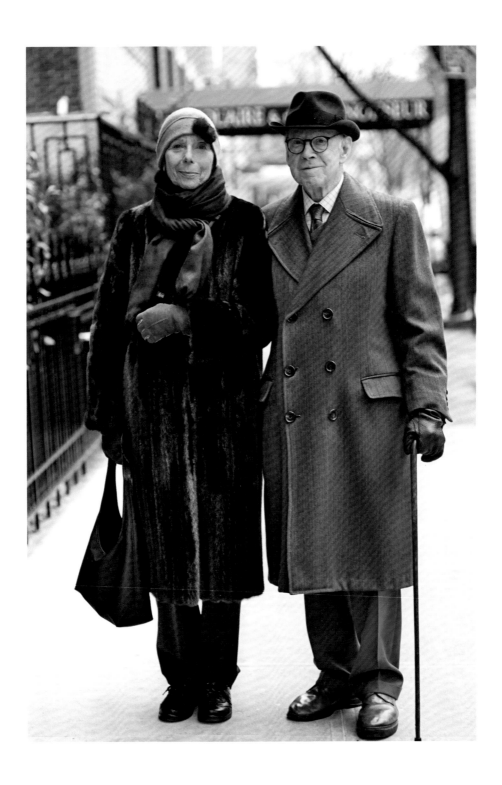

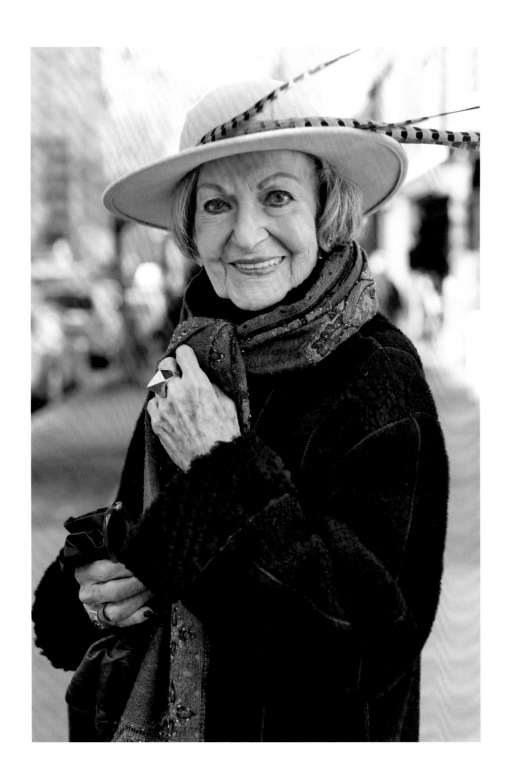

Joy Venturini Bianchi, 77

Throughout their lives, my parents honored and celebrated life through fashion. They celebrated five seasons, including "Holiday." Off we would go to I. Magnin and Saks Fifth Avenue where we would shop for the next season and for any special event that was forthcoming. It was like having a toasted English muffin for breakfast. It was a way of life! As a child, my mother gave me carte blanche to dress up with her clothes and shoes. During these formative years, my parents made it clear that fashion was a natural channel to express "Who I Am"—a way that could be felt by myself and by others.

When I choose clothes that feel connected to my innermost soul, I feel like I have escaped gravity and that I have a direct connection with the rest of humanity. True fashion can destroy boundaries and lead to conversations that can bring us together as a community where I can share higher ideals, including the beauty and needs of people with developmental disabilities. It is the place where our deepest selves can rise up into our consciousness, where we can become more fully ourselves—more fully human. Our hidden self, as well as what has been wounded in us, can emerge through darkness into bright light!

Fashion can truly unite us as a community—a place where we can truly enjoy each other, perhaps even to love each other—as we celebrate life and celebrate difference.

Through my mission at Helpers House of Couture, San Francisco, which benefits those with developmental disabilities, it has helped us to connect to women and men as we mutually explore fabric, shape, volume, cut for all sizes! In these moments, it becomes clear that "God is in the details," that each person is exquisite because she/he has been made in the image and likeness of God.

When a real connection between the woman and a dress exists, something extraordinary happens. Ralph Rucci says:

> *The clothes ignite a sense of spiritual awareness.*
> *The woman realizes: it is not just the garment; it*
> *is her self that is brought forward, empowered, elevated.*

In truth, clothes can dress a person's soul and become an outward expression of the inner self. At this moment, *style is born*!

Jean Vanier founded L'Arche communities for those with disabilities around the world. He profoundly believes that clothes have an effect on us as we welcome the joys and sadness of our daily lives.

> *Do not let yourselves be dominated and crushed by negative feelings or by your negative self-image. You need to react against them. Do not put on a sorrowful face or dress in clothes of mourning. Put on light colored clothes and some perfume. Take care of your body and do everything you can to fight against these forces of darkness. It is not an easy struggle, but it is worthwhile. It leads to liberation and life.*

During my 63-year mission with those with disabilities, I saw firsthand our friends grow in grace and in spirit when we went downtown, shopping for outfits that celebrated who they really were. They then became armed with dignity, purpose, and self-assurance as they connected to people on the bus, at Helpers Ghirardelli Square store, and wherever else they went.

In 2012, I was diagnosed with stage-four appendiceal cancer that had metastasized to the abdomen and colon. I ran to church sobbing, telling God that I loved life and did not want to die. Upon entering the operating room, I fantasized that I was wearing Ralph Rucci and Tom Ford gowns! It is now 2016 and those very same gowns have actually been worn!

Even though my years equal 77, I feel I am 15 years old.

Each morning upon awakening, I ask God:

What exciting surprise awaits me today?

Despite enormous daily challenges, a special, precious gift is always entering my life.

Celebration is for sharing what and who we are! One way to celebrate is to discover what it means to put on special clothes for special events!

May we join Ari Seth Cohen in joyously celebrating our brothers and sisters and the beauty of age, patina, authenticity, imperfections, and a sense of belonging!

May each of us be seen as unique, as precious, as special, as important!

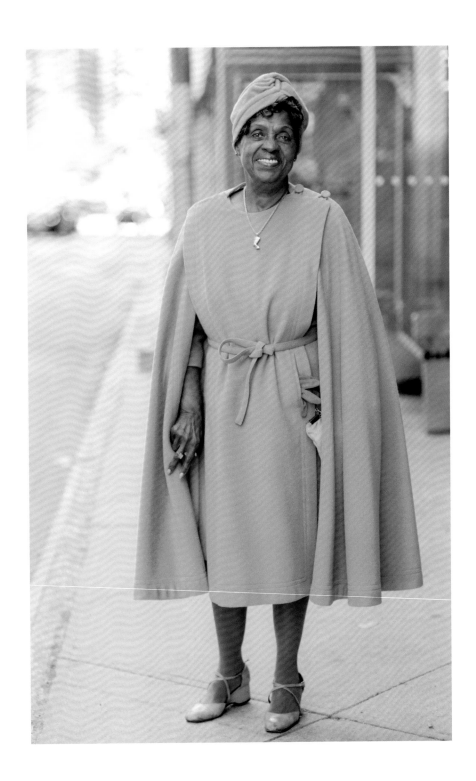

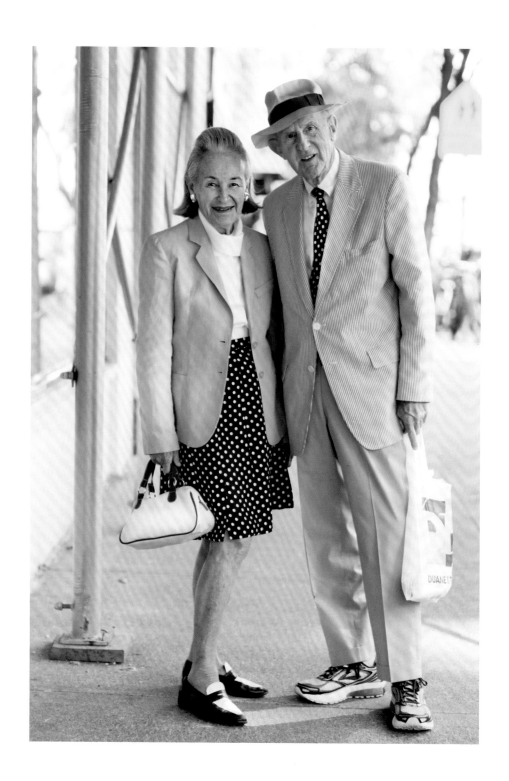

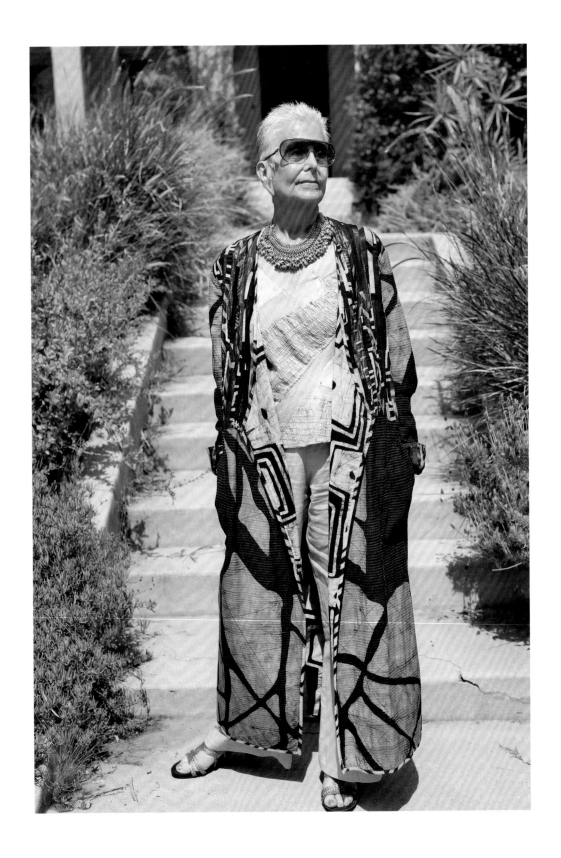

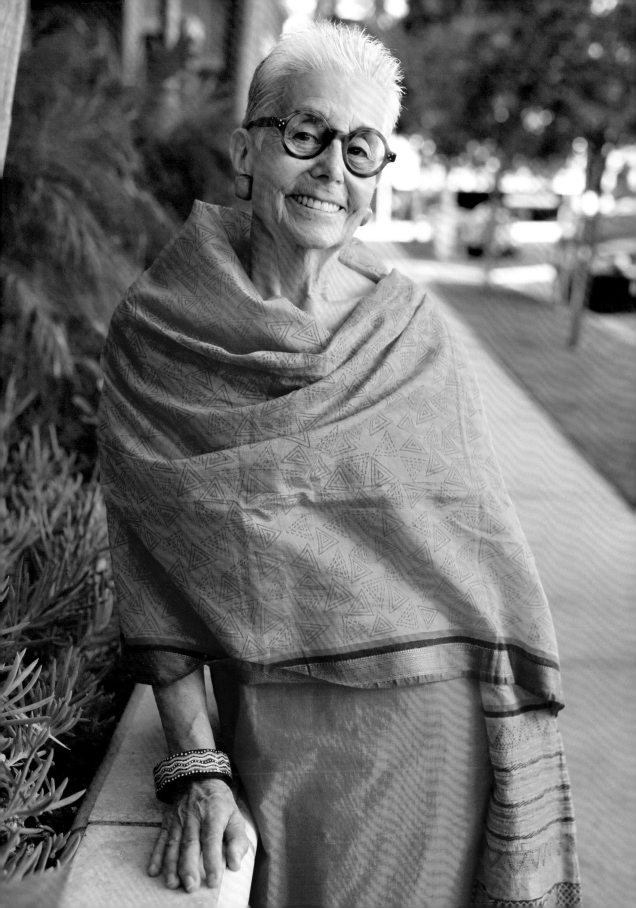

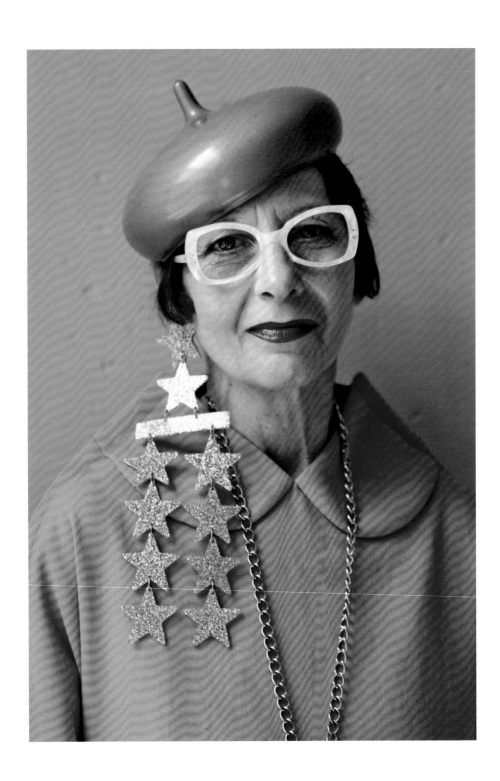

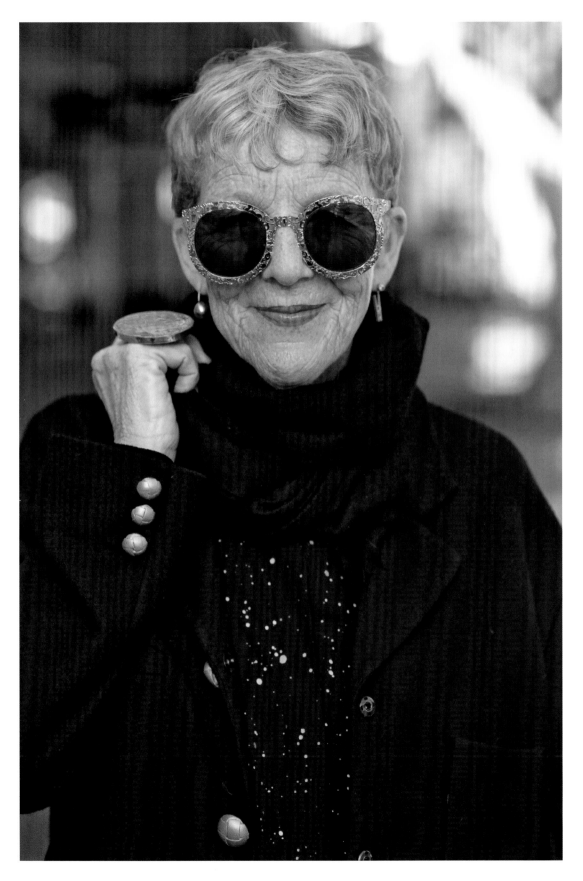

Gretchen Schields, 67

A childhood spent in faraway lands opened onto a world of stories within stories, an ever-changing picture book of ethnic costume and decoration, the continuing influence of everything I create.

I was born in Japan, named Sakura San for the cherry blossoms in bloom, and as my *ahmas* whispered tales of fox spirits and samurai, I stared at the dancing patterns of their kimono, til the patterns became the stories that I heard.

I imagine the geisha who whose obi now forms a part of my Silk Road necklace. Love stories from her ukiyo-e, her floating world, lisp to me through the embroidery of cranes and curling waves as I make my necklaces from her obi. Some of her lives again, her story told within the story of my textile jewelry

Next door at the Egyptian ambassador's residence, the monkeys and I were playing roughhouse. I remember that hot African day, cicadas chittering. I began petting the languid, spotted leopard, when she suddenly lunged at me. Her alert handler grabbed her chain just in time. That quick flash of brown and yellow spots—a moving pattern that could have changed everything. A story with an arc of surprise, and a surprise again—the child was saved

I construct my jewelry with multiple storylines of color, texture, and pattern. My necklaces have a complicated plot of elements. Earrings reflect the flash of the wearer's eyes, opening her ear to secrets. Wear the necklace over your heart—it adds its voice to yours. Adornment is the power to proclaim your own creative story.

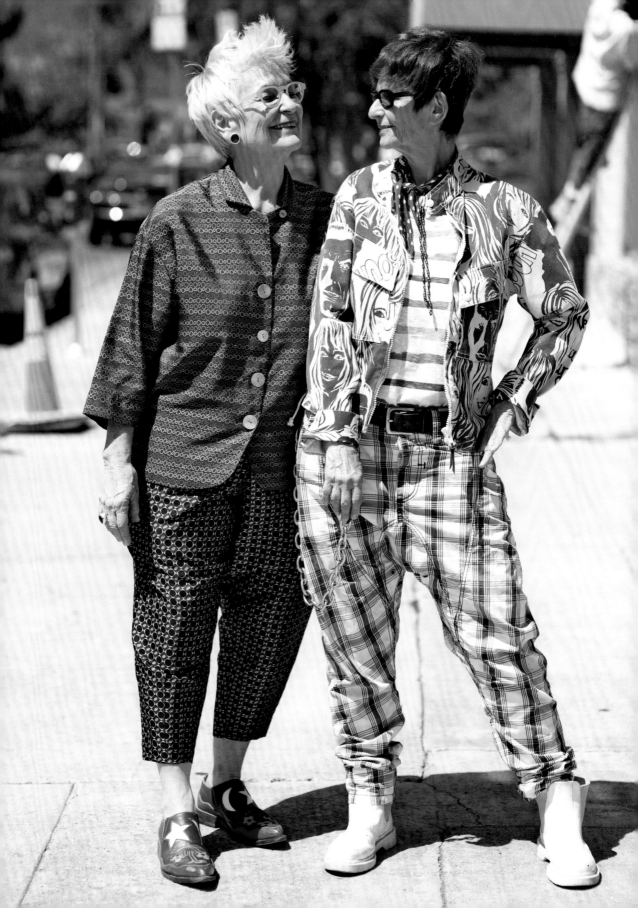

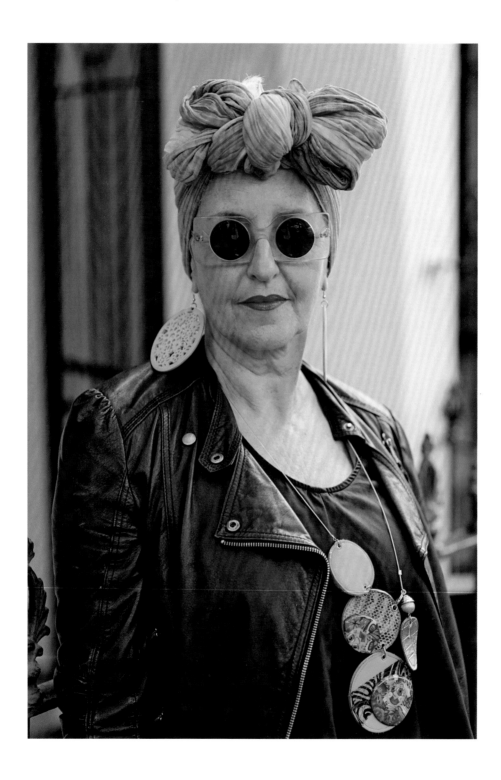

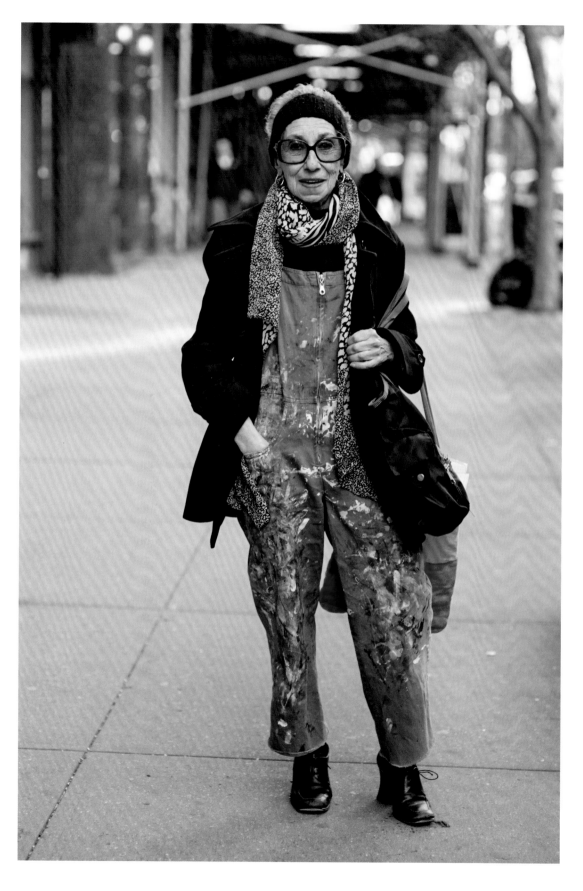

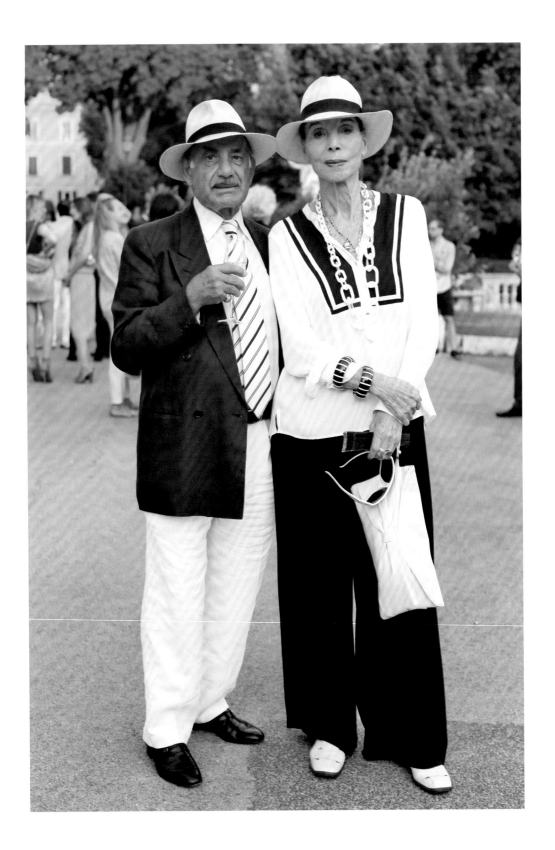

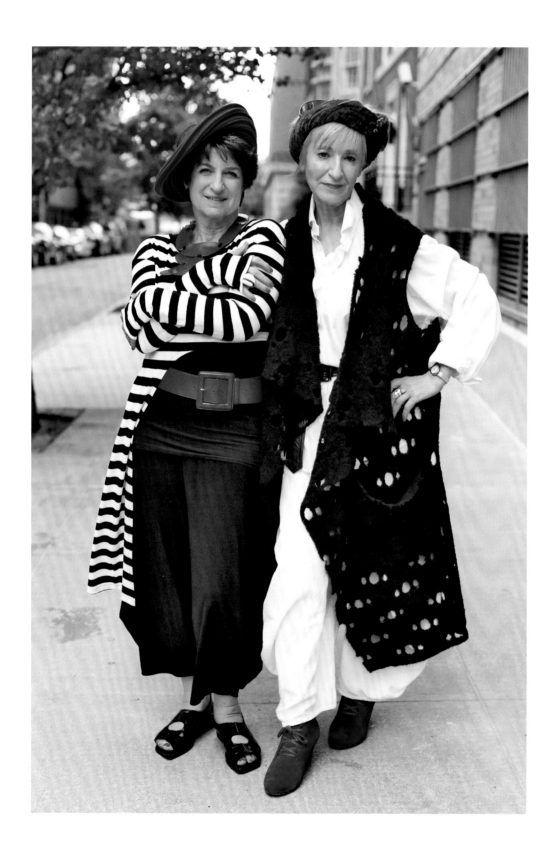

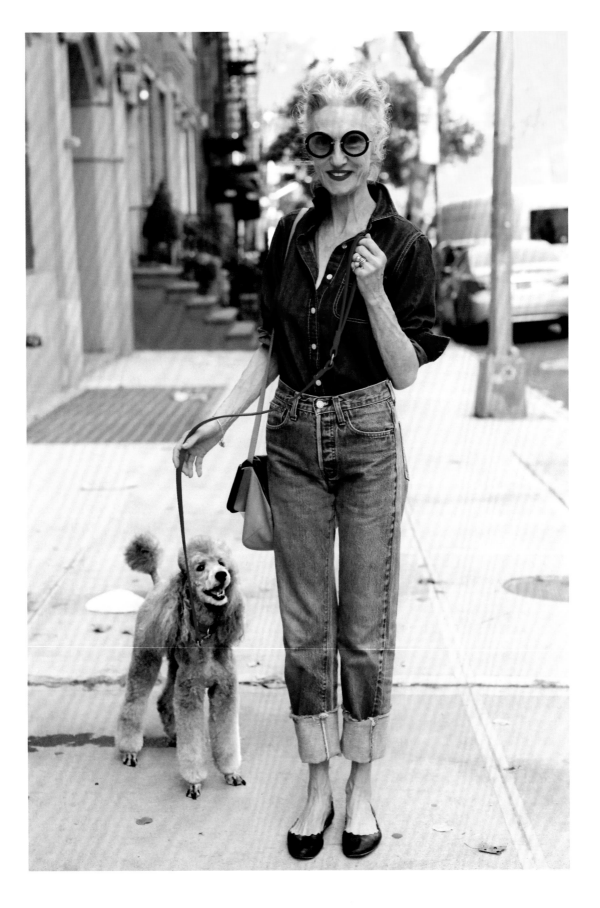

Linda Rodin, 67

I met Ari about three years ago and felt totally comfortable with him and myself—wrinkles and all! Ari has a way of embracing everyone.

I'm 67 and I have never felt the urge to dye my hair—I started turning gray at 35—or have a face-lift. For me it has always been *health is wealth*, and everything else is all fine with me. Chasing my youth has never been a goal of mine.

I won't say that.

I love and embrace all of these outward signs of aging. It is not easy to face the mirror most mornings, but as long as I feel good, I imagine I look good. In life, perception is everything.

For me it is all about how I feel—that comes first, always. If I feel well and rested, everything else is a gift. I have worked very hard for all I've accomplished. I value reliability and trust most of all. To know that I share a vision with so many women is the greatest gift. I never would have expected this visibility or would have ever sought it out.

Thank you Ari for exposing me to such a wonderful audience. Bravo!

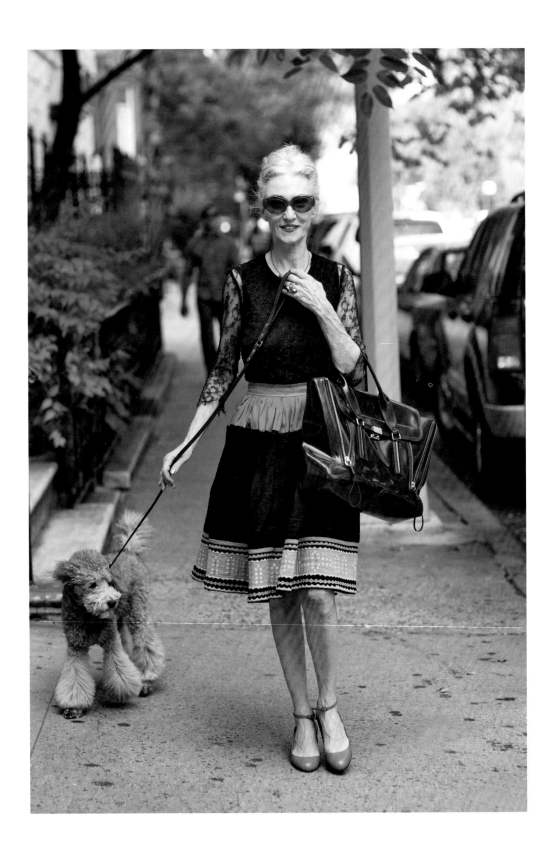

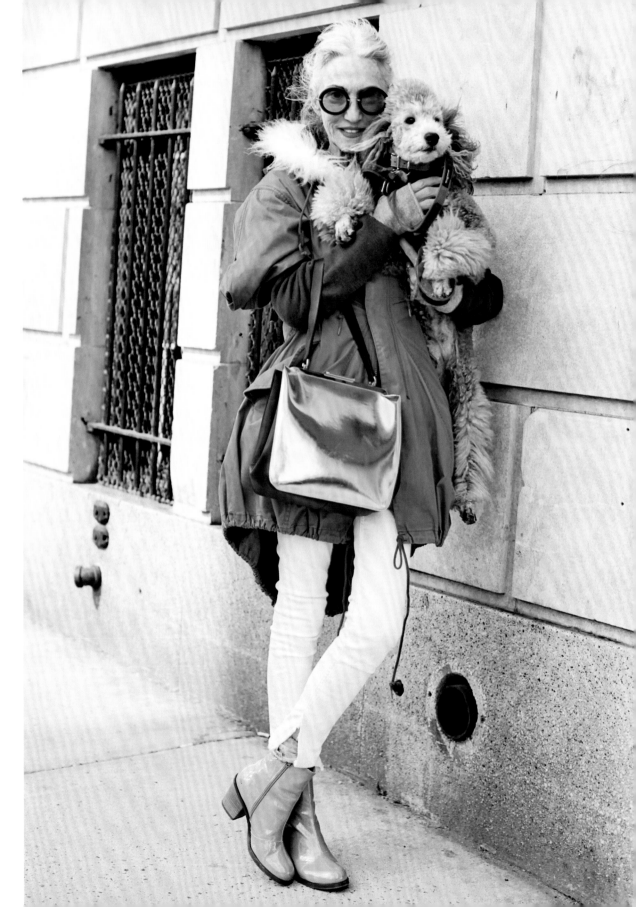

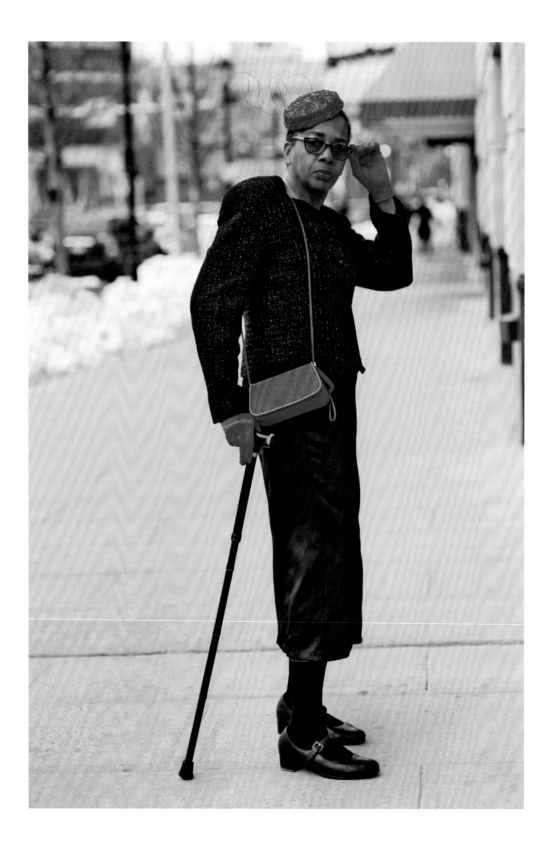

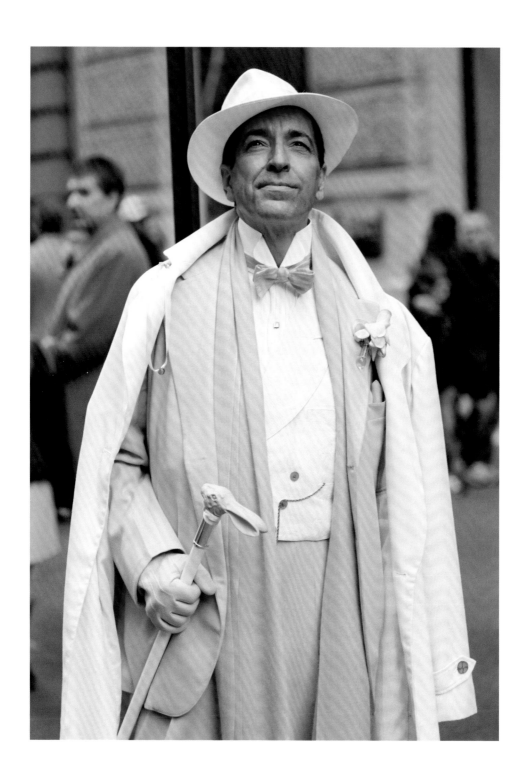

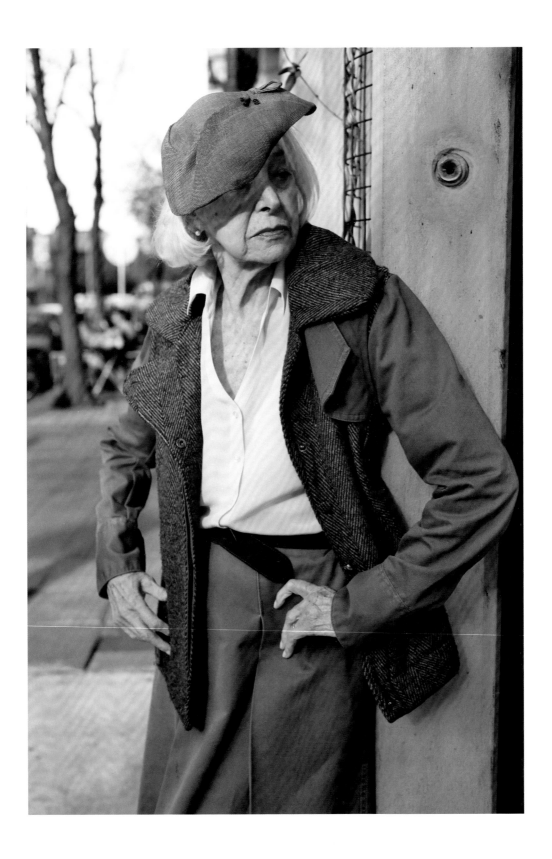

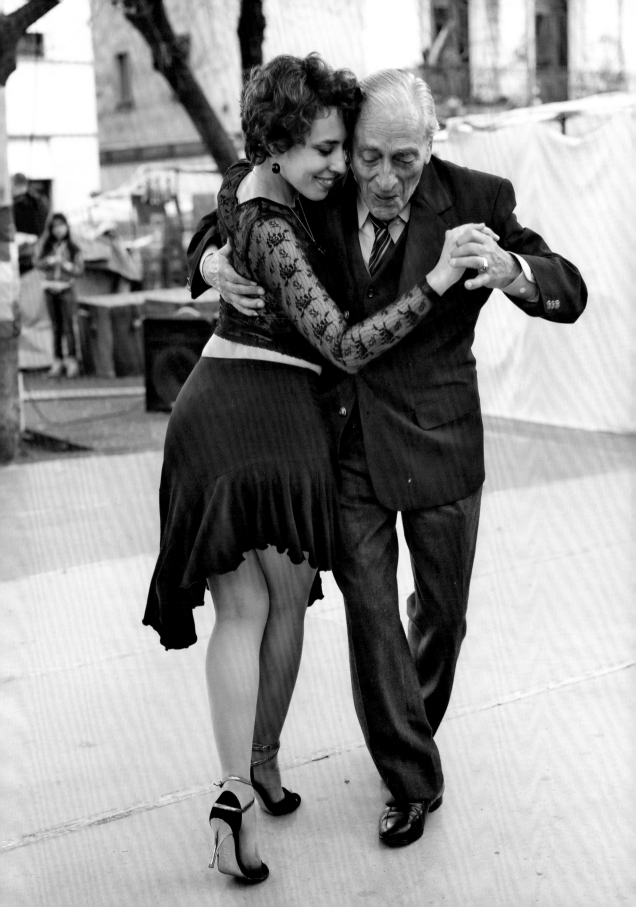

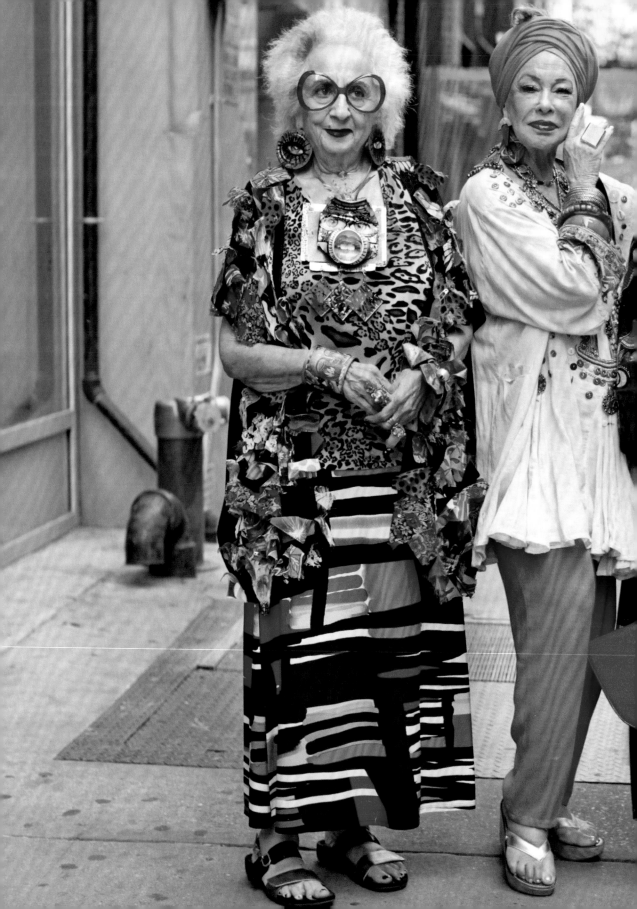

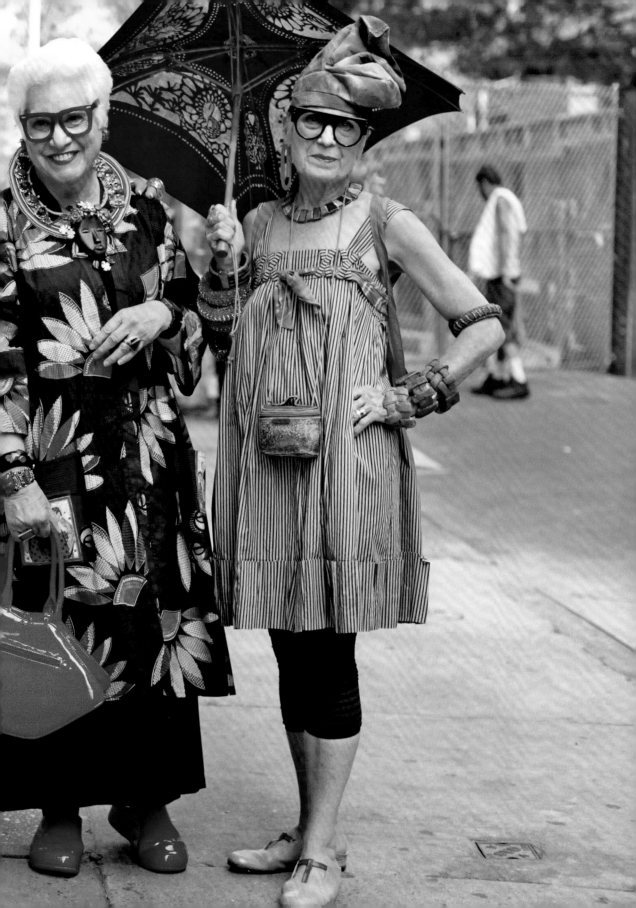

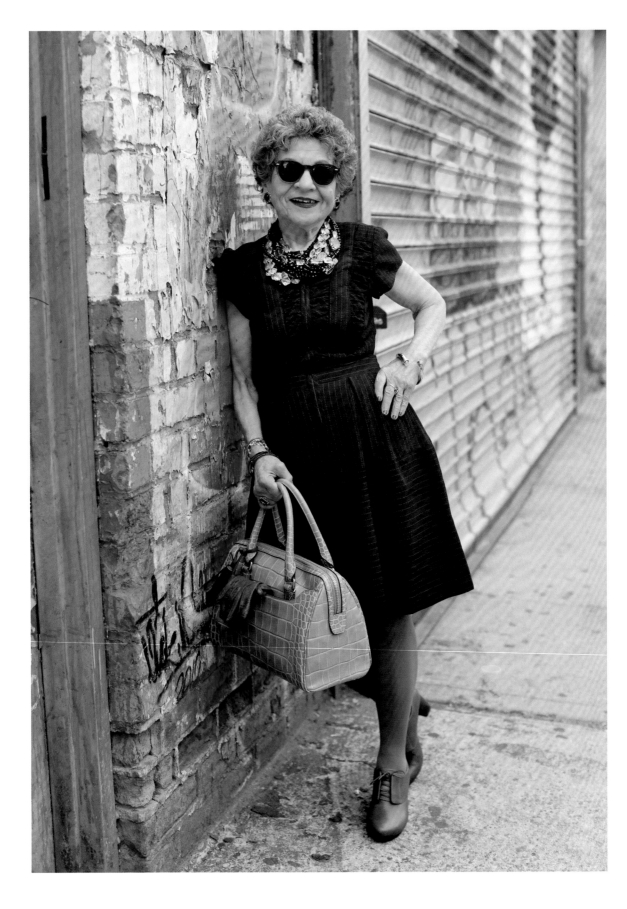

Mary Anita Efron, 75

My life is the story of a woman and her wardrobe. No doubt an X-ray of my brain would primarily show closets and racks containing my current wardrobe. Yes, this is the confession of an obsessive clothes piggy, but it's also my way of coping with the world as I age and shrink. To paraphrase Audrey Hepburn— enchanting universal icon—looking my best is my way of dealing with the world; meaning the better one looks the more one is treated respectfully and taken seriously. We who begin with diminutive stature and are over 70 years have a special problem in obtaining *presence* in an ageist society, and by presence I mean conveying a sophisticated, intelligent, adult persona. While not presuming "to give advice" I am happy to share my strategies and tactics for coping with the transformations of the aging process, and making a happier and easier time of it.

What follows are my personal formulae for makeup, shapewear, and wardrobe for my petite antique state, along with brief sketches of some famous personalities.

So many surprisingly tiny women have achieved colossal presence with their personalities, brains, and mode of dress: for instance, Gloria Swanson's character Norma Desmond so aptly said in *Sunset Boulevard*, "I'm still big. It's the pictures that got small." Ms. Swanson was, in fact, 4'11", but became grand and luminous by her exotic glamour.

"All right Mr. DeMille, I'm ready for my close-up," Norma Desmond announces in her final heartbreaking moment. I get ready for my close-up every time I leave my apartment. At 75, nature needs a lot of help, and I have no problem with artifice over nature. Developing the skill of makeup application has been close to a lifelong practice; I've always tried to assess needed changes as time advances. Obviously, the cosmetics industry gives us more than enough options. Makeup-counter personnel are nearly unanimously eager to share product information. While I can't look younger, I can look better and fresher. As Madame Helena Rubinstein used to say, "There are no ugly women, only lazy ones."

Madame Rubenstein was another diminutive (4'10") force of nature whose accomplishments are astonishing, especially considering her background: born in a small Jewish town near Kraków in 1872 to an Orthodox Jewish family, Madame Rubenstein created a huge cosmetics empire, amassed a magnificent, eclectic art collection, had palatial homes in Paris, London, and New York, and was remarkably progressive, culturally and politically. In spite of her small size she wore masses of large jewelry, which looked stunning. The recent exhibition, *Beauty Is Power* (Helena Rubinstein's slogan since 1904), organized by the Jewish Museum, New York, was a revelation of her extraordinary biography. The frontispiece of the excellent catalog for the exhibition has the image of Picasso's tapestry *Confidence*, which was in Madame Rubenstein's posthumously dispersed art collection.

Now let's consider underpinnings. "Flatter-U corsets do what you wish Nature would do—that is, a scientific equalization of the flesh," proclaims a girdle ad, ca. 1930. Modern shapewear has even improved on the corsets that had formerly conquered nature, but experience has taught me I need help to find the right garment, so I shop at stores with large lingerie selections and enlist the services of a sales associate. Modern shapewear, if properly fitted, is comfortable, confidence-building, and yes, rights the wrongs of nature.

Confidence personified, blond bombshell Mae West had no need of outwardly provocative lingerie. Her flamboyant characters seduce with their brains and humor, lusty smirk and rolling hips, never doubting the power of her beauty to rule the male human animal. Ms. West is so smart and sexy, her ample curves squeezed into embroidered and beaded satin gowns, happily slithering toward the camera or her male prey on six-inch platform shoes, which are always hidden by a long dress. Five-foot tall with a giant personality, she would say things like, "When choosing between two evils, I always like to try the one I've never tried before." Way before the feminist movement, Mae West turned the tables on men, treating them the way they were mistreating women. In the early 1930s Ms. West once spotted an extremely attractive young man on the Paramount lot and said, "If that boy can talk he's in my next picture." The picture was *I'm No Angel*, the "boy" was Cary Grant, and she told him to, "Come up and see me some time. Anytime." Playwright, screenwriter, actress (on the stage since age 7, and 40 years old in

her first movie), aka The Statue of Libido, Mae West had—and still gives us—a wonderful time, always beautifully and fully dressed, and under all she no doubt wore the very best foundations to be had.

Hollywood studio designers and stylists of the past seem to have known everything about making under-sized women look like normal, average-height adults. Apparel for Judy Garland (4'11") and Natalie Wood (5') exemplify this skill: outfits designed for these megastars made the eye travel vertically; eye catching details such as jewelry or embellishments were up near their heads, proportions were never exaggerated, and fit was always perfect. Practical, timeless, and flattering, the styling devised for Judy Garland and Natalie Wood is the mode I've followed for many years.

My wardrobe consists primarily of items devised during the 1920s—skirts, sweaters, and trousers—and the 1930s—shirtdresses, fitted sheath dresses, fitted jackets, and swing or straight skirts. In other words, what used to be called All American Sportswear, which can go anywhere, depending upon accessories. By keeping lines simple and colors on the dark side—either monochrome or harmonious—a longer illusion is created. Baby Jane moments are to be avoided, so all hem lengths must at least cover my knees. Style is eternal and fashion is ephemeral. I look for pieces that will be wearable for many years and span multiple generations, since I have a lovely daughter-in-law and glamorous granddaughters.

How we put ourselves together sends a message about presence in this ageist superficial world, so why not use some artifice to advantage?

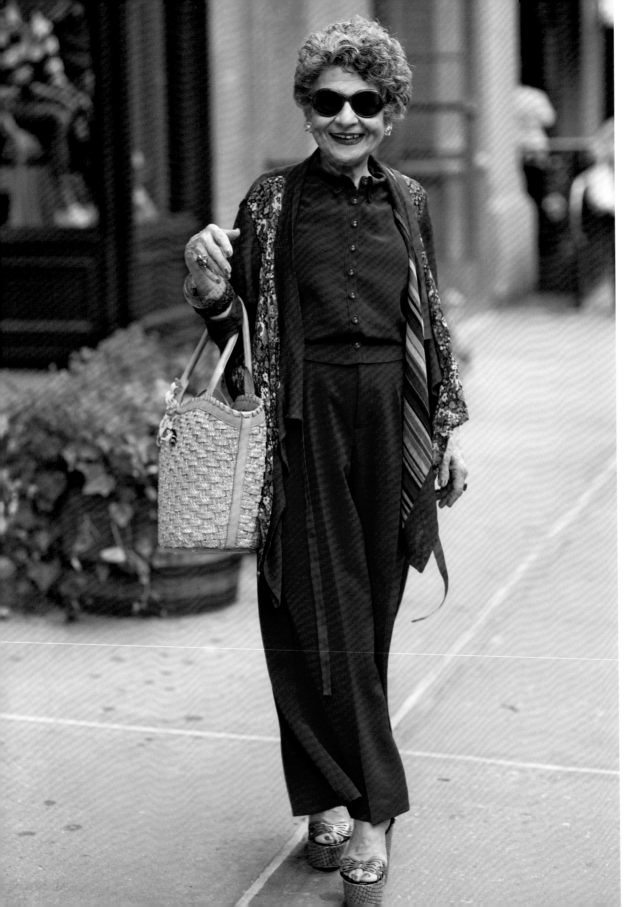

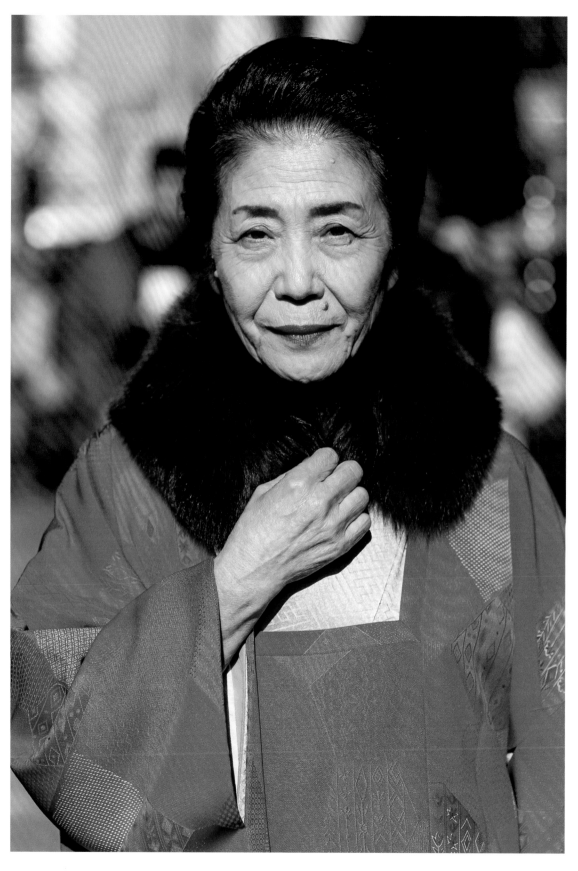

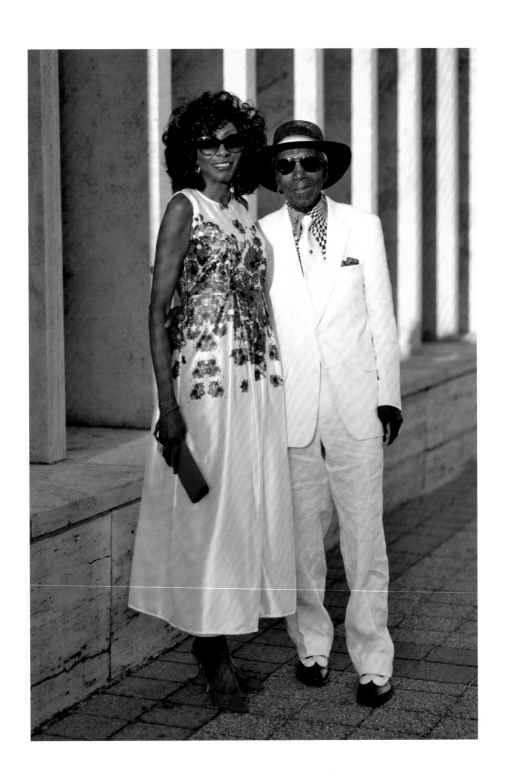

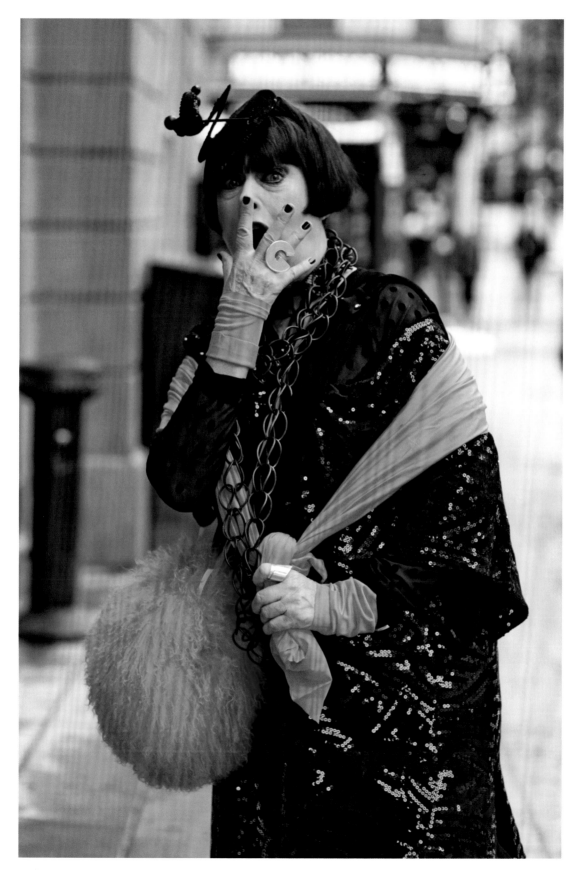

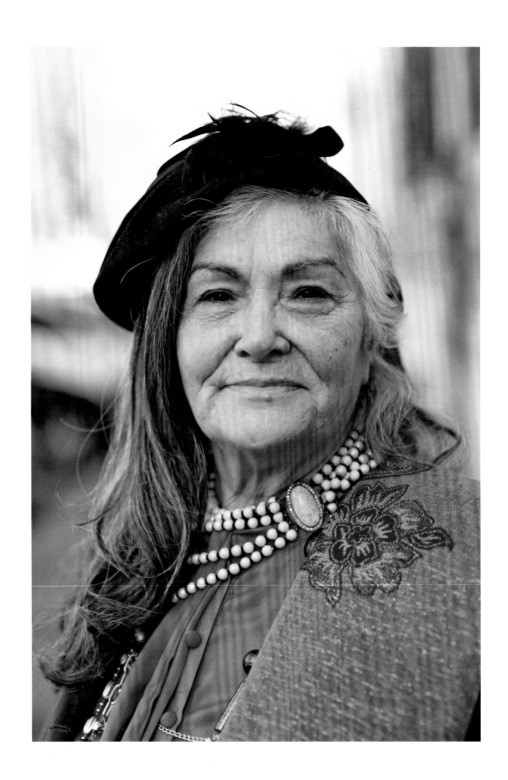

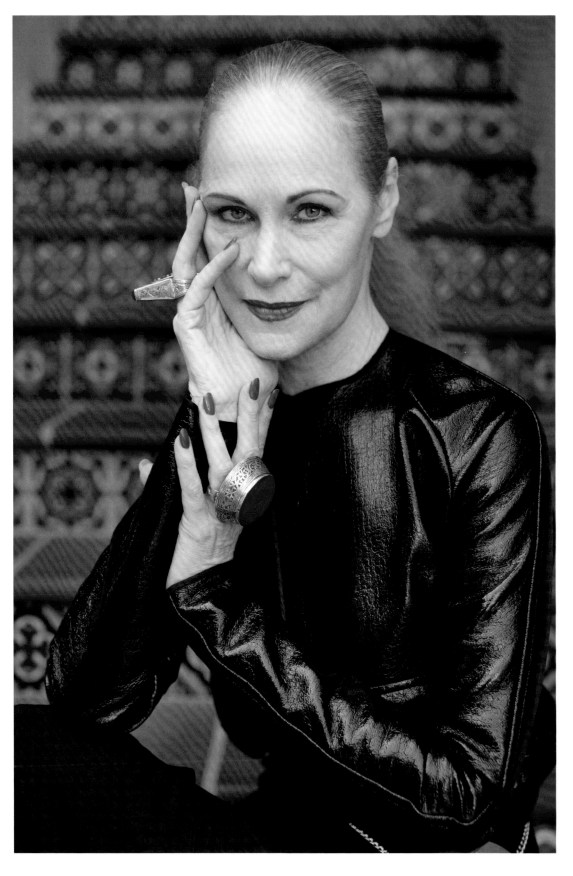

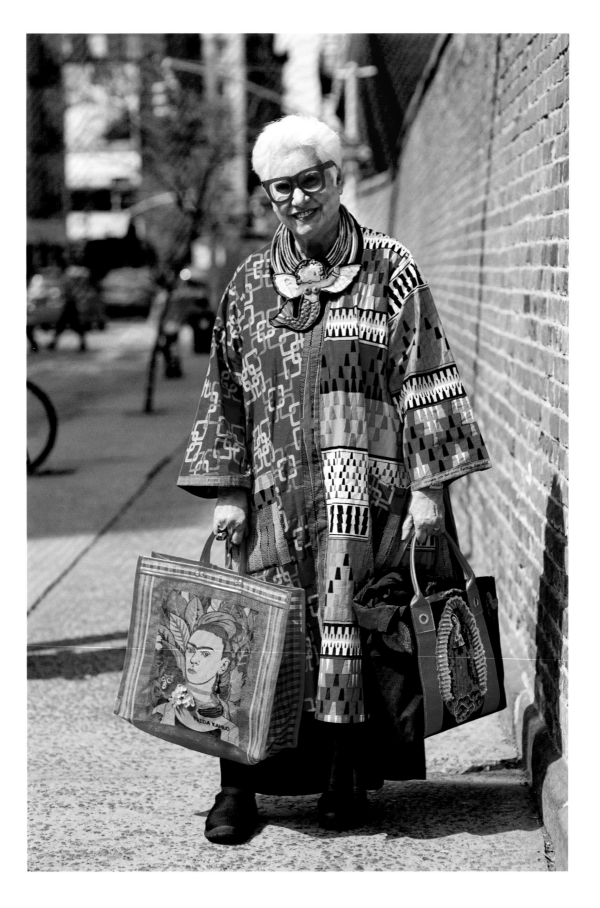

Sue Kreitzman, 76

My age is somewhere between mid 70s and eternity, but I am not *really* an old lady—I'm just cleverly disguised as one. I know that I am not immortal, but I *am* ageless. Traveling through time as long as I have is an adventure and a privilege. Every morning that I wake up and find that I can still think, I can still move, I am still *alive*: that is a good day. Advancing years can often bring great gifts and great surprises. The secret to having a happy "old age" is to be open to epiphanies, thunderbolts, and unexpected visits from the muse.

For many years, I was a food writer and broadcaster. One morning I was editing the proofs of my 27th cookbook with no idea that my life was about to change completely. I was scouring the proofs for typos and checking the integrity of the recipes when my hand picked up a marking pen, and that hand drew a mermaid on a piece of scrap paper. Although I always loved art and color, it was a well-known fact that I could not actually do it myself. Even my doodles were boring. But there was a mermaid! Festooned with snakes, wearing a fish for a hat! Where the hell did that come from? I scrabbled for more markers and colored her in. She was in charge, not me. I have no idea what happened—I simply burst into art. From that moment on, I was obsessed. I drew like a madwoman. Eventually I began painting, first with nail varnish, then with acrylics. I began making astounding sculptures out of junk and detritus. I never wrote another cookbook, and my obsession with food was gone with the wind. I was an *artiste*—what a lovely and strange state of affairs. Was it a visitation? A psychotic break? Did the muse bite me in the bum? Or perhaps it was the menopause. But from that moment on, my life changed forever, I became a different person entirely. It was a gift from the universe and I am forever grateful. I am still obsessed and possessed, and I now have a global reputation as an artist and curator. Miracles really do happen!

How lucky I am: relatively healthy, a supportive family, a wild assortment of vivid and talented friends. At this age, we may not be dead yet, but we can almost see it from here. It's the memento mori thing: remember death, but choose life for as long as you possibly can.

My message is this: be open to change. When the muse bites, do not ignore her. It is *never* too late to unlock your hidden talents, to finally do the things you always dreamt of doing, to realize your full potential. With the menopause, with advancing age, great adventures can begin. Be ready to embrace them. Be bold, be adventurous. Do profound things, dazzle yourself and the world. Contribute to society, and live large. Life is short, make every moment count. It is never too late to find your passion.

One of the great joys of my unexpected new life as an artist has been the artist friends, young and old, who have gathered around me; they are my tribe. By now, I have a huge and inspiring collection of their art and my own art. When I leave the house, I cannot bear to leave the art behind, so I wrap myself in it, in a very literal way, and sashay forth into the world, a walking collage. Here are my style tips for a happy and artistic life of art style:

- Less is less, more is not quite enough.
- As far as exuberant color is concerned, throw away the color wheel; everything goes with everything!
- It is quite okay to wear an entire ethnology department around your neck.
- Good taste is overrated.
- And finally... *Don't wear beige, it might kill you!*

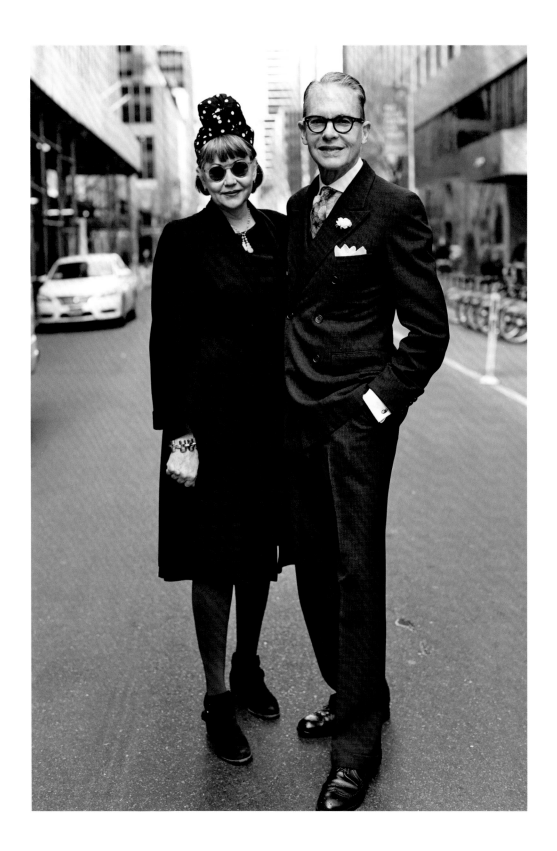

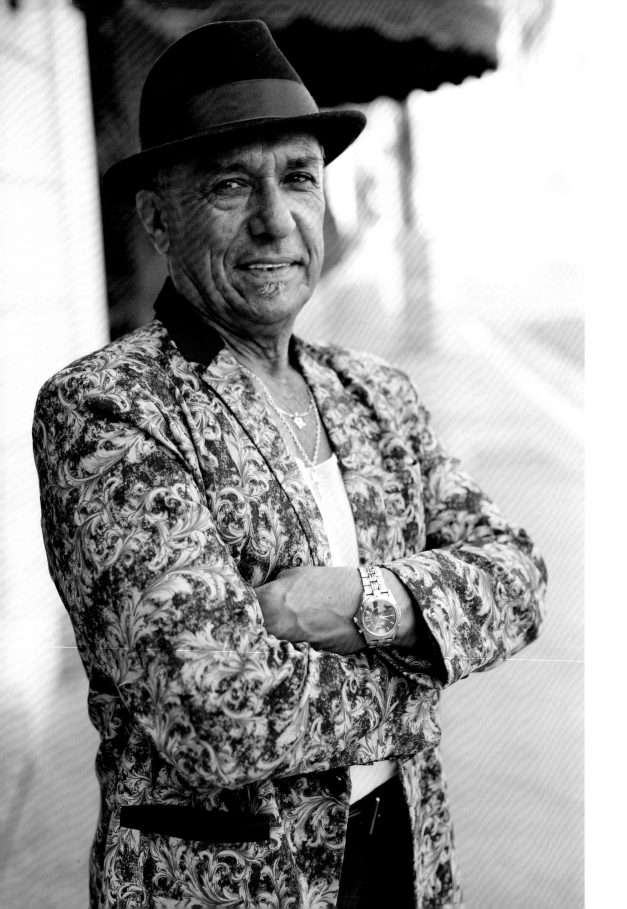

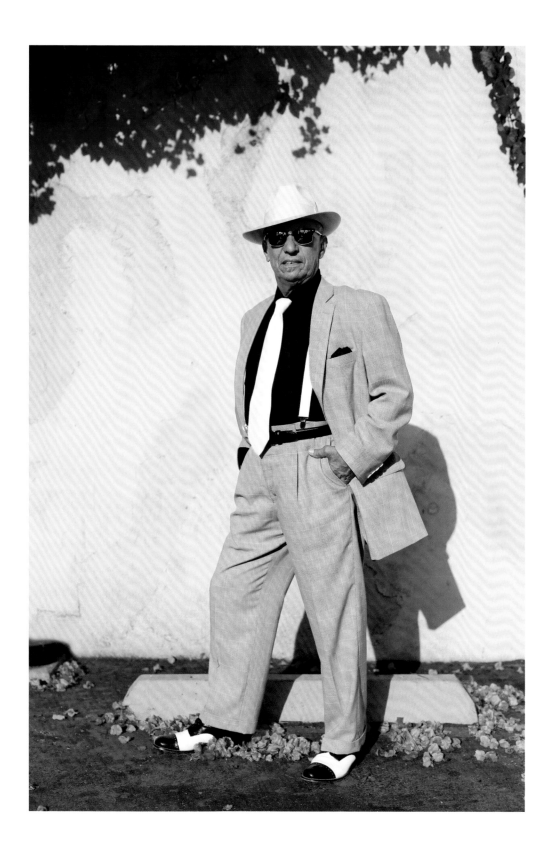

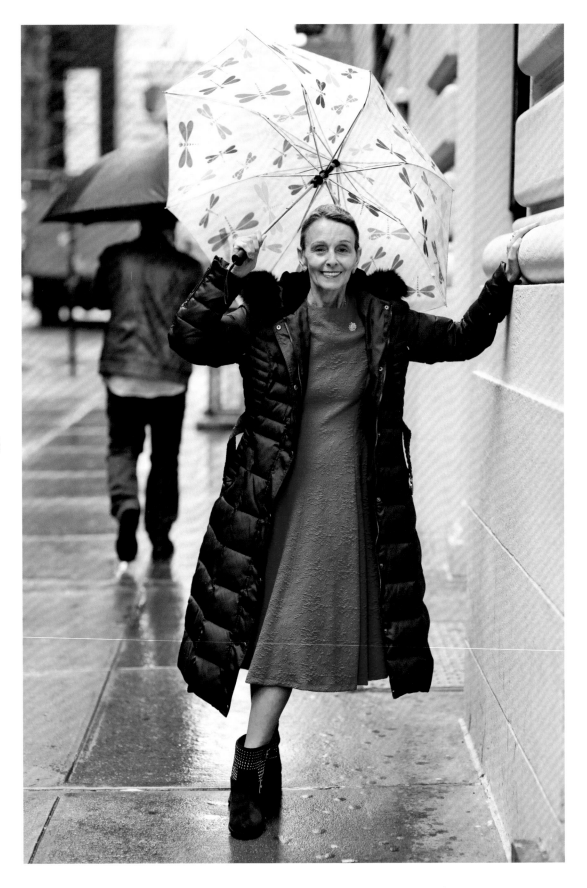

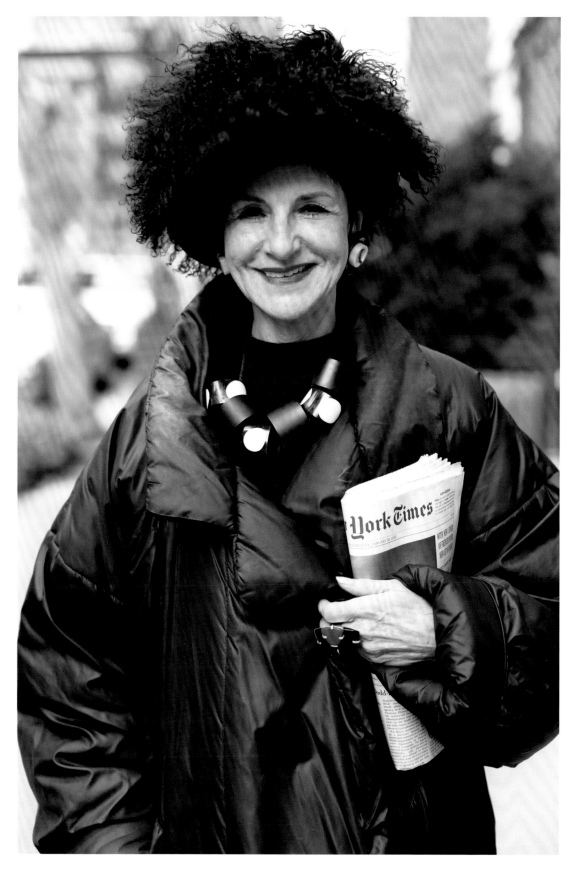

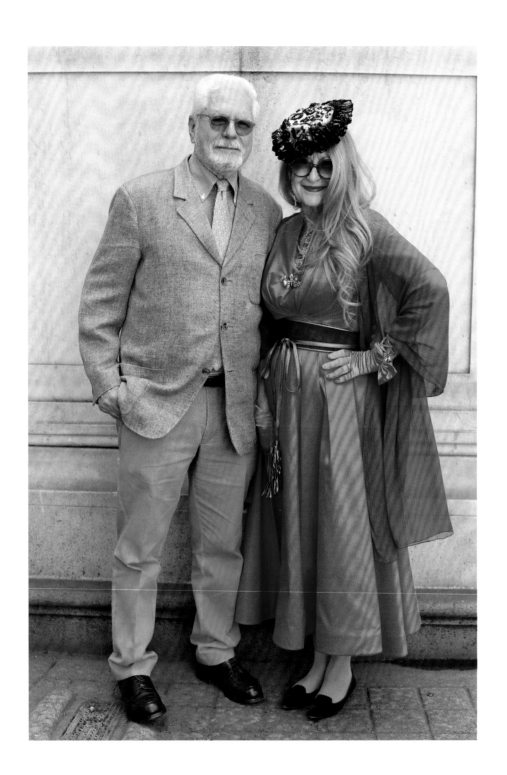

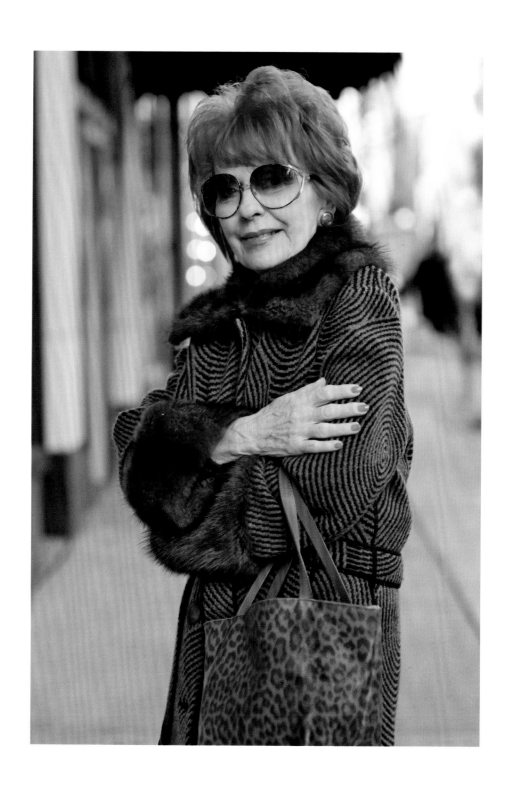

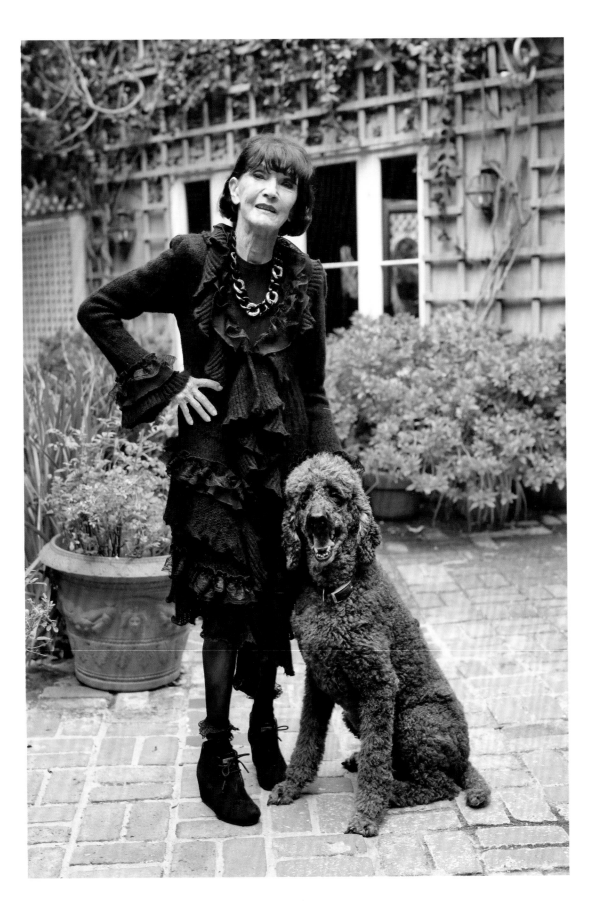

Phyllis Sues, 92

On the Internet, TV, and radio, in magazines and newspapers, everywhere you look—it's all about age. I'm approaching my mid 90s. But what I really am is a yogi, tango dancer, jump-roper deliciously enjoying every breathing minute of a fantastic 92 years.

I've had a very creative and active life from the minute I was born. Good genes and a good mom and dad. *Challenge* was part of my vocabulary at an early age. Living a successful dancer's life in New York City in the 30s, 40s and 50s and performing in five hit Broadway shows *Kismet*, *Oklahoma*, *Bloomer Girl*, *Brigadoon*, *High Button Shoes*, and dancing to the choreography of Agnes De Mille, Jerry Robbins, Michael Kidd, and Jack Cole—that's called living in style.

To be 92, or any age, and sedentary, overweight, and dealing with memory loss is no way to live. Aging can be exciting, creative, active, and even daring. But—that's a huge but—it's not easy to own this. It takes work, desire, and most of all loving what you do every day, every minute, every second, even if it's washing dishes.

I never questioned why I was on this planet. I knew instinctively I was one of the lucky ones. Now at the age of 92, I realize I'm not just lucky. It takes plain hard work to be in the kind of condition I'm talking about at almost any age.

I learned the word dedication when I took my first ballet class with the great George Balanchine. And that dedication has filled every part of me for 92 years. I use the word challenge constantly because that's what it's all about. I look for, and long for, challenge every waking moment. My mantra, "never give up," is a driving force that will always make me a better dancer, yogi, jump-roper, musician, and even a better writer.

I mention "musician." My mother was a concert pianist so it was only natural that I should also be a pianist. I did give it a go for a few young years, until ballet took over my life. Between the age of 14 and 75 the piano was far from a part of my life, until my mom passed away in 1993 and her beautiful Steinway grand piano was shipped to me. That was the rebirth of piano in my life and the birth

of creative improvising, which led to the composition of six tangos for the album *Tango Insomnia*, featuring piano, bass, percussion, violin, bandoneon, guitar, and flute, and a jazz album, *Scenes of Passion*, featuring piano, bass, percussion, and guitar. My favorite song on *Scenes of Passion* is called "Nite Time." It's a true story, and a piece of my life during my second marriage, and if you take it as a personal experience, it's very meaningful. I can't say I wish it had never happened because I firmly believe all that happens in life happens for a good reason and we're not God, so we have to accept whatever comes in whatever shape or form.

Actually some of these things were not in my grasp until age 85, even trapeze.

I had one other career at age 50: fashion designer. That lasted 22 successful years. There's no question, I've always been active in many ways all my life. And looking ahead, who knows what's still out there? Whatever it is I'll be ready.

If I had to do it all over again I wouldn't change a thing. I'm still very much here. What's good about living is living. I rarely think about the number 92. As you know, it's just a number. It's what you do, not how you count.

I know you hate to hear this, but I'll say it anyway. "If I can do it, you can do it!" Even though I have arthritis and osteoporosis, I don't allow either of them to be active members of my life. And neither is cancer, which I conquered at age 79.

So you see—if I can, you can! That's the title of my someday autobiography, *If I Can! You Can!*

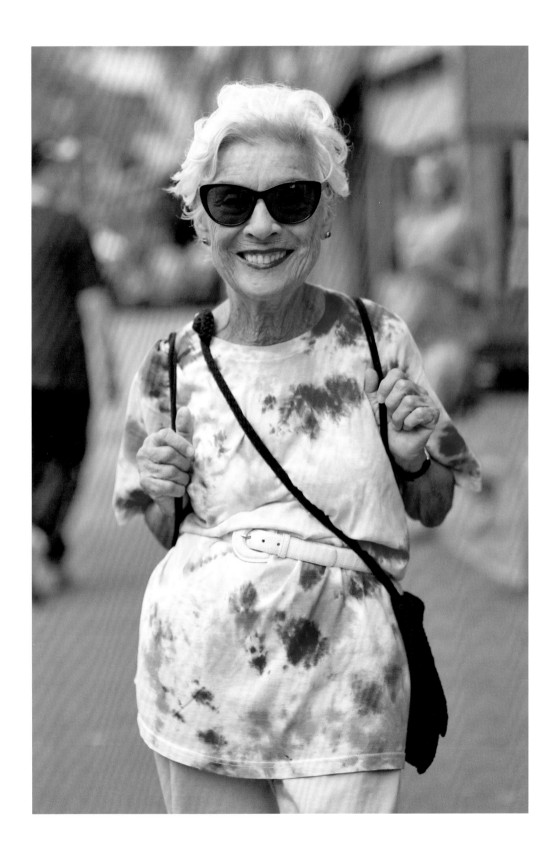

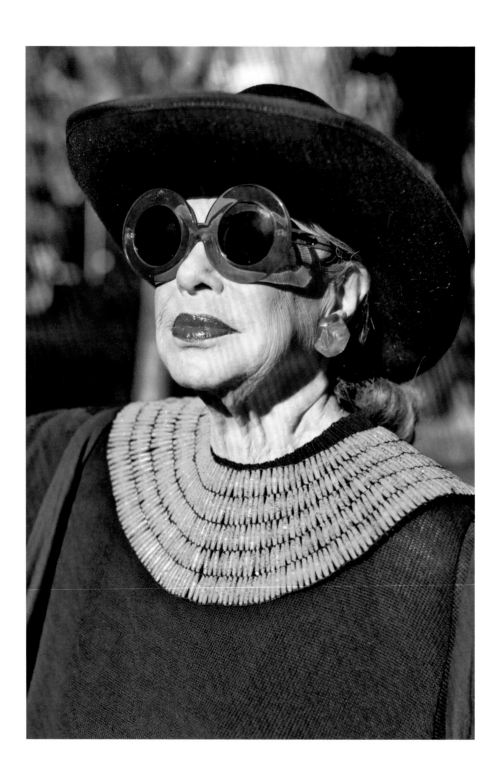

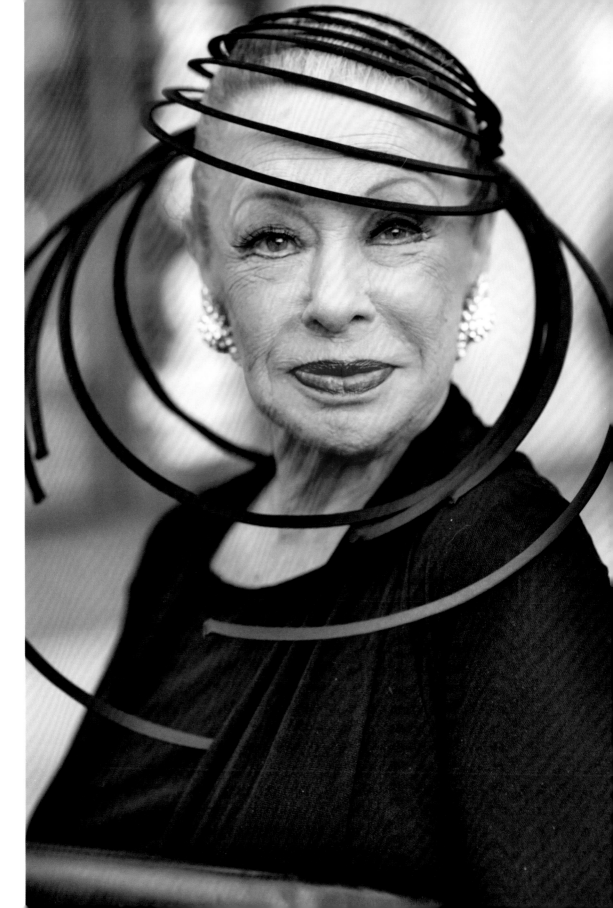

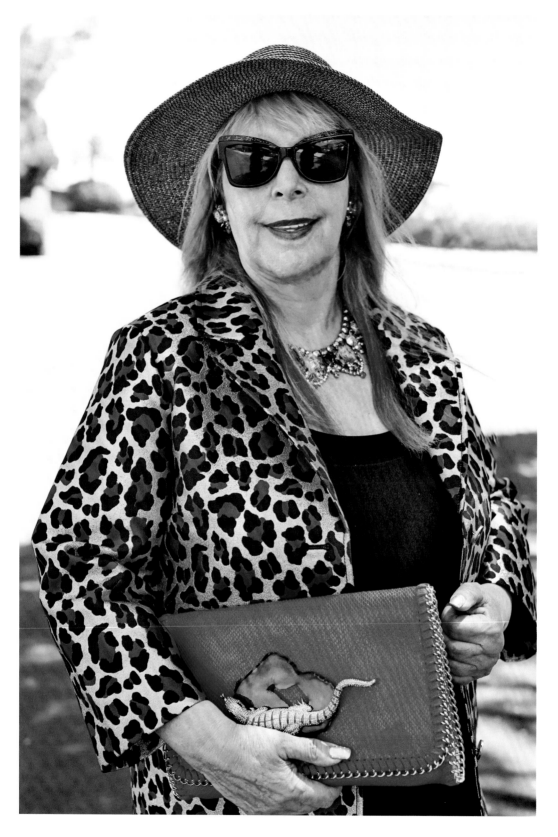

My amazing mom **Frances**, the mother of *Advanced Style*

Acknowledgements

I want to thank every single one of the men and women on these pages for stopping to let a young man in crazy patterns take your photograph. Some of these experiences lasted only a minute, while others have blossomed into the most powerful and life-affirming moments of my 33 years on this planet. Thanks for being courageous, for never giving up, and for showing the world that you are only as old as you feel…and dress.

Thanks to Eric Lee for your amazing editing skills, for listening to my crazy stories, and for all your love and support.

Mom and Dad for encouraging my creativity.

Valentina Ilardi Martin for always pushing me to take a risk.

Fanny Karst, my partner in crime, who joined me on many of my style-hunting adventures.

Lina Plioplyte for capturing the magic of these brilliant women on film.

Debra Rapoport, our "camp counselor," for continuing to keep the movement alive in your many wondrous tea parties.

Michaela Trotsky for always supporting and taking care of me when I needed you.

Natalia Martinez Sagan for your guidance, warmth, and welcoming in Buenos Aires.

Thank you to two of my childhood style icons Zandra Rhodes and Carol Channing for allowing me the privilege of taking your photographs.

Fancy Schmancy Cohen Lee for providing hours of cuteness and love and for being the best doggy in the whole world.

Photo: Ben Ritter

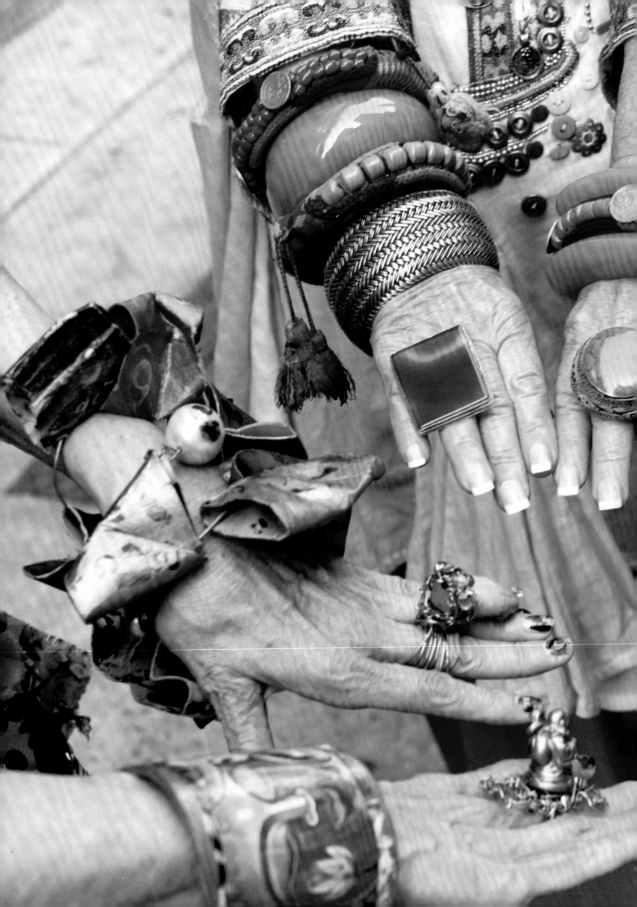

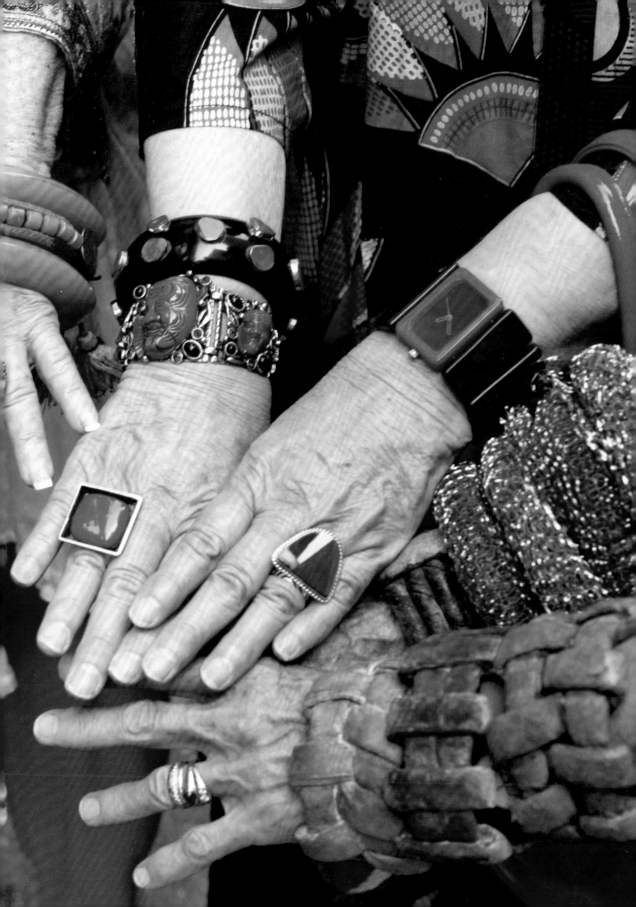

Advanced Style: Older & Wiser

Photographs © 2016 Ari Seth Cohen
Foreword © 2016 Simon Doonan
All other texts © their respective owners and used with permission.

advancedstyle.blogspot.com

Published in the United States by powerHouse Books,
a division of powerHouse Cultural Entertainment, Inc.
37 Main Street, Brooklyn, NY 11201-1021
telephone 212.604.9074, fax 212.366.5247
e-mail: info@powerHouseBooks.com
website: www.powerHouseBooks.com

First edition, 2016

Library of Congress Control Number: 2015960587

Hardcover ISBN 978-1-57687-797-5

Printed by Asia Pacific Offset

Book design by Krzysztof Poluchowicz

10 9 8 7 6 5 4 3

Printed and bound in China